The Art of
Hogarth

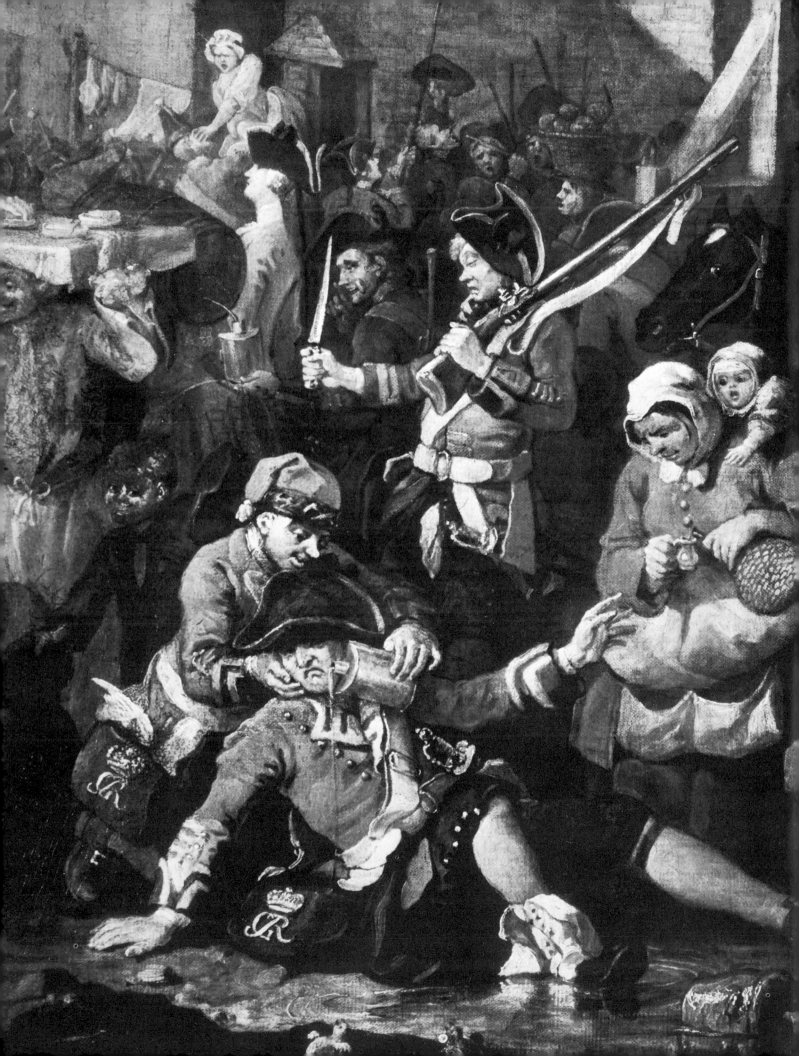

Ronald Paulson

The Art of
Hogarth

Phaidon

Frontispiece: Detail of *The March to Finchley* (Plate 102)

Phaidon Press Limited, 5 Cromwell Place, London SW7 2JL
Distributed in the United States of America by Praeger Publishers, Inc.
111 Fourth Avenue, New York, NY 10003

First published 1975
All rights reserved

ISBN 0 7148 1640 X
Library of Congress Catalog Card Number: 75–52

Printed in The Netherlands by Drukkerij de Lange/van Leer NV, Deventer

Contents

Preface

William Hogarth is in some ways the most accessible of English artists. He dealt with everyday subjects, told compelling stories, and made people laugh and cry. His designs were engraved, and so from the time of publication to the present have not lacked a wide audience. But for this very reason many people have never thought of Hogarth as a painter. The situation was momentarily remedied in the winter of 1971 by the great exhibition at the Tate Gallery, London. Anyone who saw those paintings can no longer doubt Hogarth's stature as a painter.

One can still, any day of the year, enjoy a cross-section of his best paintings in the octagon room of the Tate, the six paintings of *Marriage à la Mode* and *The Shrimp Girl* in the National Gallery, the eight paintings of the *Rake's Progress* and the four of the *Election* in the Soane Museum, and his most impressive history paintings in St Bartholomew's Hospital and the Foundling Hospital—all within a radius of three miles. The situation is less fortunate outside London. Aside from the several major paintings in the Fitzwilliam Museum in Cambridge and the dozen in the Paul Mellon Collection in the United States, the great mass of Hogarth's paintings are scattered one by one in the museums and private collections of the world; they are seldom brought together and, when reproduced in books, generally without distinction.

The purpose of this book is to reproduce Hogarth's best paintings, and it is primarily devoted to Hogarth the painter, though it includes drawings and engravings when these are representative of a particular phase of his career. From the outset to about 1728 Hogarth was an engraver by trade and prepared for his more complex engravings with drawings (usually for a publisher who had to be sold on the project), but much of his creation was carried out directly on the copperplate itself. From 1728 onward he devoted a great part of his time to painting, working out his ideas on canvas, sometimes into a finished painting, before starting the engraving. He was incredibly fluent in the medium of oil paint, and there is nothing else in English art quite like the unfinished (usually background) areas of his paintings and the oil sketches he left behind in his studio. It is not exaggerating to say that he thought in paint, at least as far as forms and representations were concerned.

The general sweep of the reproductions in this book, therefore, will be of the paintings, with a few stretches in which Hogarth's art is best seen in drawings or the engravings themselves. (For a brief period between 1746 and 1751 he returned to the practice of producing preliminary drawings for his popularly oriented prints.) In a few cases, like *The Enraged Musician*, we can see the evolution from the rough oil sketch to the preliminary form on the copperplate (recorded in a proof) to the final engraving.

The selection of the paintings is based on my assumption that the 'modern moral subjects' or 'comic history-paintings' are primary in an assessment of Hogarth's place as an artist. In reproducing the portraits I have chosen only a sampling of the different types and the most striking successes, inevitably emphasizing the conversation pieces over the single portraits. The subject of the introductory essay is

Hogarth the artist, and strictly biographical information is condensed into a chronology following the introduction.

Although this is intended as a general critical introduction to the enjoyment of Hogarth's art, I have included much material that is new or corrects errors in my *Hogarth: His Life, Art and Times* (1971). Parts of sections 1 and 4 originally appeared in a different form as BBC talks and in *The Listener* (1972), parts of sections 5 and 8 in *The Burlington Magazine* (February 1972), and the material on *Paul before Felix* in section 6 in *The Burlington Magazine* (April 1972) and *The Art Bulletin* (1975). The caption for Plates 63–65 is a condensation of a note in *The Burlington Magazine* (1974). The Phaidon Press and I are most grateful to Her Majesty The Queen for gracious permission to reproduce works in the Royal Collection. We should also like to express our thanks to all those other private owners and museum curators who have kindly allowed us to reproduce works in their ownership or under their care.

Introduction

1. The Prison Cell

No English artist painted more prison interiors than Hogarth. His first major painting was of the interior of Newgate and his second of the Fleet Prison for debtors. In his earliest original inventions, the progresses of a harlot and a rake, he dealt with protagonists who end in literal prison cells or in the locked rooms of a madhouse, but who, even when 'free', are housed in ever smaller, more enclosed rooms that resemble cells or are metaphorically prisons.

Hogarth's art never lost—indeed it cherished—the dirty smudges left by life. From his eleventh to his sixteenth year, his family languished in the Fleet Prison and its Liberties. Although his father may have spent his first months in a cell, the family lived the whole time not in the prison proper but in a room or two in a house enclosed within the *precincts* of the prison: that is, a room that resembled a room but was in fact a prison cell. Hogarth himself never breathed a word about this time of his life. But, though he never spoke of it, the prison is never far away in his paintings and prints.

A prison itself does not at first appear, or only at a distance and seen from the outside. Although he shows a prisoner in the stocks or tied to a stake or being whipped, he places him outside in open space (Figure 1). The first representations of a prison interior are those of *The Beggar's Opera* (1728, Plates 10, 11, Figures 2, 20), where the prison is not a real one but a painted set on the stage of the Lincoln's Inn Fields Theatre. John Gay's immensely popular ballad opera gave Hogarth the subject, and offered him an excuse to portray the inside of a prison, and only a *play* prison at that. But there is a real prison of sorts all the same; though standing in the middle of a vast and obvious stage, Captain Macheath, his legs fettered, is hemmed in by his rival loves, Polly Peachum and Lucy Lockit, each demanding that he acknowledge her as his wife. And, though he appears wonderfully jaunty under the circumstances, he is also hemmed in by the girls' fathers, who want to see him hanged, and beyond them by the audience sitting on either side of the stage itself, who want him to fulfil the entelechy projected by theatrical conventions.

The Beggar's Opera allowed Hogarth to experiment with the idea of a prison, but what happened a year later gave him as subject an actual prison. The cruelty and corruption of the Fleet's warden, his persecution and exploitation of helpless debtors, had become so blatant that a committee of the House of Commons was formed to investigate. Hogarth accompanied the committee into the Fleet and sketched the scene from life—a return after fifteen years, or perhaps his first actual visit inside the prison where his father had once suffered. The scene he chose to paint is one in which a prisoner is confronting the warden in the presence of a tableful of M.P.s (Plates 5, 6). Something real is happening here, and yet Hogarth has arranged the scene as theatrically as *The Beggar's Opera*, with the same essential elements including the audience.

With his first series of invented pictures, *A Harlot's Progress* (1732, Plates 23–28),

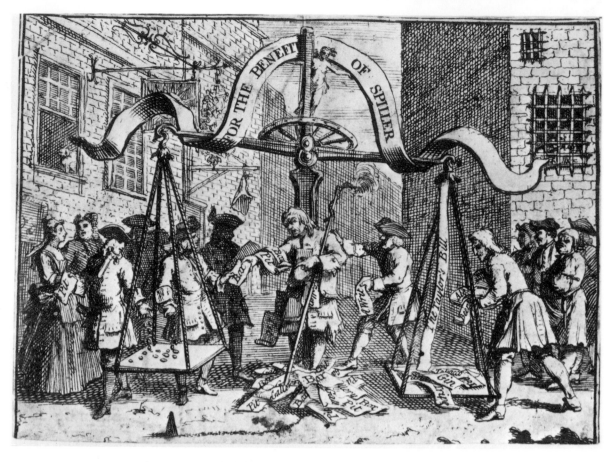

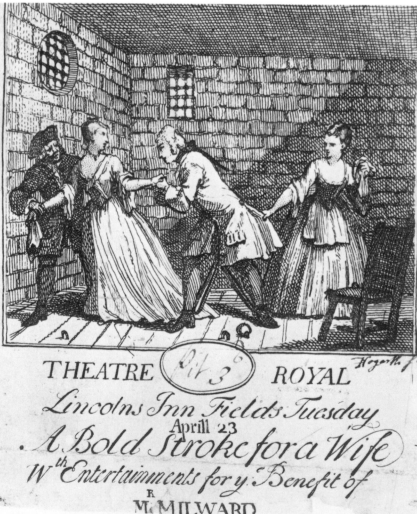

Figure 1. *Benefit Ticket for James Spiller*. 1720. Engraving, $3\frac{3}{8} \times 4\frac{3}{8}$ in. (enlarged). London, British Museum

Figure 2. *Benefit Ticket for William Milward*. 1728. Engraving, $3\frac{7}{16} \times 4\frac{1}{16}$ in. ($5\frac{1}{4} \times 4\frac{1}{4}$ in. platemark). Windsor Castle, Royal Library

Hogarth abandons all sense of play and makes us aware of an enclosure—a room which appears to be a drawing-room or a boudoir but is a prison. The Harlot is imprisoned in Bridewell, the prison for women, but from the second to the final plate she is in rooms that are ever more closed and confining. Only the first scene is out-of-doors; the young girl is just off the York Wagon, in which we see a great many anonymous girls packed like sardines: *she* has emerged as an individual into open space. The sky is open, but the buildings already encroach and nearly close it. Daylight and the spaces of her native Yorkshire are already only memories, and she is about to pursue the life of a 'lady' in London, following the bawd into the dark, narrow doorway; and in the next scene she has become mistress of a wealthy merchant in a heavily over-furnished room in the City. The only opening remaining to the outside world is a half-open door, out of which her lover is escaping. But her keeper learns of her two-timing, and in the next plate she is lodged in a shabby chamber in Drury Lane; this time the door opens to admit a magistrate, who has come to arrest her for prostitution. In the following plates she is not only encompassed by prison walls but by the flannel wrapped close about her body for the sweating cure for syphilis, and in the last plate by her wooden coffin. 'Here', as Bosola says to the Duchess of Malfi, 'is your last presence chamber.'

In the *Rake's Progress* (1735, Plates 30–43) the hero never ventures out-of-doors except once, and then he has hidden himself inside a sedan chair to get unseen past creditors from his flat to St James's Palace, where he hopes to curry a pension, but he is pulled out into the open air by a beadle (Plate 33). The walls get closer and thicker until in his Fleet cell he is surrounded by prisoners whose attempts to escape extend from wings to alchemy to the man who carries a proposal for paying the national debt (the proposal put forward by Hogarth's father in his pathetic attempt to free himself from the Fleet). The Rake's only escape from his cell is into madness and the chains of Bedlam.

In each case, one asks, what gets the person into this real or metaphorical prison cell? Macheath got himself into his particular tight corner by pretending to be the only love of each girl, and the debtor in Hogarth's Fleet Prison painting—any debtor—by living beyond his income, trying to be a gentleman on the income of a coffee-house proprietor or a poet. In both these paintings I have stressed the theatricality, which is, I think, partly Hogarth's way of gilding or transforming a deeply unpleasant subject. But it is also clear that Hogarth saw at the bottom of this sort of confinement the pretence at being, or the attempt to be, something one is not, the leap beyond one's true identity into a kind of confidence game played on others and oneself. The Harlot is a young girl from the country who is trying to be a lady, and the Rake is the son of a merchant who thinks that if he copies all the aristocratic vices he will be an aristocrat. Their cells do not completely separate the prisoners from other people, who in fact crowd around them like an audience that sees through the actor's role; both walls and audience cut off the actor from the open air.

The out-of-doors begins to appear again in *The Four Times of Day*, which

followed the *Rake's Progress* in 1738 (Plates 52–55). All four scenes are outdoors, but they are in squares or streets, outdoor rooms or corridors hemmed in to a greater or lesser degree by buildings intruding from right and left like the wings of a stage set. The degree of outdoorness, so to speak, is indicated by the amount of sky left open between the buildings, and by the size of the 'room'. The first, 'Morning', shows the great, empty square of Covent Garden early on a winter's morning, with groups of lovers, tramps, and school children, hunched in small groups, trying to keep warm. By contrast, one straight, rigid, unbending old lady echoes the geometrical lines of the buildings; she is trying to be as stark as the church to which she is directing her steps.

The third *Time of Day*, 'Evening', shows the countryside around Sadler's Wells, with only low structures at the left and right edges of the picture. And yet out in the open space, like Macheath with his 'wives' and fathers-in-law, is a poor, thin little husband in the shadow of a huge, overpowering wife on a stiflingly hot summer's day. There is a great deal of sky overhead, but in the engraving it is full of heavy dark clouds moving in the direction of the man and his wife, who have left the crowded city to get a breath of fresh air.

These four pictures represent Hogarth's 'town pastorals', progressing from winter to autumn, dawn to midnight, and youthful freedom (compare the cold adult presence of the old lady in 'Morning') to aged freedom, with grown-ups playing like children with wooden swords and masonic regalia; from young couples kissing to errant husbands and magistrates drunkenly wending their way home after masonic ceremonials. The scenes are all structured on a contrast between the straight lines, closures, controls, and supports of the architectural structures, repeated in the rigid old church-goers, who carry with them their own confining chambers, and the cheerful, messy crowd of people doing their own thing. This is the contrast, with which we are familiar in the works of Bruegel, between the worlds of Lent and Carnival, repression and Saturnalia, probity and drunkenness, and so on.

The scenes of Hogarth's successful and ebullient middle years are summed up in *The Enraged Musician* (1741, Plates 63–65), where the musician is seen enclosed by a window and venting his rage on a motley crew of London's natural noise-makers in the street outside. The musician plays his violin inside his closed house, according to notes on a staff arranged according to harmonic laws, while the scissors-grinder, ballad-singer, and chimney-sweep emit their cacophonous sounds any old way. Worse, he tries to impose his order on them. And yet Hogarth draws no conclusion from the sheer contrast: there is something to be said for the ordering of art—of his own art in the representation—as well as for the vigour of nature.

Were I to construct a world view out of the spatial relations in Hogarth's graphic works, I might suggest that according to him people have to live in the city—there is no escaping to a truly pastoral setting in the country, however desirable this might be. As Dr Johnson said, 'when a man is tired of London, he is tired of life; for there is in London all that life can afford.' The maximum freedom a man enjoys is out in

the open streets and squares, with some sky overhead and a perspective, not entirely closed, leading into a distant glimpse of countryside. This is the necessary state in which human actions can be charted and judged within a known system, with spatial co-ordinates in perspective and moral in social customs. Beyond this, a person becomes increasingly entrapped by shutting himself off from contact with what is outside himself—especially if he is an artist, a musician in his studio or a poet in his garret.

The problem of confinement, originating in childhood trauma, is discernible in almost every aspect of Hogarth's life and career: in his concern with institutions like St Bartholomew's Hospital, with the establishment of the Foundling Hospital, and with the reform of prisons and madhouses; in his determination to break the closed monopoly of printsellers on the distribution of the engraver's product and of patrons on the painter's. It can certainly be related to his inbred hatred of confinement by rules, precepts, academic assumptions, or whatever constricts the individual. He wanted the least structured sort of an art academy—a democratic one, where the young simply came and learned and the mature artist taught and worked. He was solidly against the idea of a Royal Academy with ranks, classes, and salaries. The rules of the art treatises on how to draw and paint, and the categories in which kinds of painting were placed, were all anathema to him.

And yet he always worked within their framework. He did not himself simply go out and paint what he liked, but defined, with the help of a writer like Henry Fielding, and sometimes rather pedantically, a new genre in terms of the highest traditional genre, history painting. The traditional elements always remain, however ridiculed, modified, or absorbed. He never deigned to deal with lower forms on the academic scale of excellence, though he liked to paint still-life and landscape details; far less did he allow anyone to suggest that the scenes he painted were drolls, which were lower yet on the scale, or caricatures, which were altogether off the map. While displaying a sense of artistic liberty far beyond his contemporaries—and exceeded only by Gainsborough in the next generation—he nevertheless worked within the system. And he painted real or sublime history as well. Partly it was to show that he could, but partly also because he too saw himself as something he was not: a history painter in the great tradition, though (at the same time) strictly indigenous to English soil. He was not that, however hard he tried to emphasize the similarities between his painting and Raphael's. In fact, as some part of him knew, he invented a new and never-to-be-repeated form, as intellectually complex and demanding as the literary works of his contemporaries Swift, Fielding, and Sterne. His career was devoted to exploring the limits of imprisonment as well as the dangers and challenges of life outside that ordered structure. He never himself ventured completely outside the confines of contemporary assumptions.

It is not possible to assign precisely the debt to Hogarth's own conscious and unconscious and to the determinations of his time, place, and culture. But the closed room, the haunting image of his work, the source of its most intense reverberations,

is certainly connected with the age's fear of prisons, confinement, and compulsion. An anthology could be constructed that extends from criminal accounts like Defoe's of Jack Sheppard's escapes, but also his *Journal of the Plague Year*, to Pope's *Eloisa to Abelard*; from Addison's

> The mind of man naturally hates everything that looks like a restraint upon it, and is apt to fancy itself under a sort of confinement, when the sight is pent up in a narrow compass

to Richardson's Pamela and Clarissa, whose cells are Hogarth's drawing-rooms and boudoirs. The archetypal room, of course, reaches back to Plato's cave and forward to the representations of Matisse, Bonnard, Vuillard, Francis Bacon, and Edward Hopper, or (in other forms) Pinter and Bertolucci. But Hogarth produced for his contemporaries the definitive image of that dark room of the mind by which Locke figured the process of perception. The individual's world is a closed room which has little access to the outside and is stocked with the impressions, the objects and collections, that make up the owner's character, or (in Lockean terms) his ideas. The imprisonment is self-imposed in that he has chosen these ideas himself, but they determine his every action, and they are themselves imposed on him because they are what he has seen when looking out through those narrow chinks upon the world —often seeing only his own reflection in the paintings of older, crueller times he collects and hangs on his walls.

In Hogarth there is also the tragi-comic disparity between the little, cluttered, illusory world of the room and the real world outside, of hard truths like the law, disease, unpaid bills, and the unstructured crowd of noise-making individualists. This is the larger Newtonian world of gravity, extension, and motion, which is felt within the room as physical consequences—and of course also on those rare occasions when someone like the Rake ventures from his chamber into the out-of-doors. In the engravings, toward which the paintings were directed in these early years, and in which the Hogarthian world view was most forcefully expressed, it is also the colourless world of primary qualities only; of geometry and geometric perception, in which curving human shapes roam helplessly.

2. The Conversation Piece

When Hogarth broke away from what he later, in his autobiographical notes, referred to as the 'Narrowness' of his apprenticeship to a silver-engraver (a 'business too limited in every respect'), he was nearly twenty. He stresses how little time was left in which to learn the craft of book-illustration and topical engraving, and then the much more ambitious pursuit of painting. His engraving supported him only until he could launch himself as a professional painter. This he finally did, when he was already past thirty, but the form he chose was not the grandiose Kneller portrait, the one viable type of painting in monetary terms, let alone the heroic histories of Laguerre and Thornhill: it was the small, crowded, cheap portrait group, neighbour

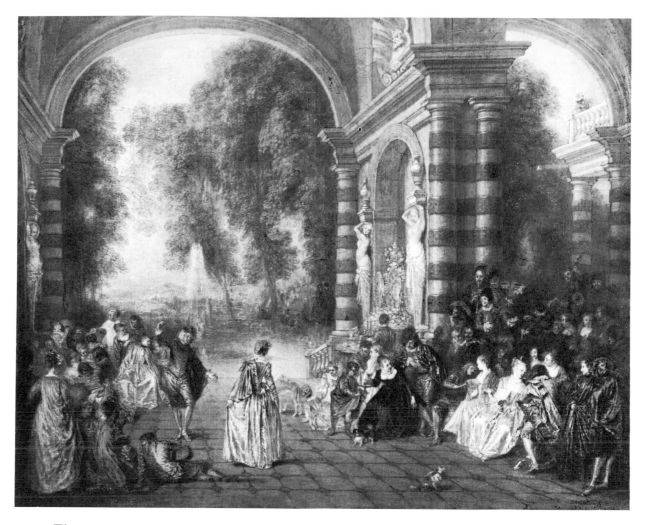

Figure 3. Antoine Watteau (1684–1721), *Le Bal Champêtre*. Dulwich College Picture Gallery

to the topical engravings and illustrations with which he first brought himself to public notice.

We do not know whether Hogarth ever saw the paintings Watteau made during his brief stay in London (though he certainly saw many engravings after his paintings).[1] But it was the Watteauesque picture, in which various people, including some actors, in costume and out, mingle in a setting that is more or less a stage, that attracted Hogarth. One asks of *Le Bal Champêtre* (Figure 3): Is the background a painted set or a natural landscape? Is Pierrot a man, an actor in a play, or a part of a painted backdrop? The Watteau pastoral was transformed by Philippe Mercier into a conversation piece, with portraits and some real architecture. Mercier was working in England and producing conversations by 1725–6, and his English imitator, Bartholomew Dandridge, shows one direction in which this sort of picture could be carried: his *Price Family* (1728, Figure 4) has nothing but a serpentine line of people straggling across an indeterminate setting of foliage and river, a thick fog filling the background, out of which emerges only a tree or bush. Hogarth began with a few outdoor scenes, but these lack the totally unbroken flow of Mercier and Dandridge, the sense of people like those who glide through a setting in Watteau's *Pèlerinage à Cythère*. As Waterhouse has said, 'Dandridge has grasped the principles of Rococo style, which Hogarth never did';[2] but of course Hogarth never sought to grasp this principle. He replaced openness with a closed, stage-like composition, with foliage

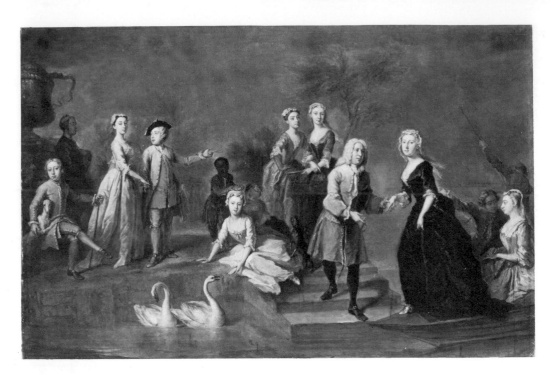

Figure 4. Bartholomew Dandridge (1691–*c*.1754), *The Price Family*. New York, Metropolitan Museum of Art (Rogers Fund, 1920)

or architecture closing the scene on either side like the wings of a stage set, and in these terms he begins to define his sitters.

The *Beggar's Opera* and Fleet Prison pictures (Plates 10 and 11, 5 and 6), which inaugurate Hogarth's original contribution to the genre, are only more schematic representations of the relationships in his other conversations between actors and audience (wardens, prisoners, or Parliamentary Committee as audience), children and parents, and humans and pets. The children are always carrying on in a mock world of play-acting, and the conversation pieces seldom lose the sense of theatre, with curtains frequently hanging on one side or the other of interiors. In *The Cholmondeley Family* (Plates 19, 22) the children are framed by the opening leading into an inner chamber, and they are in the act of kicking over a pile of books. The father and older members of the family are not now looking at the performance, but performance it still is—a play within a play. The children tend to be cut off from the rest of the family, sometimes separated into conversations of their own, where they can play at war, marriage, or politics without their parents' interference.

When the children are absent what remains in the adult conversations as a centre of real instinctive nature is the pet dog. The people are so well-behaved, so posed in one sense or another, amid such elegant furniture; the dog is so unclothed (un-costumed) and uninhibited, knocking over books, chewing on a picnic basket, or mussing a table-cloth. When the family has no dog, one suspects Hogarth gives them his own. The pug becomes a kind of signature, strutting across the foreground carry-ing a stick in his mouth or growling; in *The Wollaston Family* (1730, Plate 15) he has his paws up on a chair and is standing upright like a human (as he does with a one-eyed bitch in the *Rake's Progress*, plate 5, where the couple parallels the Rake and his aged, one-eyed bride). He parodies Mr Wollaston, the host, in the same way that the children in the family parody the pretentions of their parents. Standing on the single wrinkle in an impeccable rug, he is the cause of the one small spot of disorder in the

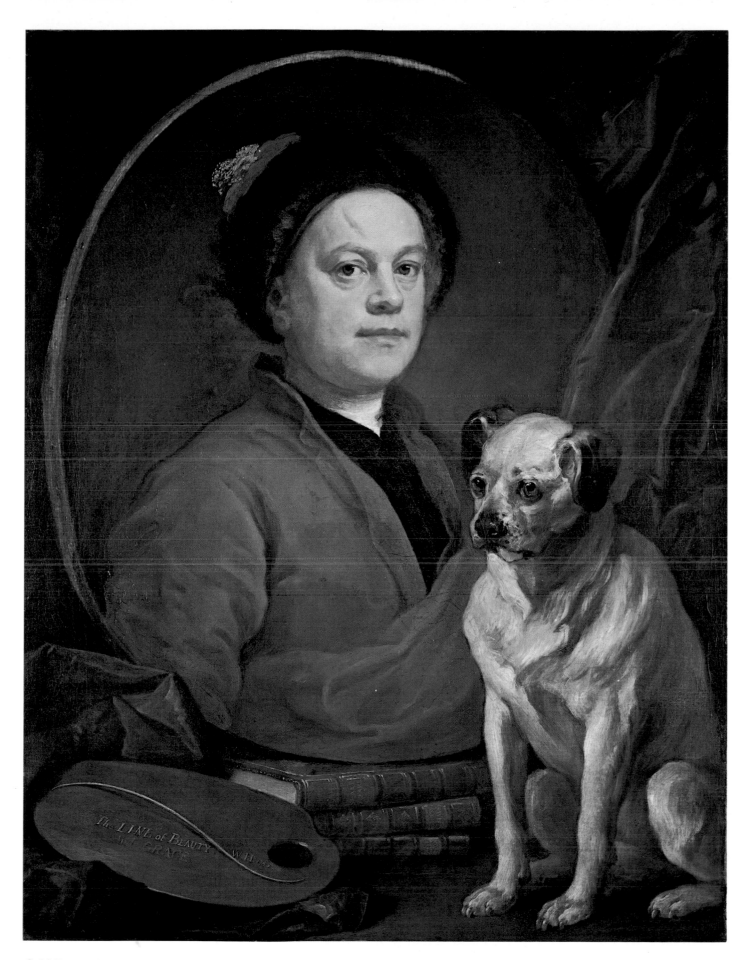

Self-Portrait: The Artist with his Pug. Dated 1745. Oil on canvas, $35\frac{1}{2} \times 27\frac{1}{2}$ in. London, Tate Gallery

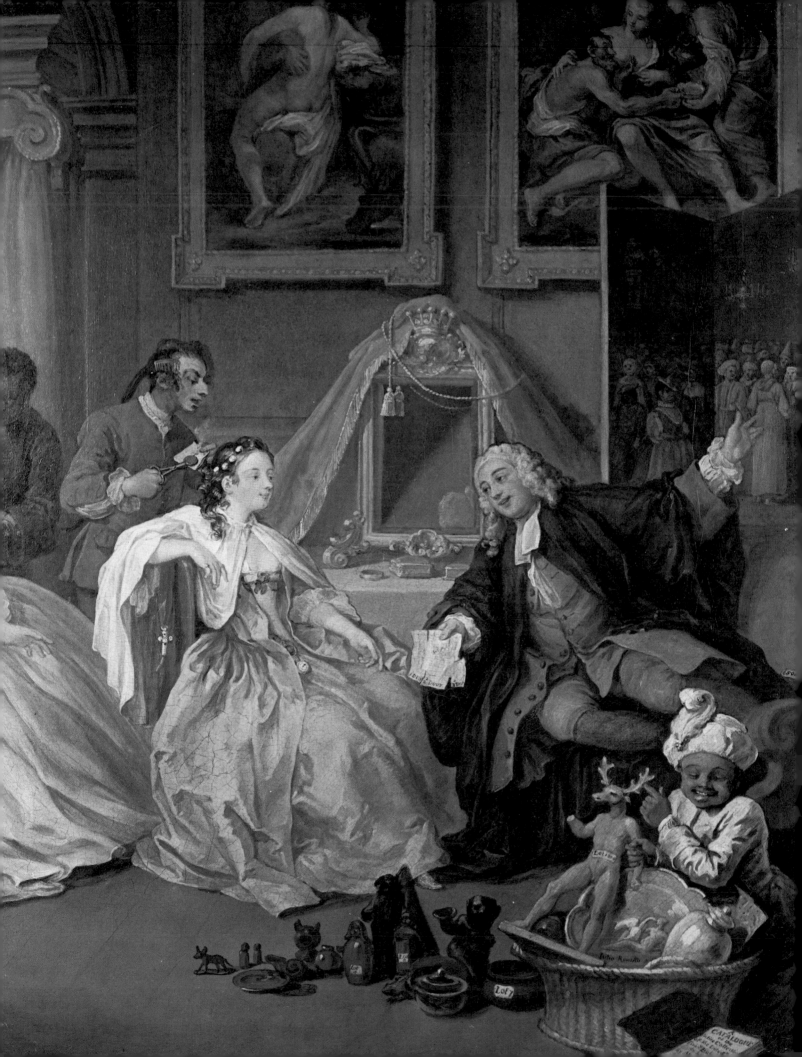

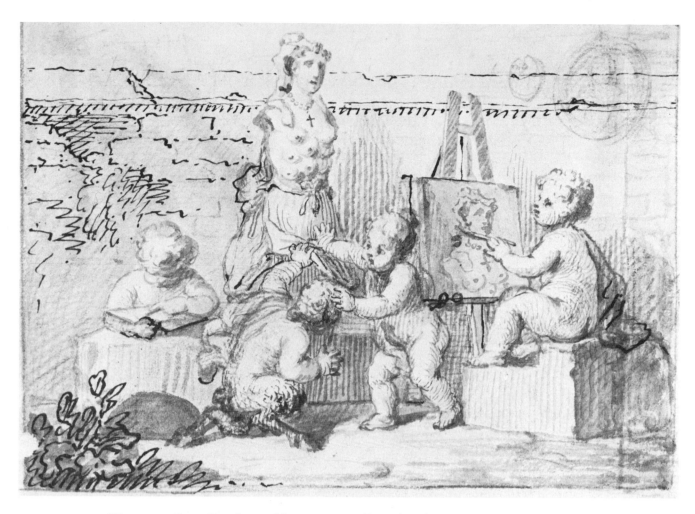

Figure 5. *Boys Peeping at Nature*. 1731. Drawing, $4 \times 5\frac{1}{4}$ in. (enlarged). Windsor Castle, Royal Library

proceedings. In *The Strode Family* (1738, Plate 68) he is still in the foreground, now a small model of the Trump of Hogarth's self-portrait (p. 17) and bristling at the dog of the family his master is painting (the family's dog has a bone or bit of meat placed before it on a plate). And in *Lord George Graham in his Cabin* (1745, Plates 72, 73) he wears a wig and mimics the humans in just the way the painter himself does. He is an intruder, someone who came into this room with the painter, an ambiguous symbol of nature, disorder, and, in the particular Hogarthian sense (as in the irreverent faun who lifts the skirt of Nature in *Boys Peeping at Nature* [Figure 5]), of art.

Art in the more conventional sense appears in the painted scenery of *The Beggar's Opera* and in the sitter's collection of paintings hanging behind him on the walls of his room in *The Strode Family*. Perhaps, for Hogarth, the most important historical phenomenon of his time was the rise of collecting, of the Dilettanti Society, of the Grand Tour, and of all the sources that stocked a house and garden with curiosities chosen by the owner. It was, I suppose, inevitable that some painter should note the irony that the sitters in a conversation piece are often subordinated to the very milieu that is supposed to define them and their prosperity. These objects remain only generic shapes in most of Hogarth's portrait groups, but in what he called his 'modern moral subjects' (and Fielding called his 'comic history-paintings') he explores the possibilities of using surroundings to define the figure in a precisely

Detail of
*Marriage
à la Mode*, 6
(Plate 83)

meaningful way. He reveals their implications as status symbols, as models for emulation (one of the motives, according to the art treatises, for collecting and hanging them), and so as objects that condition and shape as they characterize, collections that dominate and form the collector, inanimate things that perversely control human lives.

Hogarth's Fleet Committee painting can lead either to the *Denunciation* and *Christening* (c. 1729, Plates 9, 14) and *The Beckingham Marriage* (1729, New York, Metropolitan Museum) as portrayals of real people at a public ceremony with witnesses or to *The Beggar's Opera* as a drama with an audience in attendance. In either case Hogarth is developing a new kind of portrait group that is quite consciously neither portrait nor genre nor history painting but partakes of all three. One might well ask whether the second scene of the *Rake's Progress*, which shows Tom Rakewell's 'family' of dancing master (John Essex), gardener (Charles Bridgeman), and jockey (also probably identifiable), is a conversation or a genre picture (Plate 31). It is at any rate indicative of how the modes merge and portraits continue to appear after the conversation has become genre or 'modern moral subject'.

The basic gesture of the Hogarthian conversation piece is Mr Wollaston's outstretched hand, which seeks to connect or unify the party of disparate people who have come together under his roof (Plate 15). This is the gesture that is contradicted by the unruly dog and held in a tension between order and disorder by the artist himself, who thereby defines the nature of the conversation piece (or of families or parties). This gesture is also the bawd's in the first plate of the *Harlot's Progress* and the Harlot's own in the second, both times indicating false unions, real blandishments. In *The Marriage Contract* (c. 1733, Plate 29) the parson brings together the hands of bride and groom, but they do not touch, and the groom is turning already to a *billet-doux* from another woman. In his first scene Tom Rakewell's hand is outstretched to the pregnant girl he has just paid off. The progresses start with a false conversation gesture of unification which proves insufficient to hold things together. The gesture of drawing together or separating is the basic expressive structure of the progresses, within the open and closed, dark and light, shapes of the rooms.

The movements of hands and arms make complex chains of action that often stand for the larger action of the people within their settings. The arms of the foreground figures in the fifth plate of the *Rake's Progress* (Plate 36), participating in a marriage ceremony, merge with the distant tangle of arms in the fighting background figures of the rejected 'wife', her child, her mother, and a churchwarden. The forearm movements of both groups are linked into a series of parallel or opposing forces, projecting the confused struggle that is the reality beneath the formal ceremony of this marriage (which is also fearfully undercut by the setting, the tablets of the Ten Commandments cracked at *Thou shalt not commit adultery*, the ruinous church, and the cobwebbed offering box). The interrelated arms in the third and fourth scenes (Plates 34, 35) are expressive of what is going on at the moment, while also being part of the horizontal chain of relationships that continues throughout the scenes, broken

only once, violently, in 6, when Rakewell makes a vertical unavailing gesture toward heaven.

L'expression des passions, the great art treatise category by which history paintings were judged, offered Hogarth a stage beyond mere portraiture. It is best seen in these linked hands and arms, which are as expressive as faces. In the *Harlot's Progress* 5 (Plate 27) the first doctor's cane, his drop bottle, the second doctor's pill, and the servant woman's outstretched arm are drawn into one chain leading to the face of the dead/dying Harlot; and this leads us, in turn, back to the tangle of her arms and the bawd's in 1 (Plate 23). In much the same way the hands of the groom, bride, and lawyer in *Marriage à la Mode* 1 (Plate 75) tie this group together in a wavering line paralleled in the final scene by the hands of the merchant, the child, and the old servant woman around the face of the dead Countess. The dead face and the hands are part of a single expressive structure, whose curves stand out against the geometrical shapes of the room and its furnishings (and especially its pictures).

With the Harlot's and Rake's progresses the conversation piece has developed into a basic structure of art as well as experience, which our contemporary Francis Bacon has called 'a crucifixion': 'an environment in which bodily harm is done to one or more persons and one or more other persons gather to watch.'[3] For Hogarth draws upon *l'expression des passions* in the tradition of the history compositions that show a group of facial and bodily gestures responding to a central figure or action of some kind. There is no 'conversation' at all. In fact, the point is that these pictures are—like the ironically titled *Midnight Modern Conversation* (1733, Plate 17)—anti-conversations, in which the relationship is not subject-subject but subject-object, with the poor Harlot and Rake reduced to things by the surrounding responders, just as in other scenes they are reduced to objects by the objects with which they surround themselves trying to establish some assumed identity.

My terms, of course, are of the twentieth century; Hogarth and his contemporaries saw these as satiric structures, whose aim was tendentious and moral rather than definitive. They remain within the general area of intention of the conversation piece in so far as both are anti-heroic, anti-sublime portrait and history. For while the conversation shifts the emphasis from the individual sitter to his place in a milieu, the comic history shifts its emphasis from a hero who does something to the people responding to him once he has lost his freedom of action. Implicit in every one of Hogarth's comic histories is the academic history painting, in which a hero's choice and action are meaningful and take up the whole picture or are responded to by an admiring group of bystanders. When the Harlot or Rake has become, as in the last scene of each progress, a mere topic of conversation, the audience has become the subject, and the result is a scene of pure response, like *The Laughing Audience* (1733, Plate 58), which appropriately, as subscription ticket, introduces the *Rake's Progress*. This, Hogarth's characteristic structure, can be extended in the direction of either comic or sublime history painting—the genres to which he felt an ambitious artist must devote his greatest energies.

3. The Reading Structure

When a Londoner in 1732 received his subscription set of the engravings of *A Harlot's Progress*, what he saw was the latest in a series of ambitious English engraving ventures. In the early 1720s there had been Dorigny's engravings of the Raphael Cartoons of the *Acts of the Apostles* (in the Royal Collection at Hampton Court), followed by equally elaborate engraved sets of Thornhill's *Life of St Paul* around the cupola of St Paul's Cathedral, *Marlborough's Battles*, and the *Life of Charles I*. These lives of heroic figures had been interrupted in 1726 by twelve large engraved illustrations for Samuel Butler's *Hudibras* by Hogarth himself (Plates 2–4), which recounted the exploits of an anti-hero, but in the same reproductive-engraving style as if he were a hero and there were a series of Cartoons or paintings somewhere from which they were copied. The forms and compositions were heroic battle scenes, but not so the figure of the hunchbacked little protagonist himself.

These were the engraved series that preceded the *Harlot's Progress*, and it would have been obvious to Hogarth's audience that he was following them with the life of a harlot; and that his engravings were allusions to old-master history painting, intended to pass for histories in a sense not altogether unrelated to that in which *Gulliver's Travels* passed in style and format for a genuine travel book. This time not only the protagonist represented a comic disappointment of expectations but also the literary text itself; for she was no fictional character but a contemporary prostitute, whose name many readers would have remembered, and she was surrounded by a recognizable bawd, rapist, magistrate, and probably clergyman from the London of the early 1730s. This series of engravings was shortly followed by one portraying the life of a rake, and Hogarth had established a new genre that was all his own based on an elaborate play of allusions.

Though paintings existed as *modelli*, the engraving was the perfect embodiment of Hogarth's theme. The 'reader' of these progresses saw a copy of a copy which was itself about the copying of inappropriate social behaviour. For this was the great age of copying paintings, as replicas or as forgeries, and disseminating them in engravings at yet a further remove from the original. It was also the age (or the dawning of it) when writers asserted that an 'original'

> rises spontaneously from the vital root of Genius; it *grows*, it is not *made*:
> Imitations are often a sort of *Manufacture* wrought up by those Mechanics,
> Art and Labour, out of pre-existent materials not their own.[4]

Hogarth, beginning his career as an engraver, was aware of the market in copies; avoiding reproductive engraving himself, believing in the normative nature of originality, he made copying a main theme of his work. However we parse them, Hogarth's prints are not imitations of life but of engravings—of history paintings, of penny moralities, or of book illustrations. But then paintings are copied and included inside these engravings, and people are shown copying the actions depicted in the paintings.

The second scene of the *Rake's Progress* (Plate 31), which shows Rakewell in a conversation with gardeners, musicians, and jockeys, also sets him up as a Paris who cannot choose among his options. The identification is made by the picture above his head, one of his own collecting, *The Judgement of Paris*, which is flanked by two portraits of game-cocks so nearly identical as to make choice impossible. The next scene (Plate 34) shows that he has chosen Venus. As Hogarth himself tells us in *The Battle of the Pictures* (1745, Figure 6), Rakewell in the brothel is portrayed in the composition of a *Feast of the Gods*—the sort of travesty Fielding was producing on the London stage at the same time. The Rake is related to those epitomes of aristocratic vice, the Roman emperors, self-styled 'gods' portrayed in copies after Titian on the wall. He has fixed his identity by breaking the mirror, wiping out his own image, and by slashing out the faces of all the emperors except the worst of the lot, Nero.

The group of Nero, the blind harper, and King David carved on his harp is a brilliant bit of allusive play. The harper is present at the burning of the tavern, or at any rate of the representation of the world ('totus mundus') by one of the prostitutes,

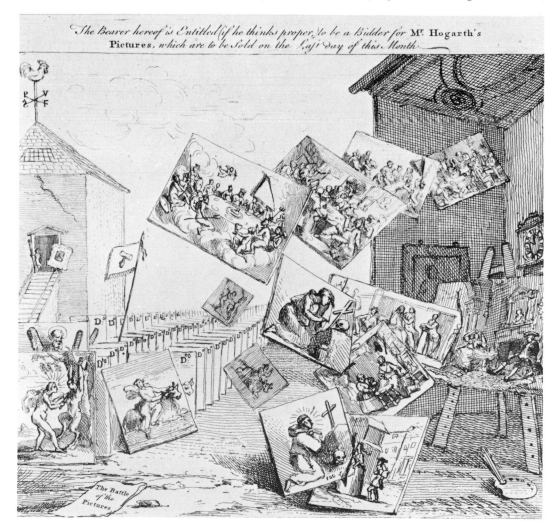

Figure 6. *The Battle of the Pictures*. 1745. Engraving, 7 × 7⅞ in. London, British Museum

as the blind Homer imagined himself present at Ilium, and as Nero sang the 'Sack of Ilium' while Rome burned.[5] (The fire itself becomes general in 6, where the gambling den burns, and particular in 8, where Rakewell sinks into oblivion, 'burned out' in body and in syphilitic brain.) The effigy of the Biblical harpist, warrior, and king is placed so as to overlap the frame of Nero's portrait, and their relative size makes the one facing the other appear a David to a Goliath. The upward movement of the harp suggests that David is physically challenging the emperor in a mock confrontation between Hebraic and classical cultures, the musician-poets of the Old Testament and the Roman world. In the context of both the second and third scenes, the Rake is indeed a comic synthesis of these heroes and their achievements. Paris, Nero, King David, and the Rake are all awaiting the posture woman's stripping and dancing on the platter, another Venus, another Helen or Bathsheba, with the same deadly consequences.

The most obvious allusion is in the final scene, where Rakewell, stretched out in his death agony on the floor of Bedlam, is made to recall Caius Gabriel Cibber's Bedlam figures, *Melancholy* and *Raving Madness*; the composition, including the surrounding figures, would have been recognized as a *Pietà* or a Deposition by anyone familiar with the sorts of pictures to be seen in engravings and in the painted copies hung in country houses (Figures 7–10). (As if he had carried the Christ allusion a little too far in the painting by showing Rakewell clothed only in a loincloth, Hogarth changed this in the engraving to dark breeches.)

The audience recognized the allusion to Christ, and with this in mind looked back over the whole series, spread out on the wall in a row or in pairs of prints. The sixth scene now seems perhaps an *Agony in the Garden* and the second as much perhaps a *Christ in the Temple*, who, rather than surprising the learned men with his maturity, learns only how to enjoy himself. Or rather than a *Judgement of Paris*, possibly in the light of the third scene it is a Temptation by the things of this world (*totus mundus* again). 'One G—d one Farinelli', inscribed on a sheet of paper in the engraving, makes the sacrilegious equation with a character who confuses art with religion, Paris with Christ. One may then notice all the crosses suggested by window frames, even by the Rake's detached queue in the seventh scene, and certainly the juxtaposition of various heads and 'glories' or haloes: the platter behind the posture woman's head in 3 and the IHS emblem behind the bride's head in 5.

But if this effect is allusive, there exists also something we might call a source for the Rake's perplexed gesture in the engraving. In the back of Hogarth's mind was *The Painter torn between Olympus and Everyday Life* by Marcus Gheeraerts (Figure 11), which no one but Hogarth could have been aware of—and which may have been in his mind for the composition of 6. The choice pattern implicit here was activated by the *Judgement of Paris* in 2, and even earlier in 1 by the choice between the money bags on the table (just removed from locked chests) and duty to the girl standing in the doorway leading to the outside world. The Biblical allusion is conscious; the

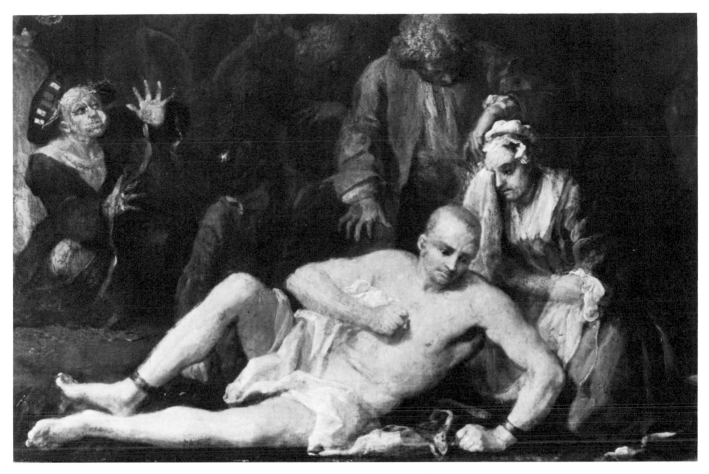

Figure 7. Detail of *A Rake's Progress*, 8, painting (Plate 41)

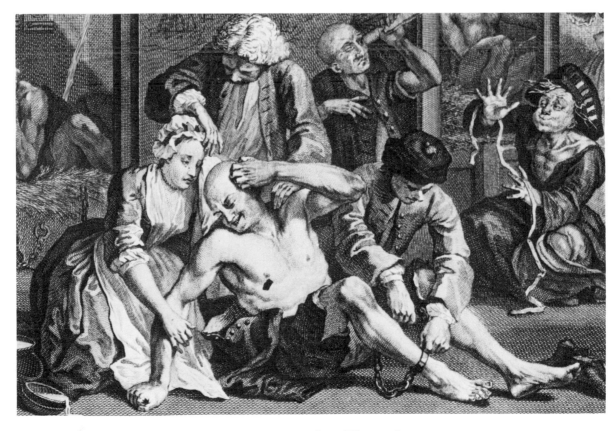

Figure 8. Detail of *A Rake's Progress*, 8, engraving (Plate 42)

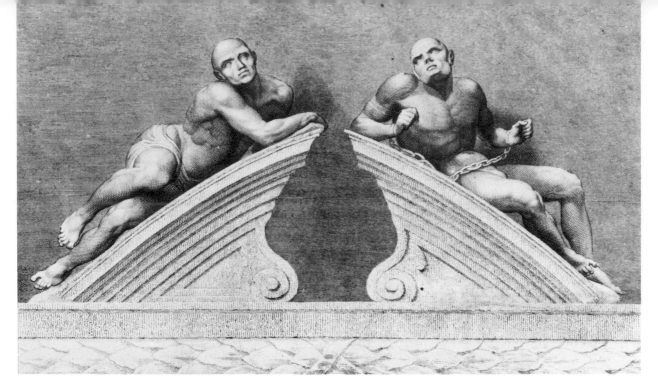

Figure 9. Caius Gabriel Cibber (1630–1700), *Melancholy* and *Raving Madness* (from the portal of Bethlehem Hospital; engraving by W. Sharp, 1783, after drawing by T. Stothard). London, Guildhall Museum

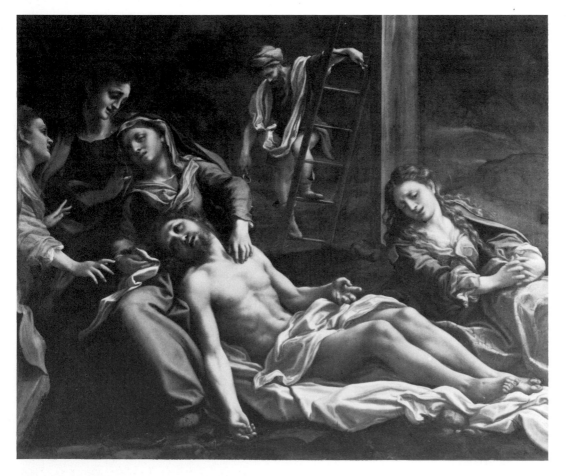

Figure 10. Correggio (1494 [or 98]–1534), *Pietà (Compianto su Cristo Morto)*. Parma, Galleria. Others are Annibale Carracci's *Pieta* in the National Gallery, London, and Domenichino's (formerly Lord Kinnaird)

borrowing from Gheeraerts may be unconscious but reveals something about Hogarth's underlying intention, of the way his mind worked, in the *Rake's Progress*.

The relationship between heroic ideals and commonplace everyday reality was, of course, the basic metaphor explored by the Augustan satirists, Butler, Dryden, Swift, and Pope. But the *Rake's Progress* is not so much about this relationship as about man's hopeless penchant for role-playing; and so is related to the early theatrical paintings and the conversations: in 1 Rakewell is playing a young aristocrat, in 2 he is Paris who chooses Venus and so is in her arms in 3, and by 6, having lost all of his money at gambling, he is in the pose of a Christ in an *Agony in the Garden* and in 8 in a *Pietà*; even as he sinks into despair and madness he continues his evasion of self-realization, begun by paying off the girl and breaking the mirror. Serving the same purpose, the baroque perspectives and compositions suggest the theatricality that defines the young merchant's son, and the uneasiness he shows in his assumed roles.

The Hogarthian progress is an extraordinary intellectual achievement, a kind of art object that is less closely related to the painting of his time than to the collages of Max Ernst, the styleless arrangements of René Magritte, and more recently the

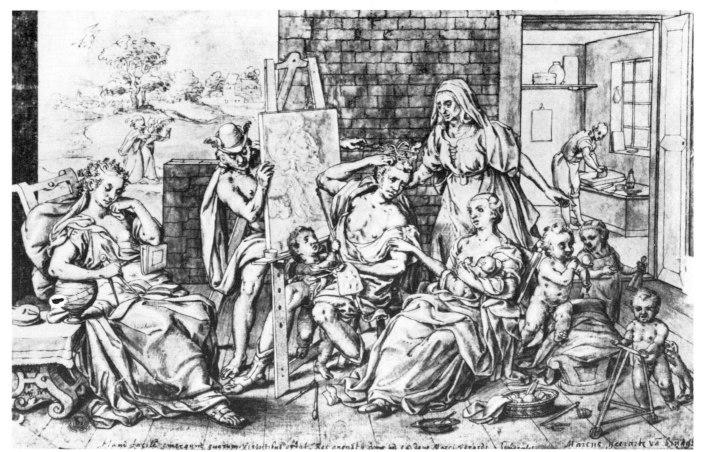

Figure 11. Marcus Gheeraerts the Elder (in England, 1568–77), *The Painter torn between Olympus and Everyday Life*. Drawing. Location unknown

'boxes' of Joseph Cornell and the objects reproduced by pop artists. Perhaps we can say of Hogarth's prints what Harold Rosenberg has said of Cornell's boxes: their success 'depends upon the inner references of the objects as objects and of their spatial arrangement within the preconceived limits of the box'. Hogarth delineates objects and people of his time and place, as well as, in the pictures on the walls, gods and heroes and Biblical figures, just as Cornell gives us not even a delineation but the objects themselves:

> his transmuted trash liberates metaphysical art from reliance upon traditional poetic emblems—fauns, swans—and mathematical forms in a manner comparable to the colloquialisms and snatches of song in 'The Waste Land'.[6]

We move around in Hogarth's scenes as in a Cornell box. We make out large shapes first and then go on to explore one after another the discrete shapes for denotation and connotation and interrelationships. What must be noted is the tension between the closed structure of the room (the box) and the open structure of meaning, leading off to an integration within the other plates, to reinterpretation of plates already examined, and to allusions that sometimes open up almost endlessly.

There is a tendency in Hogarth toward the pun, or, more generally speaking, toward using things in two ways at once. In the first scene of the *Rake's Progress* (Plate 30, Figure 12), the miser's escutcheon, a vice with the motto 'Beware', applies (1) to business opponents and the world at large; and (2) of course to the Rakewells themselves, father and son, warning them to beware. But (3) the two escutcheons, hanging as they do above the heads of the two women, Sarah Young and her mother (emphasized by the vertical lines of the door connecting escutcheons with each figure), warn the Rake of his own motto—to avoid the Youngs who will indeed, like the vice, never let him go, even unto death. Hogarth, in short, is quite capable of looking at Sarah Young as both a Good Samaritan and as an anvil around her beneficiary's neck.

But then, to go a step further in the punning of Hogarth's text, examine the 'Holy Bible' that is made holy by the hole in its cover, from which the miser has, as his last prophetic act, soled (souled) his shoe; and in the fourth plate the sign 'Hodson Sadler' behind Rakewell, which indicates that he is to be 'saddled' with the results of his spending (also with the consequences of Sarah Young's intercession on his behalf [Figure 13]). Again, 'Liberty' in the sign 'Your Vote and Interest—Liberty' on the boy's hat also refers to Rakewell's personal liberty now that he is threatened and needs someone's 'interest' and 'vote' to keep him out of the Fleet.

All of this is closely related to the nature of Hogarthian comedy—if that word can be applied to so mordant an ironist. The comic effect is based in general on a disappointment of expectations: this does not prove to be a Life of St Paul or even of a conventional Harlot or Rake, let alone a conventional *Bacchanal*, *Feast of the Gods*, or *Pietà*. But really more important for Hogarth, and different from most comic effects, is the sense of discovery—what he called in his *Analysis of Beauty* the 'love of pursuit' or of 'a kind of chace',[7] the gradual surprising revelation of at best

Figure 12. *A Rake's Progress*, 1. Engraving (3rd state), 12⅝ × 15¼ in. London, British Museum

Figure 13. *A Rake's Progress*, 4. Engraving (3rd state), 12½ × 15¼ in. London, British Museum

profoundly complicating and shattering meaning, at worst the artist's ingenuity. The reader's ingenuity is called for, and the pleasure of discovery often explodes into laughter. Above all hovers the general effect of incongruity: the discrepancy between the harmless-looking object and what, in its context, it reveals; between Rakewell and the dead Christ, or between the merchant's son and the fabricated 'rake'.

Hogarth's response to the problem of history painting was very different from, for example, Géricault's solution, a century later, of taking a contemporary newspaper story and rendering it in generalized, heroic, Michelangeloesque forms. Hogarth's attack was against the simplification of sense, morality, and application in contemporary history painting; and so his response was to complicate meaning, rendering (he believed) the complexity of life that was simplified by heroic conventions and forms.

4. 'Marriage à la Mode'

The most elaborate of Hogarth's intellectual structures is *Marriage à la Mode* (1745, Plates 75–83). At the peak of his powers and popularity, Hogarth devoted his total attention to this series, bringing paintings and engravings to an equal finish. Both are also his most French in composition and detail. Hogarth's world, of course, represents a basic contradiction to the French rococo and its moving nature indoors, concealing the actual structures of rooms, and resisting the fixity of Newton's universe. In his earlier series he had quite consciously replaced the rococo Loves of the Gods and eliminated its mannerisms (especially its Frenchness), but retained its general movement, which became the principle of readability in his engraved plates. Now for *Marriage à la Mode*, where the forms and tones, the style in general, are most rococo, he went so far as to visit Paris to see French painting at first hand (he had never before left England), to employ French engravers to give his plates the *vrai style français*, and doubtless also to pick up the latest French opinions on art, which were in fact the beginnings of a counter-reaction to the rococo that would be most memorably formulated in the attacks of Diderot.

Hogarth responded to (or independently initiated) this anti-rococo movement two years later in the simple and ostentatiously popular prints, *Industry and Idleness*. But *Marriage à la Mode* may be as much a sign of the transition in its parody over-ripeness. The French style of the engravings, at any rate, is being satirized, as in *Hudibras* and the *Rake's Progress* the baroque compositions reflected the hero's deluded view of the world around him. Far more appropriate to the subject than Hogarth's own robust engraving style, the work of the French engravers serves to represent the decadent world of the aristocracy, not (as Hogarth's perhaps ironic advertisements claimed) to suit the dignity of the upper-class subject-matter. The amorous scenes of gods on the walls of the Countess's boudoir refer as well to the sort of erotic painting that was being reacted against in France (and had been

decades earlier in Addison's and Steele's *Spectator*) as to the sort of Correggioesque painting collected by English connoisseurs.

The first scene (Plate 75) is a family gathering, and if there is no apparent Biblical or classical echo, there is the inescapable memory of a conversation piece composition, in which one expects to find familial harmony, but in fact finds parents selling their children and the germ of total fragmentation. The French engraving and composition raise the expectation of a story about aristocratic love, but closer inspection reveals a marriage contract scene, a type that had many predecessors in Dutch and Flemish genre, and the changing-hands of money.

First we make out large shapes, such as the regal-looking old man sitting under a throne-like canopy topped with a coronet. When we learn that this is only a bed it retains at least the pretence of being royal, which is the attitude the old man takes to the men across the table from him, who seem at first to be paying him court, but in fact are simply carrying out a commercial transaction in which status is balanced with cash. We also notice that the regal-looking man and the young man with his back turned are at the opposite extremities of the picture, separated spatially from their respective groups, balancing each other, and wearing similarly rich attire. Set off in this way from everyone else, they must be father and son, and the other pair, the two inner seated figures, father and daughter. Two families are being mingled here and yet kept distinctly separate: the two young people are on one side of the picture and the two fathers, roughly speaking, on the other; but the grouping is neither by family nor by marriage bonds, for the father and son are as far as possible from each other and from everyone else, and the father and daughter are as closely linked with other figures (the young lawyer who leans close, whispering in the young lady's ear, and an emaciated old man who stands between the two fathers inclining toward the girl's father) as the father and son are withdrawn from all of these middle-class types.

To confirm these impressions of shape we must, however, look to the precise denotations of words themselves in inscriptions (see Figure 14). The heavy-set father of the girl holds a paper, the 'Marriage Settlement of the Rt Honourable Lord Viscount Squanderfield'. We also read the coronet on the bed to be an earl's, and so we conclude that the son, not the father, is being married. Thus the plate is, as the spatial relationships suggested, not about the old man getting a bride (and money) but only money, with the bride intended for his son—and so about a theme concerning the opposition of the generations.

But the denotation is even more specific than *Earl* and *Squanderfield*, which itself engenders the connotations of 'squander' in this context. The Earl's bandaged leg carries the connotation 'gout', which serves to project a history, a moral judgement, and a series of relationships. 'Gout' connotes a life of eating and drinking associated with the aristocracy rather than the merchant class. Then the bandaged leg of the Earl is related to the beauty patch on his son's neck, serving to hide a sore which (in this context) would have been venereal. The gouty connotation of sickness relates them, balancing formally the Earl's flannel-wrapped foot on one side with his son's

patched neck on the other. Sickness connects them as father and son, with overtones of 'the sins of the fathers visited upon the children', which will run through the plates, concluding in the sad shape of the grandchild with its own beauty patch on the neck. The metaphor of disease permeates the series. Through its connotation of unsoundness, the bandaged leg and the patched neck relate to the building going on outside the window, half finished and in ruins, and to the merchant who is buying the son as a property but is getting an unsound piece of merchandise.

Then the patch as inherited disease connects with the stamp of the Earl's coronet, which appears on every object in the room from footstool to chairs, bed, pictures, crutches, and is even stamped (in the engraving) on the sides of his dogs. His son carries the stamp not of the coronet but of his disease in the black patch, and the sense of property is confirmed by the 'manacles' just beneath him that hold together the pair of dogs stamped with the coronet. The pair of young people above the dogs are metaphorically manacled in the same way and from the same source, as are all of these people manacled together by their avarice, pride, and lust.

The milieu is once again totally enclosed. A sense of openness is proffered by the extensiveness of large and luxurious houses, with windows and entrances to further, inner rooms, but these are false hopes of exit, each in its own way closed. In the first scene the window opens onto a Palladian building scheme of the Earl's, but it has stopped for lack of funds: a project which confines the protagonists as effectively as walls. In the fifth scene the lawyer actually appears to be making his escape out of the window of one room—his symbolic exit from the stifling situation in which his attraction to the neglected bride has trapped him, which has led him to murder—but in the next plate we learn that he has been caught and hanged. And in this last scene there are two exits from the room: one a door being taken by the physician, who has given up his patient, and the other a window with a view of London Bridge, which simply locates the merchant's house and reminds us, as we look back over the six scenes, of exactly how little egress there was for the young girl, now dead by her own hand. The pictures on the walls then are false windows that do not look out onto the natural world but rather reveal a world of art that constrains the people in the room. They are portraits or history paintings, Dutch low-life scenes or penny prints, but always closed, framed images of cruel or foolish actions in the past, a fantasy paragon, upon which the person in the room, cut off from the natural world outside, builds his own life and actions.

Traditional iconography has been totally displaced to its contemporary repository, the Earl's picture collection covering the walls and, given exaggerated prominence by the expressive use of false perspective, nearly crowding out the people (see Figure 14). The largest and nearest picture to Earl Squanderfield is a portrait of himself in the French style as Jupiter Furens, whose inflated pose he is imitating as he points down to his family tree. The Earl would, of course, have his portrait painted by a Frenchman—French portrait painters were the rage in London in the late 1730s and early 1740s—and so too he would collect history paintings of scenes

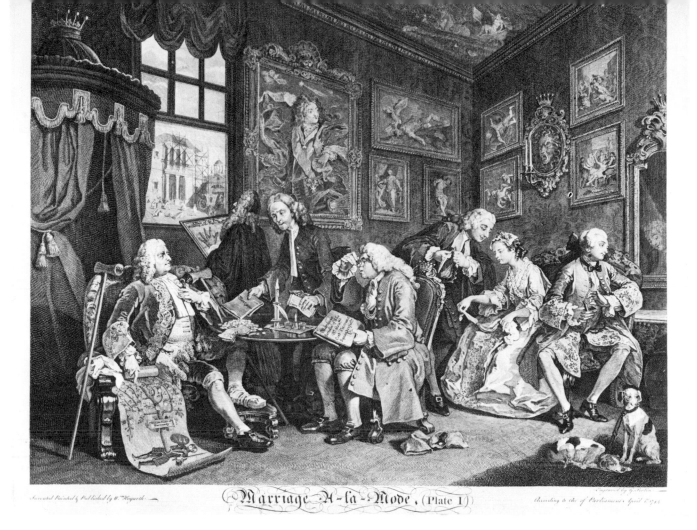

Figure 14. *Marriage à la Mode*, 1. 1745. Engraving, 13 $\frac{15}{16}$ × 17 $\frac{1}{2}$ in. London, British Museum

of violence and destruction. The man who imitates the pose of Jupiter in his portrait will also imitate the morality of these bloody fables. The picture contains a further detail that underlines its meaning: though, within the picture, a strong wind is blowing to the left, a cannon is firing to the right in the direction of the hapless younger generation.

The operation of these paintings is slightly different from that of the paintings shown in the *Harlot's Progress* and *Rake's Progress*, for they convey their meaning initially by expressive shape only, without requiring of the viewer any knowledge of the learned tradition or of art history. Anyone can see that they have, in common, images of murder and torture, and, at a slightly less general level, of martyrdom—words that come to our lips as we correlate their subjects. We then connect these metaphorically as martyrdom, murder, and torture with the behaviour of the parents toward their children in the scene below.[8]

The picture of St Sebastian shot full of arrows hangs just above the shoulder of the young lawyer, who is making advances to the bride. Their poses are parallel, and the lawyer holds his quill pen pointed like an arrow toward his heart. The end of the lawyer will be a kind of martyrdom, when he is hanged for the murder he commits for love. But in fact St Sebastian himself hardly matters. There is nothing about his story that immediately contributes to the meaning except 'martyrdom'. Rather his picture becomes a general image that recalls popular emblems of Cupid shooting

arrows into lovers strung up in this way, and in conjunction with the quill pointing to the lawyer's heart, it tells us that he is smitten and will be 'martyred' by his love, both in the romantic and the literal sense.

Directly above the nearly joined heads of the lawyer and the young bride-to-be are two more paintings. The upper one is of Prometheus being gnawed by the vulture: this is seen by the viewer as simply a general image of a man being gnawed in his vitals, a metaphor of lust which in its context refers to the flirtation below. Immediately above the lawyer's head is a picture of Cain killing Abel, and the other pictures above the lawyer—one of David and Goliath and one of Judith and Holofernes—are similar images of murder, whether with reference to the lawyer killing the young husband or the young wife herself metaphorically taking her husband's head.

The general tendency is to diminish or ignore the iconographical or learned meaning and see the painting as merely an image based on popular emblems or on what E. H. Gombrich has called 'the cartoonist's armoury'.[9] Directly above the self-engrossed husband-to-be, staring into the mirror, is the *Martyrdom of St Lawrence*, no detail of which is relevant as such; but reconstituted as simply a 'martyr' on a gridiron, it carries a suggestive parallel to the Viscount's prospective marriage bed. The physical resemblance between gridiron (with recumbent St Lawrence) and bed, and the metaphorical relationship of heat and passion, make a visual pun, which is all that matters.[10] As the subsequent plates show, there is passion to spare in the young middle-class wife, but the nobleman named 'Squanderfield' squanders his passion on prostitutes, much as his father squanders his money on Palladian building schemes and dark masters, thus leading him to the consequence of this ugly commercial marriage.

But if Hogarth has de-mythologized his images, inviting a more general communion with his audience, he has not forgotten his 'readers of greater penetration'.[11] Cain killing Abel is the most obvious example of an intrusive story: it is, of course, the archetypal murder and may be further augmented by the Biblical text with its sense of 'brothers' sacrificing in their different ways to a single God (the bride), the result being jealousy and murder.

The most puzzling, because least decipherable, is the painting in the top right-hand corner.[12] This is Domenichino's *Martyrdom of St Agnes* (Figure 15), showing the Saint's arms outstretched in prayer and a lamb at her feet. Legend describes her as a beautiful young girl who rejected her noble suitors because she was a Christian. The Roman governor of the province punished her by sending her to a house of prostitution, but even there she remained pure: those who came to her were either struck by awe or, if they looked upon her lustfully, blinded—only regaining their sight by her prayers. The governor accordingly, as Domenichino's picture shows, ordered her throat cut and her body burned on a pyre.

This picture of a girl on her bed-shaped pyre is directly above the one of St Lawrence on his gridiron—and the resemblance to a bed seems to be the common

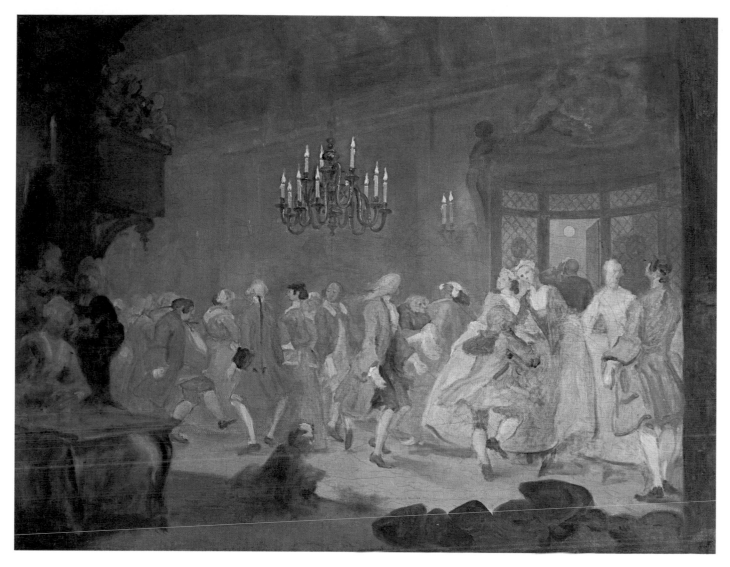

*The Wedding Dance. c.*1745. Oil on canvas, 27 × 35½ in. Tate Gallery (on loan from the South London Art Gallery)

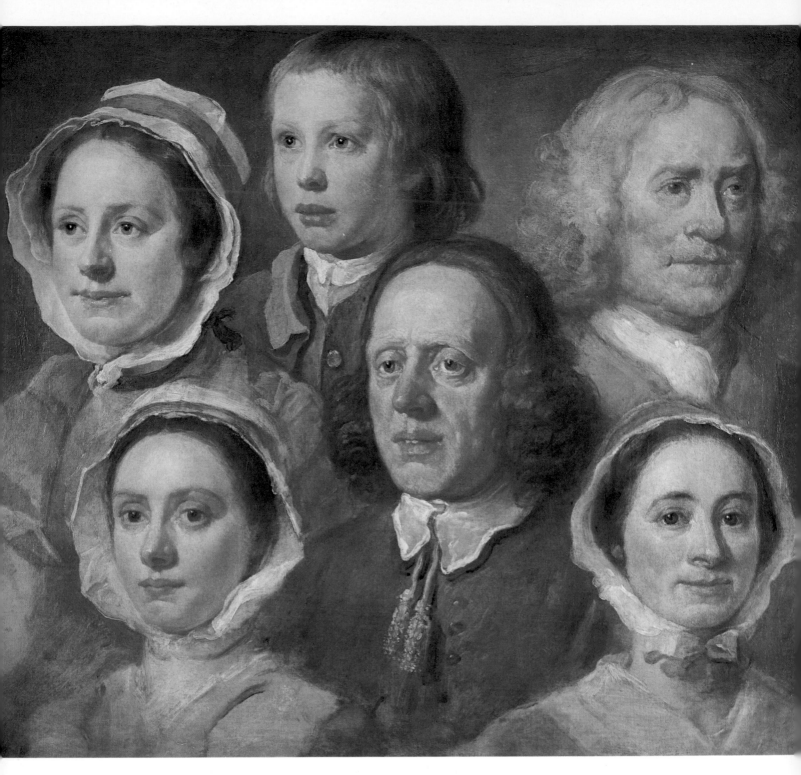

Hogarth's Servants. Mid-1750s. Oil on canvas, $24\frac{1}{2} \times 29\frac{1}{4}$ in. London, Tate Gallery

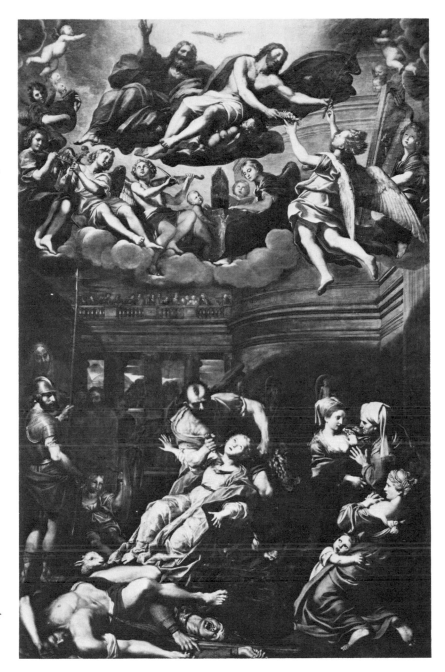

Figure 15. Domenichino (1581–1641), *Martyrdom of St Agnes*. Bologna, Pinacoteca

element. It is also the only picture except *Judith and Holofernes* that refers to the bride, and it proves to be about a girl who is receiving an immortal crown from Christ for her refusal to have either marriage with a noble lover *or* intercourse with low-born men in a brothel. (Domenichino shows the procuress standing nearby.) We recall that the merchant's daughter is proposed to by a nobleman and accepts, and (following the masquerade at which she has rendezvoused with the lawyer) goes to a brothel and does have intercourse, but her punishment too is death, though without any hint of a heavenly crown. Indeed, the heavenly part of Domenichino's picture is omitted; Hogarth has characteristically left out that part of the original painting securalizing it.

If readers meditate (or, as was the common practice, converse) on the stories behind the pictures, they will notice that on this level they have in common a confrontation between champions who represent opposing groups, whether the Israelites and their enemies or the Christians and their Roman persecutors. If Abel

and Cain are simply rivals, David and Goliath and Judith and Holofernes are champions of their respective people, the smaller or apparently weaker defeating the stronger. On the ceiling Pharaoh leads the Egyptians against the Israelites, only to be swept away by the natural force of the ocean. St Lawrence and St Agnes die for their faith against the might of Rome. St Sebastian, the typical martyr as convert, is a soldier of the Praetorian Guard who becomes a convert to Christianity, a 'traitor to his class', so to speak, and is strung up and shot full of arrows by his former colleagues. Prometheus also betrays his 'class' by stealing fire from Olympus and giving it to men.

All of this is connected with the one broken branch on the Earl's family tree, designating a marriage with a commoner. The six plates are about the relationship between merchant and aristocrat, emphasized throughout by the running contrast between the vulgarity of the girl and the languorous decadence of the boy; the hot passionate nature of the one, the slumming need of the other to stimulate his jaded appetites.[13]

We can test the 'limits of allusion'[14] in this case by proceeding one step further. The Israelite-opponent conflicts are all victories for the Israelites, for the weaker-seeming champion. In the Christian-Roman conflicts the martyr dies, a defeat *and* a victory, and in both spiritual and physical senses the Christian cause wins in the long run. The idea of a victor is less easy to formulate in the Cain-Abel and Prometheus-Zeus stories. The result in Hogarth's series is, of course, defeat for both classes, though the hardy merchant (and his feeble grandchild) is still around at the end, carrying on in his own fashion. The allusion then can be said to peter out with the idea of conflict between merchant and aristocrat, with one member of each group as 'champion' and a sense of somebody 'betraying his class'.

Marriage à la Mode embodies two themes: the struggle between the values of money and blood, the merchant and aristocrat; and the heavy weight of the past, of one generation on another. The first explains the subject-matter of the pictures on a deep level; the second why physically and intellectually the pictures are so many and so fill the scene. They are embodiments of the father, of the past, and of these antiquated values. Each room in the subsequent scenes is filled with the pictures collected by its particular inhabitant, and as the series rolls on these people act out the roles and assume the poses dictated by their pictures, until in the last two plates the young Earl, his Countess, and the lawyer are indeed in the poses of murderer and martyred.

The fifth is the one scene composed on an allusion to conventional iconography: the drooping young Earl (Plate 81) is in the pose of Christ in a deposition or burial, the Countess in the pose of a mourning Magdalen (Figures 16–18). (And the Biblical allusion is supported by the picture of St Luke and the tapestry of the *Judgement of Solomon* on the walls.) But the general slouch and position of the falling sword may derive from the figure of Ajax in Poussin's *Realm of Flora* (Figure 19). Hogarth has drawn upon a vague memory of that figure, altering it in almost every

detail; I doubt whether it served as an allusion, but it did bring to Hogarth's mind, if not to ours, the mad Ajax who threw himself on his sword, killing himself as in a sense the Earl has brought about his own death.

One result of the Hogarthian development in *Marriage à la Mode* is that the two audiences to which he addresses himself have tended to move further apart. The sophisticated audience is given something quite distinct from the general reader, no longer merely deeper, though still complementary and revealed elsewhere in simpler language to the general reader. It is too easy to say that his readers divided into groups analogous to the merchant and the Earl, because the Earl is clearly a false connoisseur and the merchant so vulgar as not to be a reader of Hogarth in the first place. Nevertheless, the two audiences are roughly represented by these two classes, and one wonders how either could have been altogether reassured by Hogarth's picture of them. The aristocrats, however, come off worse; it is their values that are revealed by the French forms of the engraving, themselves corrupt. It is not surprising perhaps that when the paintings of his 'comic histories' were sold at about the time of publication, the earls and viscounts did not make the sale the resounding

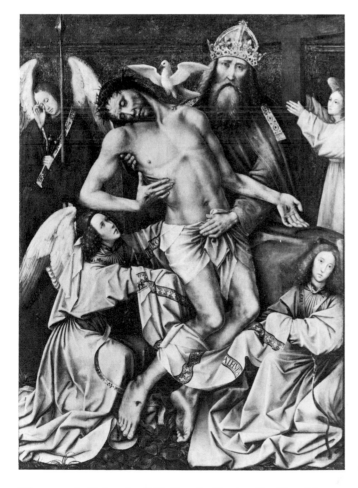

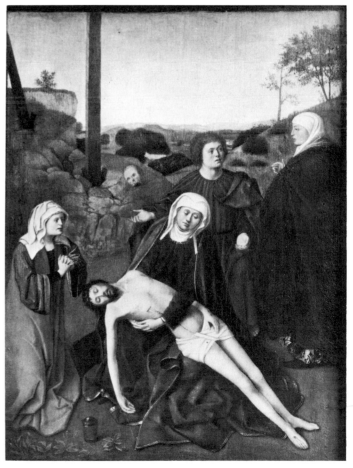

Figure 16. School of Colin de Coter, *Le Retable de la Trinité*, central panel. Paris, Louvre

Figure 17. Petrus Christus (*d.*1472–3), *Deposition*. Paris, Louvre

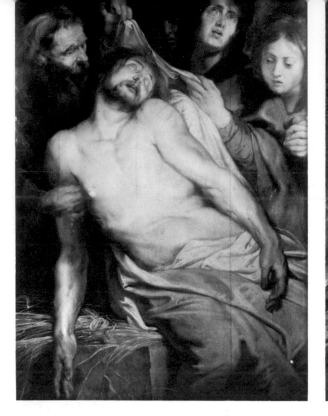 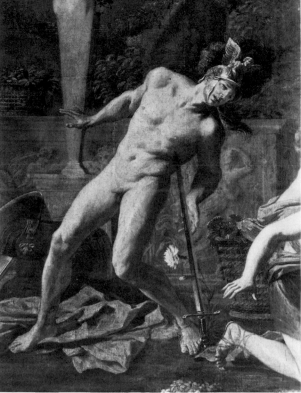

Figure 18. Peter Paul Rubens (1577–1640), *The Entombment of Christ*. Antwerp, Koninklijk Museum. Another picture with the peculiar twist of Christ's body is Carracci's *Pietà* (Louvre); also the *Trinity* attributed to Guido Reni (Rome, Chiesa della Trinita), and even the Christ in Michelangelo's *Entombment* (National Gallery, London)

Figure 19. Nicolas Poussin (1593/4–1665), *Ajax*. Detail of *The Realm of Flora*, Dresden, Staatliche Kunstsammlungen

success Hogarth would have liked; and that *Marriage à la Mode* itself was finally sold for a pittance.

5. Meaning in Colour

> Since it was only the idea which counted for him, he often said that a reproduction would serve as well to communicate his intention as the original painting.[15]

This statement about Magritte applies equally to Hogarth and the matter-of-fact literalness, monochromatic and relatively uniform in texture, of the style of his engravings. A very different matter are the paintings he made in preparation for the engravings. In these, painted in oil with wonderful fluency, the spatial relations are worked out in pigment and colour, and the results are often more interesting than the engravings—though in a completely different aesthetic way.

I cannot emphasize too greatly the difference in the *reading* of a Hogarth print and the *seeing* of a Hogarth painting. Hogarth's drawings too have usually only the end of organizing a print, and the print only the end of readability. Everything in the print is directed toward reading and verbalization; and this precludes 'style', which in a Goya or Tiepolo etching narrows or simplifies the meaning at the same time that it radically sharpens the intensity of a single emphasis.

Hogarth's earliest surviving 'paintings' are monochrome watercolour drawings for *Hudibras*, probably made more for the printseller than for purposes of engraving.

Hudibras' First Adventure, made in 1724 or 25 (Plates 2, 4), shows him still defining areas by lines in the manner of an engraver. According to George Vertue, it was after he completed the *Hudibras* engravings (1726) that he began to paint in oils; and his earliest datable commission was in late 1727.[16] The earliest authenticated oil paintings that survive (the Lewis version of *The Beggar's Opera*, the Iveagh *Falstaff examining Recruits*, *The Denunciation*, *The Christening*, *The Woodes Rogers Family*, and *The Committee of the House of Commons*) are still painted in the manner of the *Hudibras* watercolours. They are small and meticulous, delicately painted, with a dark neutral background, and the figures, rather stiff and angular, are indicated by linear means. The style is particularly evident in the oil sketch of *The Committee of the House of Commons* (Plate 5), which must be the earliest version of the subject; and the linearity is carried over into the finished painting (Plates 6, 7).

Within a year or so Hogarth had developed from a style that defined by lines to one that defined by volumes; the second, essentially *alla prima* painting, first appears in background figures, then in small, independent sketches, and finally, with various degrees of finish, in all his paintings. *The Christening* clearly follows *The Denunciation* (both 1729, Plates 8, 9, 14), because it shows the transition from the hard, dry, angular, and linear style to the beginnings of a softer, more fluent painting in volumes. The earliest painting in which Hogarth is completely at home in his medium, defining in the freest *alla prima* manner, is a sketch of *The Beggar's Opera*, probably of 1729 (Figure 20).

With these preliminary distinctions in mind, we may ask how colour and texture operate in the paintings. Even in the earliest paintings, where Hogarth still defines by lines, his figures emerge in highlights of a greater or lesser intensity, or a more or less clear focus (or finish), from a neutral background. The closed perspective of the room in the engravings is rendered more mysterious by the relationship of the few light colours to an indeterminate background of large neutral areas of olive, grey-green, or brown. The engravings are so readable partly because their focus is multiple, their emphases weak, their tonal contrasts not sharp, and their lines distinct—as on a page of printed text; unlike these relatively unsubordinated structures, the paintings of 1730 to 1740 are all subordination, with only a few crucial figures and their expressions standing out. The prints define, the paintings suggest.

The problem of colour for the theorists of art fell under one or another aspect of decorum. Such modern tags as Wölfflin's, that linear = being and painterly = seeming, or the psychologists', that colour is more emphatic than black and white, offer a marginal commentary on the seventeenth-century critics who argued that line appealed to the intellect and colour to the emotions.[17] Colour, as Dryden put it, is 'the bawd of her sister, the design or drawing: she clothes, she dresses her up, she paints her, she makes her appear more lovely than naturally she is; she procures for the design, and makes lovers for her: for the design of itself is only so many naked lines.'[18]

In one sense this means that colour is a secondary, cosmetic quality, reliant on the

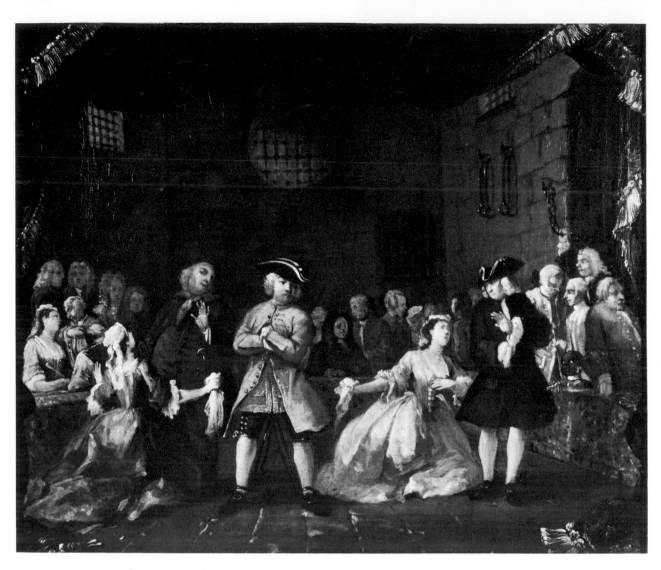

Figure 20. *The Beggar's Opera.* 1728–9. Oil on canvas, $19 \times 22\frac{1}{2}$ in. Private Collection

senses, not inherent in nature itself. It may be thought of as a projection of the poet's mind, as self-expression or how he sees as artist, opposed to the black-and-white *real* world of primary qualities in his engravings. The artist appears in a different relation to his subject. In the print he is effaced, and form as form is less evident because the print is reproductive to begin with, a copy of a copy: the 'idea' is all that remains. The execution, the self-expression, is back in the painting. These flourishes produce a picture that is about the print's subject *and* about the artist who shapes and sees reality in this way. The effect on the subject is rather like that of the colour filters on the harsh Fieldingesque realities in the film version of *Tom Jones*. Experience is embedded in amber, and while one result is to draw attention to the artist, another is to suggest that there is a beauty and vitality in even the most sordid events.

But Dryden can also be interpreted, closer to his intended meaning, as a follower of Lomazzo and Franciscus Junius, who connected colour, as another of the rhetorician's tools, directly with the painter's function as orator and poet to teach, delight, and move. Hogarth may, in the early paintings, be reflecting the view of these art treatises that colour and light could be used to define reality *or* to move the passions. His flickering chiaroscuro, so much more evident in the paintings than in

the prints, may have been intended to bring out the painting's ability to move, as opposed to the print's to be read. Didactic art can therefore draw on either information (or meditation) or on persuasion, depending on its emphasis.[19]

The distinction between painting and print is plain in the story-telling potential of the latter—the movement from left to right, from past to future and from cause to effect. All of this is absent in the painting which, made by Hogarth consciously with reversal in mind, does not 'read'. For example, the causality of the first plate of the *Rake's Progress* is emphasized as the eye moves up from the objects denoting the miserly father, to the lawyer settling the estate, to the son spending the father's money, to the girl he has made pregnant and is buying off. Reversed, the girl blocks us and turns the composition into a static, sentimental view of the situation from her point of view. In so far as a story remains, it is that of the girl, spread out into the past. The result is more static than the engraving, perhaps closer to the eternal caught moment of a genre scene. But this is not to say that the colours do not also emphasize the contrast, in a moral sense, between the Rake and the girl or the Rake and his surroundings.

The question is whether Hogarth achieves in his series what Roger Fry called 'a successive unity'—and do we mean, in Hogarth's case, a view that takes in the pair or all six or eight pictures, or merely keeps 1 and 2 or 1, 2, and 3 in mind as we follow them like a Chinese landscape painted on a long roll of silk?[20] Or does the question apply only to the engravings, and a temporal unity of a kind we know from literature, with the paintings made purely for their own sakes?

We can begin with the simplest consecutive structure, the pair. In the outdoor *Before* and *After* (1730–1, Plates 12, 13) the unity of the compositional whole is obvious in the contrast of this scene versus that. But the formal pattern is reinforced by colour pattern: Hogarth balances the colours quantitatively in both pictures but rearranges their relative proportions. The dominant red of the girl's skirt in *Before* is displaced in *After* to the flushed faces of both boy and girl; her skirt is now reduced to a bare crescent over the white of her petticoats and the pinks of her thighs. The blue of her long stocking replaces the dominant blue of the boy's suit in *Before*, now reduced and obscured by the appearance of his unruly linen. In the indoor version of only a few years later, however, the colours play no part at all (J. Paul Getty Collection); they are simply repeated, and the elaborate contrast is displaced from 'character' or incident to symbolic objects, or to the exclusively *readable*. I wonder if this transition does not indicate Hogarth's experiment with and abandonment of expressive relationships of colour for parallelism. (The colours change too: the outdoor pair is dominated by blues, salmon reds, pinks, and white; the indoor pair by pinks, greens, and white.)

The *Rake's Progress* is, of course, a much more complex case. However its eight canvases are arranged, whether in a row or two deep, we are aware of the predominance of earth colours, a single wedge of blue sky appearing in 4, with struggling people emergent from the dark background. (In one sense, of course,

Hogarth was painting his own 'dark master' pictures in these early paintings-for-engravings; attempting to extend the concept of the copy to the painting itself.) Searching for some parallel or contrast, and perhaps recalling the pale, aristocratic shape of the young man in *Before* in contrast to the flushed, dishevelled, and collapsed figure in *After*, we may relate the Rake, full-length, fully clothed in 1 and the prone, unclothed figure in 8. A certain continuity might be traced in the pale pinkish-grey of his suit in 1, the pink of his dressing gown in 2, and the almost obscene pink of his bare skin in 8. More can perhaps be said about an individual painting like 8, where the raw pink of the Rake's body is balanced by the refined pink of the fine lady's dress (which recalls the pink of his dressing gown in 2), and is related to the deep red of his keeper's coat.

In general, however, the series seems to move not by comparison and contrast of colours (let alone any scheme that corresponds to a temporal or causal progression) but by degrees of colour concentration. If we take the normative sense of the whole to be the neutral background colour, which is itself symbolic of ordinary 'colourless' existence, then the emergent bright colours reach a peak of warmth—earth colours into intensely hot reds and yellows—in the brothel (3). The pinks and reds are building up to the left of it in 2, and in 4 the Rake is pulled out of a red sedan chair, located at the left side of the canvas, almost as if it were an antechamber to the brothel in 3. (Sarah Young, his benefactress, wears a bonnet with a touch of pink and a pink rose in her bosom.) And thereafter the scenes get cooler and darker, from the cold, grey-walled church, in which the Rake takes his aged bride, to the darkness of the gambling house, prison and madhouse. The colours locate the peak of pleasure and involvement with the colourful world, and then document the Rake's gradual isolation, until he is merely a spot of flesh or colour, laid out almost like a piece of meat in a market, a cool pink that recalls by contrast the warm reds of the brothel.

The relationship of neutral tones to bright highlights is most schematic in *The Distressed Poet* (*c.* 1735, Plate 61), where the bright red of the milkmaid from the outside world, and the wife's blue dress, and both women's rosy cheeks and creamy complexions, are contrasted with the pale, faded poet (a pale pink-and-green striped dressing-gown against a pink-and-green bed, blending into the neutral ground of the room). The colours support what is done formally by the heavy lines of the poet's cubicle: these cut him off from the room, which is itself cut off from the outside world. If there is a readable structure in the painting, it is different from that in the print; the colours divert our attention from the poet to his wife, whose function as mediator between the poet and the outside world becomes the subject.

The colour scheme that emerges in Hogarth's paintings runs from salmon red to pink, from pale green to grey-green and a dark bottle green, with sometimes a gold near the green, and a blue set against white, separated from a red. Hogarth often floats a red and another related shade with a royal blue nearby in large areas of grey or green. We have seen how this works in the early paintings, but with the 1740s the whole effect begins to change from a group of bright spots flickering across the

canvas, withdrawing into unfinished background, to the use of large simple forms on a uniformly finished canvas. There are still large neutral-coloured areas in the architecture of *Moses brought to Pharaoh's Daughter* (1746, Foundling Hospital, Figure 21), but these are themselves shapes that are as clearly a part of the pattern as Moses himself. No one is emerging from the indeterminate area, as for example was the case in the *Scene from 'The Tempest'* of about 1735 (Plate 50), where Caliban and Prospero half emerge and Ferdinand and Miranda stand out in clear focus from the neutral brown of the mountain-side with their blues, whites, pinks, golds and reds.

In *Marriage à la Mode* Hogarth fills in everything; neutral background becomes a series of distinct areas in solid colour, and the canvas a complete mosaic of different but related planes and areas of colours. Robert Wark is very good on this colour effect: 'The paint is applied in rather crisp daubs, retaining its identity as pigment on canvas, rather than losing itself in the objects it describes.'[21] He argues that the lack of 'compelling focus' depends

> on such factors as color, light and shadow, and paint application. There is no broad massing of light and shadow to direct one's attention. The colors, fairly high in intensity and value, often meet one another abruptly, with little gradation of tone to soften the transition.

This effect should, however, be contrasted with the opposite effect in the earlier paintings, in which there is indeed a 'broad massing of light and shadow to direct one's attention'. So if we accept the characteristics of rococo as two-dimensionality and lack of emphasis, then *Marriage à la Mode* is Hogarth's most rococo series of paintings. It is a half-way house between the shimmering tones and strong contrasts of the earlier paintings and the large flat areas of colour in *The Election* (1754, Plates 106–115).

On the other hand, the eye still wanders in those early paintings; the dark only focuses us on various areas without producing what we could call a 'good gestalt'. Moreover, the relative undifferentiation of the *Marriage à la Mode* paintings is somewhat deceptive. Certain areas are emphatic, made out first, and dominate the picture space of the painting as of the print. These are not, however, the same areas. As in *The Distressed Poet*, our attention is drawn to a pattern that runs counter to the reading structure. The figure of the Earl is dominant in the engraving of Plate 1, with the men at the table appearing to be paying him homage (Figure 14); although we learn from 'reading' that a bargain has been struck, the formal relationships tell us that social roles are being maintained. In the painting (Plate 75), the pattern is disrupted by the large red area of the merchant's coat in the centre of the canvas. (The case is even plainer in 4, where the eye is drawn to the gesturing woman in white, framed by the large pink tester, and not to the Countess, who in terms of the readable structure is the centre of interest.) The painting is also the reverse of the engraving; it does not lead the reader in through the figure of the Earl but instead balances the two groups, whereas in the print they are causally related, from left to right: the parents' greed *produced* the manacled children.

The priority of shape, texture, and colour draws attention to a pattern that (partly because of reversal) is invisible in the print. The manacled dogs and the young couple begin a long undulating curve that runs across the entire picture from left to right, interrupted by the upright figure of the usurer. The soft curves of the people, though hardening in the stiff posture of the Earl and the jutting discontinuity of the usurer, are played against the geometrical angles of the picture frames; but taken altogether the pictures also make a gentle curve over the heads of the humans, their hard edges floating above the soft curves of bodies. They no longer weigh down on these people, as in the engraving.

Further, in paintings that are, like these, all colour the viewer finds that the colour actively prevents him from getting down to the reading structure. Turning from the print to the painting of the marriage contract, one is initially aware of pinks, greens and golds, and these colours and the texture of the paint hold the attention, producing an independent pattern, making it much more difficult to get to the details and inscriptions. The colours may have cognitive importance of their own, as (once again) with the salmon red of the large, confident area of the merchant's coat, which is contrasted with the faded pinkish attire of the decadent earl; but mainly they fix our attention on these two shapes in relation to the large area of green velvet wall with gold picture frames. The pictures themselves are part of a colour-texture pattern and resist the intense scrutiny they are given in the print. We are held by simpler, more expressive structures than can be allowed to emerge in the print.

6. Conventional History Paintings and Portraits

'The Harlot's Progress by *Hogarth*', said the Revd William King, 'would purchase an hundred Saints. . . .' Writing in 1736, four years before Fielding's similar praise in *The Champion*, King was defending the satirist's choice of unpleasant subjects.[22] This sort of praise only spurred Hogarth to produce *pleasant* subjects; and in the same year he unveiled his first conventional history painting, *The Pool of Bethesda* (Plate 44).

When he had finished the *Rake's Progress*, published with resounding success amid the last flurry of piracies and the enactment of the Engravers' Copyright Act, Hogarth took what must have appeared to his contemporaries a giant step, offering to paint gratis two huge religious subjects for the staircase of St Bartholomew's Hospital. In these conventional histories he had no need to construct his own meaning, and so he was able to produce structures simpler and bolder than the *Harlot* and *Rake* permitted. But he did, of course, choose his own texts, the story of the Pool of Bethesda and the Good Samaritan (Plate 45), both appropriate to a hospital for the poor. He had grown up under the hospital's shadow; now as a governor and decorator he probably wandered its wards, and in *The Pool of Bethesda* he recorded with clinical detachment some of its patients in a scene bearing at least a family resemblance to the last painting of the *Rake's Progress*.

The two panels again make a pair: not, as in *Before* and *After* (a version of which he published as engravings about this time), a contrast but a parallel between the uncovered victim and the ministering figure representing charity in each. Both Christ and the Samaritan are dressed predominantly in red: Christ's upper (outer) garment is blue, his tunic red; the Samaritan's under-robe, the upper part of his attire, is ochre, the lower or over-robe is red, and his hat catches the blue of Christ's robe. Colour emphasizes the parallelism between the divine and human acts of charity.

In the background, behind the Samaritan, is the Levite who walks past without pausing, his head buried in a book of the law, and the priest mounting the hill who looks to heaven and accepts the homage of an admirer. In *The Pool of Bethesda* the figures in the right background illustrate the verse (John 5:7, inscribed underneath) about why the lame man whom Christ cures cannot get into the pool: he has no one to help him, and others keep crowding ahead of him. Hogarth creates a tableau, a chain of action, connected through hands and arms, of a woman and her ailing child being pushed aside by a burly attendant who accepts money to assist a more prosperous group—a servant woman helping her beautiful unclothed mistress, whose protector is giving the instructions. One of Hogarth's implications is that this is a disease of love, the sort from which both Harlot and Rake suffered. His 'invention' is to elaborate one part of the story, turning it into not only a typically Hogarthian emblem of human corruption, but an example of a second kind of love in contrast to Christ's charity.

The two prominent figures in the foreground, however, are the sick and wounded men who are being ministered to; and they are as unmistakably similar to the prone Rakewell in Bedlam as are the background figures to the two young lady sightseers who giggle behind their fans (Plate 43). One wonders about these stripped figures: running through Hogarth's work is the imagery of clothing, usually connected with disguise and the sense of social versus private self, role-playing versus natural instinctual being. The nakedness in the parable of the Good Samaritan is combined with King Lear's 'bare forked animal' as a stripping away of all affectation to create an image that in the 'unpleasant' subjects proceeds from the madman in Bedlam to the disembowelled Tom Nero in *The Reward of Cruelty* (1751, Plate 122).

There is also a dog present in both panels: the wounded man's wounded dog licking its bloody leg, and the black dog in the other panel, which leans over the edge of the painted frame and looks down at us, the spectators, as we climb the stairs. These may be Hogarth's trademark, or related to the iconographical tradition in which dogs represent the natural self; they also recall, inevitably, their prominent role in Hogarth's conversation pieces. Indeed, the nakedness of the victims is another version of the naturalness embodied in the dogs among the over-dressed gentlemen and ladies in over-furnished rooms.

Christ's role is that of a William Wollaston, or some other conversation-piece host, with his outstretched hand in a gesture of connection and unification. In the

St Bartholomew's paintings the host's gracious gesture has become the single point of contact projected in a situation of isolation, pain, and self-regard.

The closed room with its pictures and furniture has become a wide circular arcade, through whose arches is visible an idyllic landscape; but within the enclosure and around the pool are also trees and luxuriant foliage, making a landscape in which the characters of Hogarth's story are for once placed. Hovering over the pool, into which the lame and halt take themselves, is the angel who 'troubled the water', bringing about the miraculous cures. *The Good Samaritan*'s landscape is, by contrast, a bare, rocky one with a blasted tree stump behind the broken body of the robbed man.

Looking back, we can see that the protagonist of the comic histories, however guilty him/herself, was essentially the poor robbed man ignored by all the Pharisees and hypocrites who pass by. Self-interest or unconcern was the response to the Harlot in the first four plates, and in the last two the outside world was almost totally unconnected with her; so too with the Rake, where by the sixth plate everyone else was wrapped up in his own problem and ignoring the protagonist. The exception in both cases is a single good Samaritan: the poor noseless servant woman of the Harlot and the fallen woman, Sarah Young, who nevertheless faithfully follows her seducer to his end. Five years after the unveiling of *The Good Samaritan* in St Bartholomew's Hospital, Fielding used the parable in *Joseph Andrews* (1742) as a central paradigm of Joseph's situation in an unfeeling world. The role of the Samaritan was taken by a poor postilion who is later transported for robbing a hen roost and by a poor chambermaid who is otherwise no better than she should be. This figure is given a more positive value in the lighter comic works Hogarth produced in the 1730s and 40s: she becomes a pretty young girl—the drummeress in *Southwark Fair* (Plate 48), the milkmaid in *The Enraged Musician* (Plate 65), and the wife in *The Distressed Poet* (Plate 61)—who mediates between the unhappy protagonist and the world with which he cannot come to terms.

This figure, from Sarah Young to the poet's wife, tells us something about Hogarth's Christ, for she is at best aesthetically pleasing but morally inefficacious, merely a passing witness; at worst an ambiguous figure, something between Christian charity and an albatross. She is later the poor, faithful girl Tom Nero murders. Like Christ, she is used to represent not eros but agape; in fact, when we expect a theme of love in Hogarth we find instead unwanted pregnancy and syphilis on one side, a crushing charity on the other. The absence of a theme that is, for Watteau, an essential part of the play of illusion or art and nature, is strange. Love for Hogarth is only something that is perverted; even when it is a positive force, as in Sarah Young's love for Tom Rakewell, it is masochistic and fruitless. The final example of the theme in Hogarth is his *Sigismunda* (1759, Plate 131), which again represents love *in extremis*. He presents many beautiful and desirable women, but not love. His Line of Beauty itself is sexual, associated with Venus and the female figure; but not with love. This beautiful mediator who appears in his paintings of the 1730s and 40s is the aspect of his world Hogarth abstracted and tried to talk

Figure 21. *Moses brought to Pharaoh's Daughter*. 1746. 70 × 84 in. London, The Thomas Coram Foundation for Children

about in *The Analysis of Beauty*; and she is what led him to abstract completely in *Sigismunda* what had been workable in the *Analysis* as part of a total structure, including ugliness and intricacy and the 'pleasure of pursuit'. The end result is mere 'Beauty', in a few serpentine lines.

For Hogarth the difference between the satiric and the heroic mode is that in the one the Samaritan is peripheral, in the other central. In the heroic mode the Pharisees and Levites are peripheral, and in *The Pool of Bethesda* the sick at the left are beginning to respond to Christ's gesture—it is dawning on them that he can help them. But this is, in any case, to a very large extent a conversation piece which, by its mythological subject matter and heroic size (Hogarth bragged about the figures being seven feet high), the trappings of costume and the floating angel, masquerades as a history painting.

Among his other experiments in the sublime mode, the most daring is the unfinished sketch of *Satan, Sin and Death* (Plate 60). He may have known John Oldmixon's argument that when a reader comes 'to the Gates of Hell *wide open*, he certainly should have left his Delicacy behind him'. Oldmixon means that the strength of the scene calls for a certain forgivable excess in the portrayal: 'it would not be more extravagant to put Perfumes among the Ingredients of a *Stink-Pot*, than to put Delicacy in a Picture of the Devil.'[23] This together with Jonathan Richardson's urging may have led Hogarth to undertake the subject.[24] He threw 'Delicacy' to the winds in the violence of his brushwork, the garishness of his colours, but unconsciously retained it in his composition, which employs essentially the same domestic triangle of the Macheath-Polly-Peachum group in *The Beggar's Opera*: Sin is trying to mediate between her father Satan and her lover-offspring Death.

The most successful of the conventional histories is *Moses brought to Pharaoh's Daughter*, painted for the Foundling Hospital in 1746 (Figure 21). Once again the emphasis is on the outstretched hand of Pharaoh's daughter, her gesture of union with Moses, and on the great V-shaped gap remaining between them: William Wollaston trying to unite two groups of guests or Polly Peachum trying to keep father and husband from each other's throats. But, of course, the picture is called *Moses brought to Pharaoh's Daughter*, and if Moses is the protagonist he is placed in a situation of choice between his true and his adoptive mother, between nature and

rich nurture, as Macheath is asked to choose between his two 'wives' and the Harlot has already chosen between the piety represented by the clergyman and the fascinating London society of the bawd. The two centres, the two interpretations, coexist a year or so later in *Paul before Felix*, painted in 1748 for Lincoln's Inn (Plate 98): is it about Paul or about Felix? about the poor, deluded mortal who will make the wrong choice or about the superhuman mediator whose gesture now attempts to link the human and the divine? The two relationships are essentially of history painting in the choice (of Hercules, according to Shaftesbury),[25] and of the conversation piece in the tension between unity and separateness or fragmentation; of the individual hero or anti-hero in relation to society, or of the family in relation to the individual.

To think that Hogarth's sublime histories are any less idiosyncratic than his comic ones is to underestimate his recalcitrance. The Benchers of Lincoln's Inn simply asked him to paint a history 'for adorning the Chapel or Hall or both', and he chose his subject. He may have recalled his friend Bishop Hoadly's sermon, 'St. Paul's Discourse to Felix, preached before the King, February 15, 1729/30', which explains that this scene has been chosen because it gives 'a very uncommon Appearance; the *Prisoner*, undaunted and unconcerned at his own Danger; the *Governour*, terrified and *trembling*, as if his *Prisoner* had been his *Judge*; and were now pronouncing a Sentence of Condemnation upon him'. Hoadly's argument is that Felix the judge is terrified because of the accused's innocence and his own awakened conscience of guilt; and this 'created in St *Paul* a Boldness to adapt his Discourse to the Case of the great Man he spoke to. . . .' But Hogarth need not have recalled Hoadly's sermon, because in 1741 Samuel Richardson (who had already urged him to do a series on apprentices and to illustrate *Pamela*) published *Pamela in High Life*, in which he introduced a scene modelled on Hoadly's interpretation of Paul and Felix. Pamela learns that Mr B, now her husband, lord, and master, has begun to show interest in a countess, with whom he talks about the virtues of polygamy. Her suspicions thoroughly aroused, she invites him into her closet, where she has arranged chairs as in a courtroom, and sets herself up as the accused and him as the judge and accuser, saying:

> methinks I stand here as Paul did before Felix; and, like that poor prisoner, if I, sir, reason of *righteousness, temperance*, and *judgment to come*, even to make you, as the great Felix did, tremble, don't put me off *to another day, to a more convenient season*, as that governor did Paul; for you must bear patiently with all I have to say.

And, of course, her innocence and Mr B's guilt turn the tables in just the way Hoadly envisioned.

It was a bold thought, in the manner of Pamela, to choose for the Benchers of Lincoln's Inn an exemplum, garnered from either Hoadly or Richardson or both, in which the roles of judge and accused are reversed. It was a Biblical subject that would serve in either Chapel or Hall, but the minutes of 12 December 1747 show that the Benchers, not recognizing themselves in the story of Paul and Felix,

resolved that it would 'be placed against the wall at the west end of the Chapel, according to the subject proposed by Mr Hogarth'. When the painting was finished a year later it was in fact hung, apparently because of its size, in the Hall above the Lord Chancellor's seat. We do not know whether Hogarth purposely made it too large for the Chapel, but the picture represents another case of his genius for having a subject both ways or allowing, depending on the audience, a weaker and a stronger interpretation.

The difference between the histories of the 1740s and the St Bartholomew's Hospital paintings lies less in the paradigms of action or composition than in the reduction of detail and the simplification of the reading structure. Hogarth would have known two of Serlio's plates, stage sets for Tragedy and Comedy: one is a symmetrical and subordinated structure, an ideal classical town; the other is an irregular collection of buildings, some with gothic or rustic details. In the latter lies an answer to why Hogarth's earlier works are not tightly unified: they are, by that convention, comic works. When he made the St Bartholomew's Hospital pictures he was not yet willing to accept this decorum, but by the late 1740s he was producing a radically simplified composition like the *Garrick as Richard III* (Plate 88) or *Moses brought to Pharaoh's Daughter*.

Paul before Felix, in its various versions, dramatizes the transition; indeed Hogarth attempted to convert a comic scene into a scene for tragedy or, in different terms, a complex rococo structure into simple classicizing forms.[26] The original painting (Plate 98), completed in 1748, was Raphaelesque in composition and execution, drawing on the Cartoons and in particular *Paul and Elymas* (Figure 22); but in elaboration and detail it was nearly as Rembrandtesque as *The Pool of Bethesda*. The paint was applied very thinly except in the two main figures in the foreground, Paul and Tertullus, who—especially in the painting of their heads—are the most forceful part of the composition. The general tonality is rather pale, far paler than that of the *Moses* of a year or so earlier, and the colours are mainly greys, pinks, gold, and smoky blues: Raphael colours transmitted through the medium of late baroque painting. Raphael was the strongest basic influence, but the over-expressiveness of the faces and gestures shows that Hogarth has not left far behind the vigorous individuality of the St Bartholomew's Hospital paintings.

This is the painting that now hangs, revealed by recent cleaning, in the Great Hall of Lincoln's Inn. Sometime between 1748 and 1751 Hogarth memorialized this first version with his own engraving (Plate 100). He probably completed at least a pencil copy (Morgan Library) before the painting was turned over to Lincoln's Inn in February 1749. The main change was to omit the SPQR banner and the pillar that stands in the painting behind Tertullus, filling in this area with a deep perspective and more figures. The pillar was probably part of the original composition in order to anchor the left side; but when Hogarth engraved it, and so reversed the composition, he found that it worked better to let the distance recede behind Tertullus' back and so subordinate the whole scene to the figure of Paul looming front-left. The

Figure 22. Raphael (1483–1520), *Paul and Elymas*. London, Victoria and Albert Museum

undertaking of the engraving may have exposed the Rembrandt in the painting: without the colour the grotesqueries would have become more apparent. This discovery then may have led Hogarth to keep the engraving to record his work, while revising the painting itself.

If the painting was finally hung in the Great Hall of Lincoln's Inn early in 1749, it was back again in Hogarth's hands in February 1751 for 'retouching', and from a notation in the margin of the minute book it was evidently 'retouched' before it was returned. It was probably at this time that he made his substantive revisions, eliminating more figures and filling the empty space with large areas of architecture to narrow down the action to the main performers (Plate 99). The result was a far more austere and classical composition. (This was the picture as seen in Lincoln's Inn until it was over-zealously cleaned in 1970.)

In May 1751 Hogarth took the further step of issuing a burlesque ticket (Figure 23) inaugurating a subscription for engravings of *Paul before Felix* and *Moses brought to Pharaoh's Daughter*. The burlesque makes clear what he regarded as excesses in history painting of the Rembrandt school, and implicitly in his own engraving of *Paul before Felix* as it appeared to him by this time. Finally, he hired Luke Sullivan to engrave the revised painting in an even more smooth, simplified, and classicized style, which went so far as to omit the figure of Drusilla (Plate 101).

Figure 23. *Paul before Felix Burlesqued*. 1751. Engraving (the subscription ticket for *Paul before Felix*), $9\frac{7}{8} \times 13\frac{1}{2}$ in. London, British Museum

This was the most idealized and the best approximation to the ideal of history painting as Hogarth seems to have understood it; but, significantly, as in the engravings of *Marriage à la Mode*, he left the hypothetical projection to another engraver.

One impression of Hogarth's own version of the engraving carried his manuscript inscription, 'A print of the plate that was set aside as insufficient. Engraved by W.H.'[27] i.e., this composition represents an earlier unsatisfactory stage of the design. There is no mention of his engraving in the advertisements for the subscription, which presumably distributed only Sullivan's. The first mention of the alternative version as for sale was in an advertisement of 1 December 1759 (*London Chronicle*), when Hogarth replied to Joseph Warton's remarks on his use of Rembrandtesque devices in his history paintings by engraving the slighting (and erroneous) remarks on the bottom of *both* plates and issuing them, perhaps for the first time, as a study in comparison. The advertisement announces 'another Print, Price 5s. of PAUL before FELIX . . . different in Composition, but of the same Size with the former [Sullivan's], and engraved by WILLIAM HOGARTH.'

The importance of all this detail is to indicate the careful steps Hogarth took—characteristic of the man—to demonstrate his transition from less to more classical and simplified forms, in effect from Rembrandt to Raphael. We can look back to his *Pool of Bethesda* and then forward to the surprisingly large, simple, and expressive

forms of *Garrick as Richard III* in 1745 and *Moses* in 1746, and yet further ahead to the forms of the popular prints and the last histories of the 1750s.

Searching for some internal force directing Hogarth from complexity to simplicity of pattern, or from multiple to single gestalts, we cannot find better evidence than the portraits he painted around 1740. These simple head-and-shoulders portraits forced him to simplify his shapes, to work in terms of a single large figure in relation to a coherent ground. And in the *Captain Coram* (1740, Plate 87) and the *Self-Portrait with Pug* (1745, p. 17) he produced simple structures of the sort that developed in subject pictures from the spectacular *Garrick as Richard III*, which was both portrait and history, to *Moses*, *The Lady's Last Stake*, and *Sigismunda* (Figure 21, Plates 130, 131).

The undertaking of portraiture was a momentous step for someone like Hogarth who despised 'phiz-mongers' and an art market that forced serious painters to waste their talents on flattering likenesses. His decision to paint portraits was very largely a response to the success of foreign portraitists like J. B. Vanloo who, as he later wrote bitterly, were driving English artists into virtual destitution.[28] He was already, however, moving in this direction in the mid-1730s in a few informal portraits of his family and close friends; and so his first public portrait was, characteristically, of a friend, Captain Thomas Coram, the founder of the Foundling Hospital. By donating the portrait of his friend to the public institution he had founded, Hogarth was able to secure it a permanent display before all the fashionable people who visited the Foundling on Sundays. Then, he hoped, they would come to *him* for portraits. Very few came for portraits of such monumentality, but Allan Ramsay and Joshua Reynolds saw the picture, and the great period of English portraiture was inaugurated.

Hogarth was also moving in the direction of the single portrait by simplifying his conversation pictures into a single figure, a Sarah Malcolm sitting alone in her prison cell (1733, Edinburgh, National Gallery of Scotland), a Duke of Cumberland simply removed from *A Scene from 'The Conquest of Mexico'* and given a grenadier in the background (Plate 84), or a Dr Benjamin Hoadly alone in his room under a bust of Newton (Plate 85)—small conversation-size pictures which replaced human interrelations with, inevitably, more purely formal relationships. The *Coram* was largely an expansion from a small, conversation-size full-length figure to a life-size, monumental one.

The result, perhaps partly because of its conversation piece origins, is very different from the great Reynolds portraits of the 1750s and 60s, which attempted to make the English sitter as far as possible, within reason, into a Titian monarch or merchant prince, or perhaps a Juno or Jupiter out of the School of Bologna. The alternative, Hogarth's way, was to paint a sprightly, cheerful rather than dignified, likeness and juxtapose this with the trappings of a Juno or Jupiter, keeping them separate. His most successful portraits are those in which the unity of man-office-

costume has broken down, as in the great *Bishop Hoadly* (Plate 86), which has the same power as a Velazquez portrait of a dwarf or fool in court attire. Selfhood is feigned or borrowed, or the man and his office are discontinuous: the conversation gesture of connection and its tension of unity and fragmentation remain implicit in these portraits. It was James Quin or David Garrick the actors, or children who are feigning grown-up roles, that Hogarth liked to paint. Coram is an exception, a man whose discontinuity with his costume and office is his personal greatness, which transcends them and is so concentrated as to exist outside the need of a role. He stands out from his setting, and his clothing hangs about him with an independent life, part of the separating process that applies to almost every object in the painting.

The characteristic Hogarth portrait is not, however, the impressive *Coram*, nor even the extremely able imitation of the French style, *Archbishop Herring* (Plate 97), but the pair of George and Frances Arnold (Plates 94, 95). Something can perhaps be made of his painting of pendant portraits, usually father and son or daughter, which are in psychological effect two heads from a conversation picture. But formally they are quite another matter. Like none of the earlier paintings, these heads and shoulders completely fill and dominate the picture space with a unity and concentration Hogarth had consciously avoided in paintings whose subject was disunity and whose reading structure required multiple, often conflicting, gestalts. George Arnold is all of a piece, unitary and unfragmented and unambiguous, whose glance cannot be avoided nor broken once taken up. Like Coram, he is all himself and nothing else; whereas Frances, deprived of the pendant, is incomplete, undefined except in relation to this powerful father.

These portraits suggest why the usual distinction between rococo and neo-classical modes (advanced by Antal and, in his own way, by Wark)[29] is not useful for Hogarth. His early *Harlot's Progress* prints were classical in the sense that the compositions tended to be plainer, the figures balanced, clearly articulated, made fairly large in relation to the picture space, which is invariably closed; but they were quite unclassical in the sense that (as Hogarth tells us in his *Analysis*)[30] areas of light and shade are scattered in a very complex pattern that does not allow for one simple gestalt. The late prints *and* paintings are classical only in the sense that Hogarth is radically simplifying his gestalt pattern, but the application of paint, the colours, even the general compositions—certainly not the continued use of detail, however subordinated—are neither classical nor neo-classical.

7· 'The March to Finchley' and the Popular Prints

In *The March to Finchley* (1750, Plate 102), the great 'comic history-painting' of Hogarth's maturity, the reading structure has been simplified and the level of denotation reduced. There are one or two inscriptions to be read, a couple of sign-boards easily identified by anyone familiar with the English countryside, but no myths to recall or Biblical stories to plumb. Pictorially the scene is dominated by

the three foreground groups at left, right, and centre; by the great confused mass of soldiers and civilians moving in no direction unless toward the viewer; and by the set-like buildings at left and right that direct the eye back and inward to the focal point of the neat marching ranks of troops in the far distance. The most general impression is of a contrast between sunlight and shadow. A heavy shadow is cast across most of the crowd in the middle distance and slants across the buildings at the right: the sun is going down in the west. Picked out by the sunlight are the tiny lines of troops marching away in the distance and the hilltop (the town of Finchley itself); the windows of the brothel (all but one of the whores is bathed in sunlight); the three main groups in the foreground; and a few individual faces in the middle distance—of the plotting Jacobites (and the baby immediately adjacent) and of the kissing lovers balancing the plotters on the other side of the central trio of the grenadier and his two women.

The tavern sign of Adam and Eve, proprietor 'Giles Gardiner', on the left is balanced by the brothel and the sign of Charles II on the right. The first is designated by a bout of fisticuffs, the second by a solid wall reaching up to the top of the picture space, with three rows of windows each occupied by a whore leaning out toward the soldiers, and on the top of roof, in order to make the reference clear, a row of cats.

Marching seems to have been replaced by something closer to a battle scene: but on the left battle has been transposed into a fisticuffs match, a family dispute, a 'battle of the sexes', the pain of venereal infection, with the main foreground group a wife and child chiding the husband for leaving them to go off to war. In the central group, the grenadier and his two women (Plate 103), the one on the left is beckoning toward the Adam and Eve side and the weeping wife, while the harridan (who sells the *Jacobite's Journal*) pulls him off, with a violent gesture that almost detaches herself from him, toward the pillaging on the right and the houseful of whores. Her gesture leads the eye into the soldier kissing the milkmaid, who should be delivering her milk; her spilt milk is being gathered by a soldier in his hat (a chimney sweep waits next in line), and this is witnessed by a pieman who gestures his ridicule while another soldier steals one of his pies; and behind him a keg has been punctured for a drink by yet another soldier. And so on, the links leading down to the main group on the right, the prone soldier whose comrade (a Good Samaritan parody) tries to administer a drink from his canteen, which he shuns, reaching for a glass of gin poured by a sutler whose baby as greedily disputes it with him (Frontispiece).

Indeed, everything on the right is about getting something from someone else and about pouring out: the milk and wine, water and gin all seem to drain down into the puddle in which the soldier lies. By contrast, on the left everything is dry: the soldier at the far left cannot even urinate as a result of his love-making.

A contemporary would have been aware of various art-historical contexts for this picture: (1) A battle painting like Laguerre's *Battle of Donawert* from his *Marlborough's Battles* (the engraving by Du Bosc) showed the heroic commanders in the

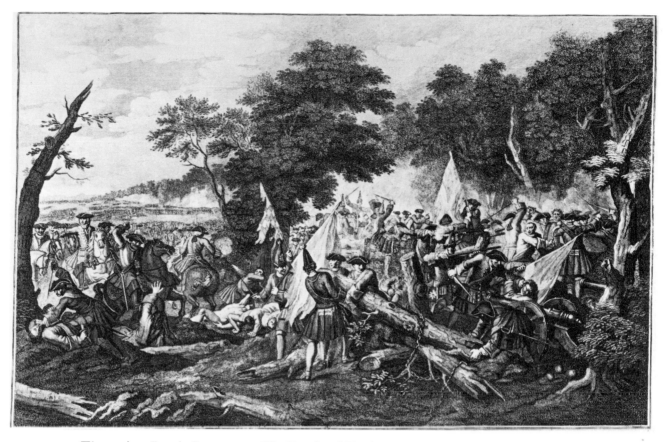

Figure 24. Louis Laguerre, *The Battle of Tanières*. Engraving by Claude du Bosc

foreground and the neat lines of their troops engaging in the distance—like those distant neat lines of troops marching in Hogarth's painting. (2) Another scene from *Marlborough's Battles*, the *Battle of Tanières* (Figure 24) is a close-up of warfare: the English have overrun the French position, are taking their cannon and removing their fortifications. Two figures are fighting to the death in the left foreground, two more in the right, and in the middle some soldiers are trying to move some logs that create powerful diagonals recalled by the flag in *The March to Finchley*. Here is all the chaos of *Finchley* but in a battle scene, not before or after: perhaps the irony of Hogarth's painting is in showing the same pitched flags and the same structure of the three forward actions but beforehand, in the peaceful bivouac.

(3) Hogarth would have known Watteau's scenes, following the battle of Oudenarde, of the unheroic time before or between battles. *Le Camp Volant* (Figure 25) is a typical example, available in C.-N. Cochin's engraving of 1727. *Le Départ de Garnison* (Figure 26), which shows troops moving out and includes departing lovers, was available in an engraving of 1737–8 (by S. F. Ravenet, who shortly after worked for Hogarth on the engravings of *Marriage à la Mode*). The context for these scenes was Le Brun's *Battles of Alexander the Great*, which allegorically celebrated the victories of Louis XIV, and the tapestries of Louis's own battles, in their way equally allegorical. I am sure that Watteau's anti-heroic scenes of war lie behind Hogarth's painting, but the difference is as notable as the resemblance; for in Watteau's the battle, as Michael Levey has said, 'lies beyond the horizon, and yet its reality is what gives point and poignancy to the temporary bivouacs and the garrisons bravely setting out'. This is an anticipation of the *fêtes galantes*, scenes of 'people released from all duty except the profoundly human one of seeking happi-

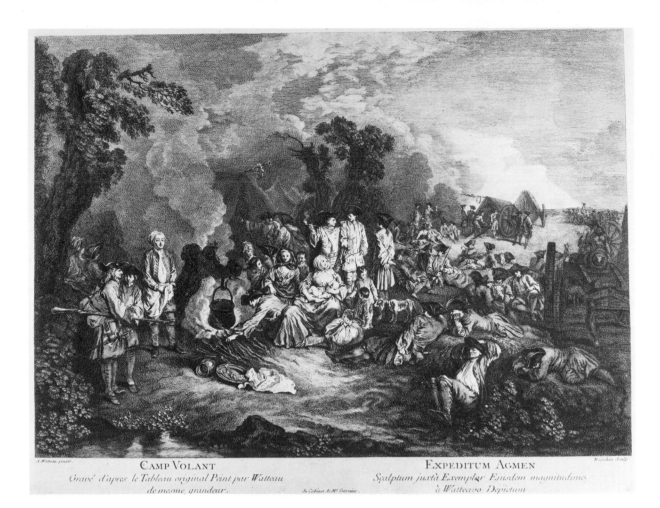

CAMP VOLANT

Gravé d'après le Tableau original Peint par Watteau
de mesme grandeur.

EXPEDITUM AGMEN

Sçalptum juxtà Exemplar Ejusdem magnitudinis
à Watteavo Depictum

Au Cabinet de Mr. Corozini

Figure 25. Watteau, *Le Camp Volant*. Engraving by C.-N. Cochin, 1727. London, British
Museum

ness. Those people too, however, will find a threat on the horizon: not of war but
of time.'[30a] In the same way Hogarth's war scene is part of his whole work: which
is about the anti-heroic, the pressure of the heroic and the literary, or of any con-
vention, to imprison the natural.

(4) In Hogarth's own mock-heroic engraving, *Hudibras' First Adventure* (Plate 4),
the heroic composition is inhabited by rustics; and in *The March to Finchley* the
anticipated compositions, of a *Battle of Donawert* and a *Battle of Tanières*, are both
subverted: the one by replacing heroism and order by chaos, the other by replacing
bloody battle by bivouac. (Although we need not suppose any knowledge of it,
Hogarth may also have been aware of Rembrandt's great attempt to correct the
paintings of ordered ranks of guards in his *Night Watch*.)[31]

If *The March to Finchley* is a sublimation or transformation of war as seen in
conventional battle scenes, then on the left we see not soldiers fighting but Adam
and Eve, the 'battle of the sexes', marriage, and prize-fighting, everything in
couples; on the right, beginning with a divisive romantic triangle, not couples but
confused knots and masses of people, not bloodletting but the flowing of intoxi-
cating and other beverages. The contrast is between combat within a social structure
and sheer promiscuity, Adam and Eve opposed to all those whores and unattached
soldiers, mere pillaging and drunkenness, and the common pool into which flow the
wine, beer, gin, and milk.

Figure 26. Watteau, *Le Départ de Garnison*. Engraving by S. F. Ravenet, 1737–8. London, British Museum

The basic contrasts also turn into a kind of progress: the drummer and piper step off marching to the right, the harridan takes up the movement with her frantic gesture in that direction, and the picture unfolds in their wake fragmenting into the chaos of the cycle of thefts and running liquids and the bank of whores' heads. (Notice that Hogarth had Luke Sullivan execute the engraving, which does not, as when he engraved himself, reverse the painting.)

The rows of whores' heads tell us something about the meaning of order to Hogarth: the only other ranked people in the picture besides the soldiers marching to Finchley are the whores in their rows of windows. Though they all try to lean out and assert their independence, they are enclosed within a system as lacking in individuality as the army. But all of the groupings, from Adam and Eve to the ordered geometry of the brothel, from the two pugilists fighting to the cycle of thievery and drunkenness, from child to mother to grown man, are structures of order; the only distinction being between natural and unnatural.

The historical context of the painting was, of course, the '45, the Young Pretender's attempt to lead a rebellion for the Stuart cause, which produced panic in London and sent troops marching to the town of Finchley, where they were to group for the march northward to meet the Jacobite army. The picture was painted, however, in 1749 or 50, nearly five years later and so is of a 'historical' subject.[32] In 1748 Fielding's *Tom Jones* had also been 'historical' in that it used as background the time of the '45. But for Fielding the '45 was a metaphor for the clash between the false ideal of order and stability in the Jacobite's absolute monarchy and the relatively disorderly but very English parliamentary system of government. Absolute and limited (constitutional) monarchies represent the same oppositions that appear on the level of character in the contrasts between a theoretical (hypocritical) paragon and a 'mixed character' like Tom himself, or between law (or justice) and mercy in

the judgement of such a character. These are the same poles upon which Hogarth constructs his history painting.

The immediate political context was the debate in and out of Parliament in 1749–50 on the Mutiny Bill. Backing the bill were the supporters of the Duke of Cumberland, chief of the armed forces, who deplored the lack of discipline in the British army and lauded the Prussian standards of the Duke. Opposing it were the supporters of Frederick, Prince of Wales, and those who deplored the drill-sergeant Duke's 'Prussianism', his treatment of soldiers 'rather like Germans than Englishmen', and remembered his reputation in the '45 as 'the Butcher'. Hogarth dedicated the engraving of *The March to Finchley* (published January 1751) 'To his MAIESTY the KING of PRUSSIA and Encourager of the Arts and Sciences!'—which, however, could be taken either as an ironic reference to Frederick the Great, whose soldiers' dicipline was proverbial; or as a straight reference to Frederick's real encouragement of the arts as opposed to George II's notorious indifference (and in this sense praise of the English Frederick, Prince of Wales, who was an encourager of the arts in England).

The ambiguity is only partly due to Hogarth's prudence and desire to hold the largest possible audience, cutting across political and ideological grounds. He was basically interested in the comedy of the contrasting values. But a general theme of his maturity is also the contrast that resolves itself into parallelism. Natural versus stereotyped actions, or heat versus cold, fire versus liquid, night versus day, shadow versus sunlight, married life versus single-promiscuity, ranks versus disorder, all prove finally to amount to different forms of the same thing. Hogarth's most modern insight was that everything is structured; every thought or act or gesture has its own invisible stereotype. He was comically aware of the paradox of freedom and stereotype in his own Line of Beauty once it was formulated in his treatise, *The Analysis of Beauty*.

An animal emblem in the lower right corner sums up *The March to Finchley*: as the manacled dogs epitomize the situation of *Marriage à la Mode*, the baby chicks separated from their mother inform us of the fragmentation that takes place in wartime and in life in general. It also indicates the off-centre quality that characterizes the Hogarthian painting, and a few years later the kind of novel developed by Laurence Sterne in *Tristram Shandy* (1759–67): the battle, which ought to be the subject but isn't, the literally minor detail which carries the meaning of the whole, and the work which is all 'digression'. The subject we would expect from the title and from conventions of painting, like the life of Tristram, is off somewhere in the far distance—the army marching to war; whereas what we see in the foreground is the troops *not* marching to Finchley. No hero but only a group of people drawing ever further apart, each a chicken without its hen; and yet with the unit of the group, the column of troops, house of whores, or brood of chicks, as norm.

A viewer is not far off the mark to sense proverbial wisdom in these images:

sayings about soldiers filling their knapsacks with hens, hens without their broods, or even (looking at the central group) 'no man can serve two masters'. In the late 1740s the stereotype painting, the 'battle scene' or 'troops marching to battle', begins to be replaced by the commonplace adage as the structure in Hogarth's works. This is the period when he moves toward simpler, more popular forms, when he develops the potentials of the broadside, the penny print, the stark blockprint, and finally the signboard.

The Four Stages of Cruelty (1751, Plates 118–122) illustrates a platitude: one must reap as one sows. But in presenting or illustrating it, Hogarth reinterprets its meaning, projecting a vision of men as victims and perpetrators of cruelty, distinguishable only as they are dominated or themselves able to dominate others. Even in Plate 1 there is the gleeful anticipation of Tom Nero's turn-about fate by the boy drawing the gallows labelled 'Nero' on the wall—the same glee shown by his captors in 3 and by his dissectors in 4. The 'St Giles' on his sleeve in 1, showing him to be a charity boy of that parish, relates him to a slum section and the church wardens who are *not* supervising him: he is himself a victim of society as the dog is of his cruelty. In 2 Nero himself, as well as the poor horse, is a victim of the miserly barristers, who have hired his hack for the cheapest shilling fare to Westminster— and it is he, not they, who is about to be reported. Indeed, the possibility is left open whether the young man is taking Nero's name for the cruelty to the horse or for the accident to the carriage. If animals are victimized by cruel humans, humans are habitually—and not merely ultimately—victimized by barristers and (in 4) physicians, the professional groups to whom tradition attributes the most callous self-interest.

However simple in appearance, the four plates are, like those of *Industry and Idleness* (1747),[33] densely interrelated: the 'good man' (the Samaritan in his latest incarnation), for instance, appears in each plate (though I am not sure that he is distinguishable from the other 'good men' in 3); the rill of blood or viscera from the victim in 1, 2, and 3 becomes the length of entrail being removed from Nero in 4; and the dog is tortured in 1 and returns to lick Nero's heart in 4, while the bird's eye being burnt out with a wire becomes Nero's eye being gouged out by his dissector. The rope is still around Nero's neck, perhaps another recollection of the plight of the dog he tortures in 1, and even the bones that serve as legs of the cauldron in which his bones are boiled recall the bone tied to another dog's tail. In each plate the movement or gesture of the weapons is from the upper left down toward the lower right of the plate; this is reinforced by the downward slant of the shadow in 1, the collapsed coach in 2, the pointing arms in 3, and the pointer and disgorging entrails in 4. And if our eye follows this line, at the lower right corner in each case we find the equivalent of the chicks and the pond in *The March to Finchley*: a dog having a bone tied to his tail, a dead sheep, the dead girl friend, and the bucket of guts, with the dog going at the victim's heart. If the dogs as victim and revenger are connected as the beginning and end of a cycle, the lamb and the girl are juxtaposed, in the

centre of this chiastic structure, as the most innocent and so most vulnerable of creatures.

For the structure is circular. In 4 the 'good man' is shown pointing to the skeleton of Field the highwayman (as if to say: Spare Tom Nero's body from the ultimate end, a monument of shame like this displayed skeleton), and Field in turn is pointing at the skeleton of another highwayman Macleane, who points back, returning the viewer's eye to the 'good man'. This diminished circle reflects the larger circle created by the entire series. The closed but round wall of the dissecting theatre brings it to consummation. In the first three plates we might have hoped to escape down the roads and alleys that lead into the distance. But we progress through the plates only to end where we began, in a circular movement, trapped in a circular room, with the same dramatis personae, the same gestures, the same rill of viscera.

After the oppressive closures of *Marriage à la Mode*, in *Industry and Idleness* and the popular prints the ratio is reversed and the outdoors becomes a dangerous (though free) space, very like that in *The Enraged Musician*: to be safe and dull you retire like the Musician into an enclosure, while outside are the vigorous noise-makers or the fragmented crowd of *Finchley*. Deep fissures of irony run through the opposing of safe-indoor Industrious Apprentice and free-unsafe-outdoor Idle Apprentice, and these anxieties appear again in *Finchley*. That nothing geometrical can contain the human is one message the picture offers, but also expressed are feelings of anxiety as the husband and wife turn into the grenadier with two wives and the unattached soldiers with many shifting whores. Here the people within geo-metrical enclosures are the whores, and in *Beer Street* and *Gin Lane* (1751, Plates 116, 117) they are the pawnbrokers. The outdoors is capable of freedom and expansiveness, as in *Beer Street* (where illusions of country life are still being painted in frames, now on signboards), or of terror and death as in *Gin Lane*. The spaces are, of course, different, the street a wider open area than the lane. But indoors has never been good—whenever one chooses it one has made a mistake, whether it crushes one, as it did the Harlot and Rake, acting as a place of escape which proves confine-ment, or becomes a place of safe seclusion as with the Poet, Musician, and the Industrious Apprentice.

In the works of the 1750s and 60s there no longer seems to be much distinction; in *Election* 1, *The Cockpit* and *The Reward of Cruelty* (with their circular interiors), and *Enthusiasm Delineated*, the outdoors with its unconcealed savagery has simply moved inside to be contained (and not quite contained) by the rules of an election, a game, or a religion (see Plates 106, 127, 122, 135).

Looking ahead to the remainder of Hogarth's career, we see that almost all of these works (with only the three or four exceptions I have mentioned) are outdoor scenes. This does not mean that Hogarth has escaped from the shadow of the prison; nor does it mean that the prison has moved outdoors. After dealing with the disturb-ing ambiguities of Industry and Idleness, of Goodchild and Idle (success as pro-tective enclosure, failure as license in an unprotected state of nature), Hogarth

found that the problem of prisons had changed its terms. The dangers of freedom, of an outdoors without closed perspectives, have struck him more forcibly. These tend to become scenes of riot, chaotic actions without any ordering structure to contain adequately the energies of people who were milling happily about in *The Four Times of Day*. Once past the first scene of the *Election* the people are out and *around* the architectural structures, in some cases trying to tear them down. Freedom is terrifying—as terrifying finally as confinement: that is what Hogarth has learned by the turning-point of the popular prints, and it pursues him to the end, to the empty unclosed landscape that stretches across *Tailpiece: The Bathos*—quite plainly unclosed by the architectural structures that merely frame the expiring Father Time (1764, Plate 137).

8. The 'Election' and the Oil Sketches

The popular prints show how closely linked the painting and print have by now become. If in the earlier work the prints proved the intricacy of readable structure, they now show the powerful effect of simplification and expressive form that leads logically to the large woodcuts for *The Four Stages of Cruelty* (Plates 118–122), which Hogarth drew himself in detail for J. Bell to cut, changing proportions from the engravings (as in *Cruelty in Perfection*), enlarging and simplifying parts (the bat, the lantern), removing the man's head on the left, the face immediately to the left of Tom Nero, and the topiary tree at the far right. Here the prints have come into their own as aesthetic objects, partly because they are making a single, powerful impact which is not qualified or complicated by other meanings.

They are pure image, the printmaker's equivalent of the marvellous oil sketches Hogarth was producing during the 1740s and 50s, which stopped several stages short of finish and thus produced a representation reduced to simple, basic shapes and planes and colour relationships. These (see p. 35 and Plates 105, 123, 124) were the studies in form, freed from the usual demands the eighteenth century put on its painters to finish (as opposed to complete) their representations, that stand as the documentation behind the theoretical statements and diagrams of *The Analysis of Beauty*, Hogarth's one sustained attempt to put on paper the assumptions behind his art.

With these experiments and the *Analysis* behind him, Hogarth returns in the *Election* paintings (probably finished 1753–4, Plates 106–115) to a complexity as great as in the *Rake's Progress* but subordinated to a simple dominant pattern. Everything we have seen about Hogarth comes to final fruition in these four paintings.

I am not sure that the painted equivalent of the woodcut, the signboard, is not Hogarth's ultimate model: model in the sense of a structure upon whose strengths he draws rather than one whose inappropriateness or unfittingness he dissects. 'I must confess I am no great artist,' wrote Dryden; 'but'—thinking of his subject, the

wretched Earl of Shaftesbury—'sign-post painting will serve the turn to remember a friend by.'[34] Simple, traditional English directness was the quality Hogarth sought, and the signboard was the most indigenous manifestation of art available to an artist of the second half of the eighteenth century—a graphic equivalent to the ballads, epitaphs, and popular songs that were being resurrected by poets seeking deeper roots in sincerity and authenticity than were to be found in Renaissance and classical sources.

It is a pity that none of the signs Hogarth concocted and/or painted for his burlesque Signpainters' Exhibition of 1762 have survived.[35] But as early as the second *Election* painting a large signboard dominates the scene, giving a simplified image of the whole, enough 'to remember a friend by'. (The final, powerful simplification was the scrawl of stick-figures on the wall in *The Invasion*, plate 1, and, to judge by stories, the graffiti Hogarth loved to study on the walls of London buildings.)[36] The painting of *The Election* is no longer different from the print but an intensification of it: indeed, for once the print itself seems irrelevant (it regresses to Hogarth's engraving style of the 1740s). The *alla prima* style has now become a bold poster- or stencil-like application of paint, analogous to the gouged white areas of the woodcut.

To take only *Chairing the Member*, the colour is now made up of large areas of pale blue, grey, green, and ochre, with a few spots of bright red, blue, and white that do not assume important shapes themselves but draw the eye to them. They neither contradict nor embody but highlight the large formal twist that is the picture's basic structure. This begins as the general twist made by the similar (but reversed) shapes of the candidate projected one way and the swine another, hinged, so to speak, on the twisted body of the bruiser in the white shirt and continued in the reverse twist of the bear-keeping bruiser in the foreground, and so outward 'turning and turning in the widening gyre' to his bear that is out of control, and to a whole series of falcons who cannot hear their falconers—the embodiment of the painting's message about the human quotient in the orderly electoral process.

The chaired member is formally the centre because he is the apex of the twist, but also because his greyish wig in shape and colour parallels the goose flying above him, and is bracketed between the white of the goose and the white shirt of the bruiser beneath him. The touch of red in the cushion of his chair finishes the matter. The red of one chair-bearer's headscarf draws attention to another significant group, and so on. If the eye does not altogether come to rest it is because it is studying ramifications of the central torque. If the shape of the member's wig and face connect him with the goose, the shape and neutral colour of his body connect him with the swine beneath him: one going toward the right, the other toward the left, both falling.

The viewer does not, I think, lose touch with the allusions: not only the art-historical ones to triumphal processions and battle scenes (Rubens, Lebrun) but the literary, for the goose above alludes to the warning of the Romans of approaching barbarians, and the swine below to the Gadarene swine.[37] As the goose flying overhead parallels the candidate, the swine parallel the madmen (possessed by devils)

chairing him. These sum up both visually and iconographically the sense of madness, falling cities, and subsidence into bestiality.

The colour is less strikingly expressive than in the earlier series, less aimed, we might say, at the passions, and more concerned with defining relationships. Intense bits of colour point up the reading structure not by giving emphasis to the object itself but by drawing the eye to objects near by or by suggesting parallels with other objects. For the *Election* paintings are a final complex statement of colour and form concerned not with a narrative and a lone protagonist but with the unit of the group, the electorate—the equivalent of those engravings of the same years that portray gamesters at a cock-fight and fanatics at a Methodist chapel.

Besides containing the echoes of battle scenes, the final scene is a virtual anthology of Biblical verses, adages, and illustrated fables. At the centre is something like 'Pride goeth before a fall,' but each group contributes its proverbial wisdom. The ass eating a thistle illustrates the story that this scene was what caused Crassus, who had never laughed, to laugh. Dryden had produced an analogy that may have been in Hogarth's mind:

> The man who laugh'd but once, to see an ass
> Mumbling to make the crossgrain'd thistles pass,
> Might laugh again to see a jury chaw
> The prickles of unpalatable law.[38]

Hogarth's point is that the ass's expression parallels that of the toppling candidate, but also that this is an epitome of the electoral process, as the chicks looking for their hen was of the military.

Hogarth is now working within the genre of Bruegel's *Old Netherlandish Proverbs*. His first scene, with its echo of a Last Supper and a Judas kiss, elicits 'He that dippeth his hand with me in the dish, the same shall betray me' (Matthew 26: 23)— referring to the poor candidates but also, of course, to the electorate. The second scene, *Canvassing for Votes*, illustrates with its central group 'Let not thy left hand know what thy right hand doeth' (Matthew 6: 3), and the third, the *Polling*, plays upon the contradictory Biblical verses (Old *and* New Testament) that say 'a blind man, or a lame, or he that hath a flat nose' (which Hogarth represented in one state of the engraving) must be kept from approaching the altar with an offering (Leviticus 21: 18) and that 'when thou makest a feast, call the poor, the maimed, the lame, the blind' (Luke 14: 13). And so on: the mosaic is filled in around these with other groups and other adages of greater or lesser applicability.[39]

If, however, with colour and form we can trace Hogarth's arrival at this elaborately organized painting, there is a different kind of composition which is equally characteristic, and may explain the contradictions we saw between the engraved and painted versions of the earlier series. This is the consciously *un*structured picture, beginning with 'Four Groups of Heads' (Plates 56–58) and *Characters and Caricaturas*, which have no reading structure and yet represent an unabashedly multiple

gestalt. The ultimate example among the paintings is the one of *Hogarth's Servants* (p. 36), which shows the radical form taken by his belief in nature over art. The several faces are merely recorded, with a conscious lack of composition in their arrangement. In fact, as Lawrence Gowing has shrewdly remarked, there is a pointed defiance of compositional devices and all attention is directed to the character and structure of each sitter's physiognomy or expression.[40] This had been the immediate source of Hogarth's interest in portraiture in the 1730s, and the interest in pure nature, or pure information, must be kept in mind against the simple expressive shapes of *Sigismunda* and the last histories.

One form this took was the compartmentalization of information, which led from the modern moral subjects with their reading structures into the separation of elements into diagram, broken into separate boxes as in the plates for *The Analysis of Beauty* (Plates 125, 126); and reappeared in *The Five Orders of Periwigs* (Plate 132), a parody of scientific or archaeological or antiquarian organization in a random series of wigs and faces glimpsed at the Coronation in 1761.

But in the *Analysis* plates Hogarth uses diagram to get at truths about natural forms that are related to those in his oil sketches: compare the pure forms and colours of *The Wedding Dance* with the engraving used for the second plate accompanying the *Analysis* (p. 35 and Plate 126), in which the truths demonstrated by paint are rendered in diagram, compartmentalized around the fully 'finished' representation in the centre. Here are the concerns of Hogarth's career as an artist: the search for the essential forms in human action, the love of building with pure paint on canvas for its own sake, and the finishing of these into a complex representation packed with coded messages.

Throughout his career Hogarth developed in the engravings his interest in the meaning of objects and actions and in the paintings his interest in their essential shapes. A painting like *The Wedding Dance* shows the curious tension that sometimes exists in a single picture between the coherence of the total composition as a study in essences and the autonomy of certain separate figures or objects quite independent of it. The chandelier and the window are finished representations; everything else is sketched in with the lowest possible level of denotation. The different degrees of finish bear no relation to the emphasis of the picture: the chandelier and window are simply two things that momentarily interested Hogarth; but the remainder of the painting shows his primary interest in the spatial problem of the total composition and the basic structure of such a scene.

There is, of course, a tendency in all of Hogarth's paintings to fragment: this begins as part of his theme, or it is a theme that evolves from a constitutional inability or refusal to relate parts into unities. Shape was used by Hogarth to relate objects in a scene but also to isolate them, make them slightly out of place in their context. The tendency of his theme as well as his own predilection was toward painting still life and milieu, and even in as uninteresting a painting as *Sir Francis Dashwood at his Devotions* (1742–6, Private Collection) there are wonderful

details of a nude and a basket of fruit. The houses in the background of *Election* 3, the bowl of fruit in *Lord Hervey and his Friends* (Plate 66), and the various objects in *Marriage à la Mode* are rendered with a truth that does not always extend to the painting as a whole. A detail like the girls leaning over the balcony in *Election* 2 (Plate 108) shows Hogarth's painting extended into the forms of Fragonard, while details of *Garrick as Richard III* (Plate 88) anticipate Goya's brushwork. Great as it is, *The March to Finchley* as a whole is not up to the image of the kissing couple, all interlocking arms and faces (Plate 103).

The tendency to want to understand the total composition but also certain separate parts of it was probably most successfully resolved in the early paintings-for-engravings, in which significant details emerged from the neutral background and from the vague, sketchy shapes that filled out the canvas. It is only with *Marriage à la Mode*, whose painting he wished to be as much a finished intellectual construction as the engraving, that he covers the whole canvas with uniform care. The result is that the colours at the same time serve their own purpose, which is a separate one from the meaning of the engravings, and in some cases contrary to their meaning. The questionable success of this attempt was one factor that led Hogarth to abandon paint altogether in *Industry and Idleness* and the popular prints, and to focus the love of paint on a series of oil sketches.

Hogarth's early work, from *Hudibras* through *Marriage à la Mode*, all takes off from the mind of an engraver: in the final product, the engraving, all sense of *making*, of execution, is secondary because what one sees is only a copy, identical with thousands of others. His later work, then, follows from the mind of a painter. We might see Hogarth's artistic progress as from product to process, from the modern moral subject to the act of painting, or (to use Levi-Strauss's terms) from contingency of event to contingency of execution. Contingency of execution, very weakly felt in the engravings, increasingly receives the emphasis in the paintings, where one senses the struggle with the medium, in fact its priority to event or occasion; and this can itself be 'the external pretext or occasion of the picture'.[41]

So it is that we end with the most famous of all Hogarth's paintings. What, at the other extreme from the prints with their readable structure, is one to say about *The Shrimp Girl* (Plate 124)? Like the heads of *Hogarth's Servants* it is simply a head-and-shoulders outside of any context save the simplest identification of occupation. It is a freer, because less finished, and larger experiment in the direction Hogarth took in his simplest portraits; it is close to the pure form he explored in other oil sketches. It may seem irreverent to refer to this masterpiece as a *jeu d'esprit*, but that is exactly what it was in Hogarth's own terms. The main line of his development was the comic history-paintings or modern moral subjects; even though, in our twentieth-century eyes, the great Hogarth may be the Hogarth of the oil sketches, that was not true in his own day. This is not to say that he dismissed these sketches—as I have suggested, they represented another kind of work, another exemplification of his ideas. The very fact that they expressed his most unofficial, free, and uncon-

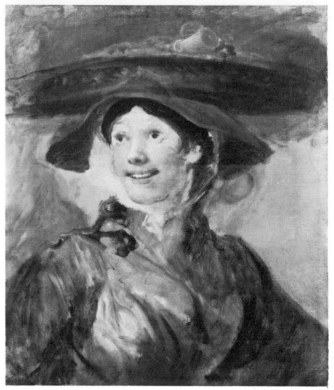

Figure 27. Frans Hals (1580?–1666), *Fishergirl*.
Cincinnati Art Museum (Gift of Mary Hanna)

Figure 28. *The Shrimp Girl* (see Plate 124)

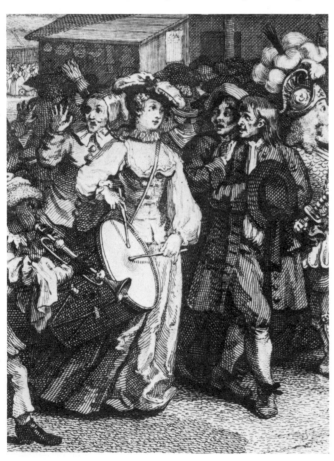

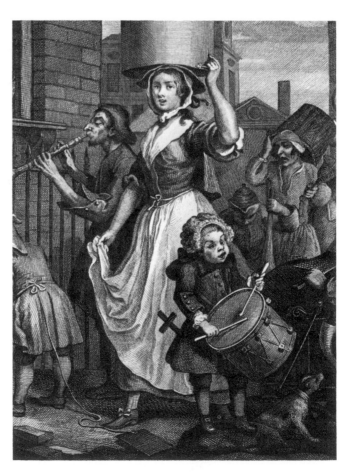

Figure 29. Detail of *Southwark Fair*.
engraving (Plate 48)

Figure 30. Detail of *The Enraged Musician*,
engraving (Plate 65)

scious self is part of their meaning—as was the case with Gainsborough's landscape sketches and paintings in the next generation. The calligraphy of the brushwork expresses not only Hogarth's belief in the Line of Beauty as an essential structure but also his freedom from the restraints of finishing a representation, closing a perspective, exemplifying a moral, or 'preparing a face to meet the faces' of the critic or connoisseur.

There is of course no reading structure in this joyous painting, because denotation is rendered minimal and there is little to detract from the play of the brush and the paint, their form, colour, and texture; but there is *something*. Hogarth is still painting within the assumptions of all his other works. There is the smiling face, barely represented but with pleasantly plebeian features, a mouth open in a smile that may graduate to a fishmonger's cry; just enough denotation to show that this is joy *in nature*, unavailable perhaps (if we put it in the context of the moral works) to more sophisticated and artful girls.

I should add that there was a type of Dutch genre picture in the seventeenth century, popularized by Frans Hals, which showed a fishergirl with a basket of fish on her head. One by Hals, with contemporary copies, has a composition similar to Hogarth's, though extending to a half-length (Figures 27, 28). And indeed a Hals laughing boy or girl is about the only precedent one can think of for Hogarth's remarkable picture.[42] As Seymour Slive has shown of many of the Hals genre paintings, it is often difficult to say whether a scene is pure genre, moralizing genre (Vanitas or Prodigal Son), an allegorical subject (the Five Senses or Four Elements), or a portrait. The fishergirl and fisherboy pictures, for example, may have been reminders of the liberty of the 'natural life' over the servitude of city life;[43] and in any case, in Hogarth's own iconography this is the case of *The Shrimp Girl*. She is one of the healthy, beaming girls he contrasts with, on the one hand, an ordering artistic or mathematical mind like the poet's or musician's and, on the other, a confused, moiling crowd of noise-makers (Figures 29, 30). He sums her up in a well-known passage in *The Analysis of Beauty*:

> Who but a bigot, even to the antiques, will say that he has not seen faces and necks, hands and arms in living women, that even the Grecian Venus doth but coarsely imitate?[44]

Notes to the Introduction

1. In any case, Hogarth would have known the *Recueil Julienne*, the first volume of which appeared in 1726, the last in 1739; from this he may have absorbed many poses and individual figures (for example, the central group in the *Harlot's Progress*, plate 1 from *La Diseuse d'aventure*).

2. Ellis Waterhouse, *Painting in England, 1530 to 1790* (London, 1953), p. 127.

3. John Russell, *Francis Bacon* (London, 1971), p. 173.

4. Edward Young, *Conjectures on Original Composition* (1759), p. 12. This was already a theme of the *Spectator* (e.g., No. 238, 3 December 1711): 'Instead of going out of our own complectional Nature into that of others, 'twere a better and more laudable Industry to improve our own, and instead of

a miserable Copy become a good Original'

5. See Suetonius, *Nero*, XXXVIII, 2; Tacitus, *Annals*, XV, xxxviii-xxxix. For this interpretation of the *Rake* (and some of my remarks in the captions) I am indebted to R. L. S. Cowley's interesting thesis, *An Examination and Interpretation of Narrative Features in 'A Rake's Progress'* (M.A. thesis, Birmingham University, 1972).

6. *The Anxious Object* (New York, 1964), p. 82.

7. *Analysis of Beauty* (1753), ed. Joseph Burke (Oxford, 1955), p. 42.

8. For identification, see Paulson, *Hogarth's Graphic Works*, I, pp. 269–70, 327. Most were originally identified by Lichtenberg (*Hogarth in High Life*, p. 30); and corrected by Martin Davies, *National Gallery Catalogues, The British School* (London, 1959), pp. 49–50.

9. *Meditations on a Hobby Horse* (London, 1963), pp. 127–42.

10. Cf. the *Rake's Progress*: the gridiron behind the Rake in 7 and the picture of St Lawrence himself in 8. See below, caption to Plates 40–41.

11. See *Spectator* No. 315 on the operation of two levels of reader-perception in epic (history painting) allegory.

12. Davies identified it as Domenichino's *St Agnes* (*British School*, p. 49).

13. It is quite possible, judging by his other references to Jews, that Hogarth intended to connect the Israelites with the merchant class.

14. See Earl R. Wasserman, 'The Limits of Allusion in *The Rape of the Lock*', *Journal of English and Germanic Philology*, LXV (1966), 425–44.

15. Suzi Gablik, *Magritte* (London, 1970), p. 63. These remarks on colour first appeared in *Burlington Magazine*, CXIV (1972), 74–5. They should be supplemented by the general comments I made on the problem of painting v. print in *Hogarth : His Life, Art, and Times*, I, pp. 405–16.

16. Vertue, III, 41. There is an unbridgeable gulf between the earliest authenticated Hogarths, the first *Beggar's Opera* (Plate 10) and the Iveagh *Falstaff*, and the supposedly earlier paintings, *The Doctor's Visit* and *The Carpenter's Yard* (Tate), attributed by Lawrence Gowing. See the *Burlington Magazine* article referred to above in note 15.

17. See Rudolf Arnheim, *Art and Visual Perception* (Berkeley and Los Angeles, 1966), chap. VII.

18. Dryden, 'Parallel of Painting and Poetry', in *Works*, ed. Scott, XVII, 326.

19. See Dean Tolle Mace, 'Ut Pictura Poesis: Dryden, Poussin and the Parallel of Poetry and Painting in the Seventeenth Century', in *Encounters*, ed. John Dixon Hunt (London, 1971), pp. 62–3.

20. Fry, *Vision and Design* (London, 1920; 1940 ed.), p. 36.

21. 'Hogarth's Narrative Method in Practice and Theory', in *England in the Restoration and Early Eighteenth Century*, ed. H. T. Swedenberg, Jr. (Los Angeles, 1972), p. 163.

22. King, 'Translator's Preface' to *The Toast* (1736); Fielding, *The Champion*, 10 June 1740.

23. *An Essay on Criticism* (1728), p. 94.

24. Richardson published his *Explanatory Notes and Remarks on Milton's 'Paradise Lost'* in 1734 and prior to publication read parts aloud to the Slaughter's group of artists, which included Hogarth. He argued that the episode of Satan, Sin and Death was the 'Allegory which contains the Main of the poem.'

25. See his *Notion of the Historical Draught or Tablature of the Judgment of Hercules* (1713). See *Hogarth : His Life, Art and Times*, I, pp. 271–7.

26. This material was first published in the *Burlington Magazine*, CXIV (1972), 233–7, in reply to Clovis Whitfield, *Burlington Magazine*, CXIII (1971), 210–14.

27. John Ireland, *Hogarth Illustrated* (1806), II, 92; John Nichols, *Biographical Anecdotes of William Hogarth* (1782 ed.), p. 451.

28. *Autobiographical Notes*, in *Analysis*, pp. 216–18.

29. Antal in *Hogarth and his Place in European Art* (London, 1962) and Wark in the essay referred to above in note 21.

30. *Analysis*, pp. 123–4, 182.

30a. Levey, *Art and Architecture of the Eighteenth Century in France* (London, 1973), p. 17.

31. *The Night Watch* had hung prominently in the Amsterdam City Hall since 1715, and Hogarth may have travelled that far north in 1748. There were also copies, including at least one of the uncropped state, which is closer to Hogarth's composition. The painting's fame had been transmitted through Hoogstraten's *Inleyding tot de Hooge Schoole de Schilder-Konst* (1678), p. 176, and Baldinucci's *Cominciamento e progresso dell' arte dell'intagliare in rame* (1682), p. 78; see Seymour Slive, *Rembrandt and his Critics, 1630–1730* (The Hague, 1953), pp. 6–7, 97–8. For the copies, see Neil MacLaren, *National Gallery Catalogues, The Dutch School* (London, 1960), pp. 343–9.

32. See Rouquet, *Description du Tableau de Mr. Hogarth, qui représente la march des gardes à leur ren-des-vous de Finchley, dans leur route en Ecosse* ([n.d.] *c.* 1750, p. 3), for the parallelism with conventional history painting.

33. For the operation of *Industry and Idleness*, see Paulson, *Emblem and Expression: Meaning in English Art of the Eighteenth Century* (London, 1975), chap. 5.

34. 'Epistle to the Whigs', *The Medal* (1682).

35. For descriptions of these, see *A Catalogue of the original Paintings, Busts, carved Figures, &c. &c. &c. Now Exhibiting, by the Society of Sign-Painters . . .* (1762), quoted in Paulson, *Hogarth: His Life, Art and Times*, II, 347–51.

36. See Philip Dawes' account, quoted in Nichols and Steevens, *Genuine Works of William Hogarth*, I, 416–19.

37. Matthew 8: 28–34, Mark 5: 1–14, and Luke 8: 26–34; cf. Paulson, *Hogarth: His Life, Art and Times*, II, 201.

38. Dryden, *Medal*, II. 145–8. The story is told in *Aesop's Fables* and Cicero's *De Finibus*, V. 30.92; also by St Jerome, Erasmus in his *Adagia* and *Praise of Folly*, etc.

39. The Biblical verses for 1 and 2 were suggested by Edgar Wind, '"Borrowed Attitudes" in Reynolds and Hogarth', *Journal of the Warburg Institute*, II (1938–9), 184.

40. Gowing, Tate Hogarth catalogue, no. 197.

41. Levi-Strauss, *The Savage Mind* (Chicago, 1968), p. 27. The third contingency, of purpose, is extrinsic but posterior to the act of creation; and this is strongly felt in the prints, and remains so to the end; but is very weak in the paintings. It is strongest perhaps in *Marriage à la Mode*, where one even senses that the paintings were prepared for the use of engravers, so as to make a particular impression upon the public, but weak in Hogarth's subsequent paintings and weakest in the oil sketches.

42. See Seymour Slive, *Frans Hals* (London, 1970), pl. 116; a copy, fig. 142; see also figs. 143–5. Jacob Cats makes the liberty-seashore, servitude-city contrast in a poem, 'On the Image of a Fisher Girl from Scheveningen Carrying a Basket with Fish on her Head' (see Julius Held and Donald Posner, *Seventeenth and Eighteenth-Century Art* [New York, 1972], p. 227).

43. Slive, *Frans Hals*, I, 144.

44. *Analysis*, p. 82.

Biographical Summary

1697 November 10: Born in Bartholomew Close, Smithfield, son of Richard Hogarth (b. 1663 or 64), a Latin teacher and scholar, and Anne Gibbons. Richard had come to London from the north, was lodging in the house of John Gibbons in Bartholomew Close by 1690, and married Gibbons's daughter Anne (b. 1661) on November 4, 1690. Four short-lived children were born before William. November 28: Baptized in the Dissenters' Register, St Bartholomew the Great.

1699 November 23: Sister Mary born.

1701 The family moves to St John's Street, a few blocks north of Smithfield. October 31: Sister Anne born.

1703 Move to St John's Gate, where R. H. opens a Latin-speaking coffee house. Another short-lived child born (and another in 1705).

1707 or 08. Coffee house fails and R. H. is confined to the Fleet Prison for debt. By the end of 1708 the family is living in Black and White Court, within the Rules, an area outside the Fleet Prison where privileged prisoners were allowed to live, with Mrs. H. selling home remedies.

1712 September 9: R. H. freed from the Fleet by act of amnesty; the family settles in Long Lane.

1713 February 2: W. H. apprenticed to Ellis Gamble, silver engraver, of the Merchant Taylors' Company, in Blue Cross Street, Leicester Fields.

1718 May 11: R. H. dies.

1720 April 23: W. H. issues a shopcard, opens business as engraver at his mother's house in Long Lane.
October 20: Subscribes to Vanderbank's Academy in Peter's Court, St Martin's Lane. Studies under John Vanderbank and Louis Cheron.

1721 Responds to South Sea Bubble scandal (autumn 1720) with engraved satire, *The South Sea Scheme*; probably executes most of the small *Hudibras* illustrations, copies of an older set of illustrations.

1722–23 Probably works on plates for La Motraye's *Travels* and Gildon's *New Metamorphosis*. Around this time meets the history painter Sir James Thornhill (b. 1675 or 76), decorator of Greenwich Hospital's great hall and St Paul's cupola, and recently knighted and appointed Serjeant Painter; visits Thornhill's free art academy in his house in Covent Garden and meets his daughter Jane.

1724 February 18: Publishes *Bad Taste of the Town* (*Masquerades and Operas*), an engraved satire on Thornhill's enemies; promptly pirated. La Motraye's *Travels* published.
March 4: *New Metamorphosis* published.
May–December: Publishes satiric prints (*Principal Inhabitants of the Moon*, *Mystery of Masonry*, *Lottery*, and *Just View of the British Stage*) and *South Sea Scheme* republished with *Lottery*.
Probably concludes contract with the printseller Philip Overton for twelve large

Hudibras plates, doubtless on the strength of *Bad Taste of the Town*; begins plates for Beaver's *Roman Military Punishments*; and lives now in Little Newport Street.

1725 Works on plates for *Hudibras*, La Calprenède's *Cassandra* (publ. September 1), and perhaps (for Jacob Tonson) *Paradise Lost* (unpubl.). Plates for Beaver published. Mary and Anne H. open a milliner's shop in Long Walk, near the Cloisters, St Bartholomew's Hospital. Publishes a satire on William Kent (*Kent's Altarpiece*, September) and finishes nine of the *Hudibras* plates by end of November.

1726 February: Twelve large *Hudibras* plates published. At the end of April the edition of *Hudibras* with W. H.'s sixteen small illustrations appears (see above, 1721). Undertakes to illustrate *Don Quixote* for Tonson (abandoned by end of 1727). During the summer the Opposition to Walpole's Ministry was formed, *Gulliver's Travels* published (October 28) and the *Craftsman* begun (December 5). December 24: Publishes *Cunicularii*, a satire on the 'Rabbit Woman', Mary Toft; on the 27th, *The Punishment of Lemuel Gulliver*, an anti-Walpole satire and gloss on Gulliver's 'Voyage to the Lilliputians'.

1727 More political satires: *Masquerade Ticket*, *Henry VIII and Anne Boleyn*; frontispieces for books. W. H. turns seriously to oil painting.
December 20: Commissioned to paint a tapestry cartoon for Joshua Morris.

1728 January: Engraves the Great Seal on the Walpole Salver.
29: Gay's *Beggar's Opera* opens and W. H. paints first of several versions; probably also *Falstaff examining Recruits*, based on a production of *Henry IV, Pt. II*.
May 28: Successful suit for payment against Morris, who had rejected the tapestry cartoon.

1729 February: House of Commons investigation of Fleet Prison begins. W. H. present in March at confrontation of Committee, warden, and prisoners; makes small oil sketch, followed by paintings of the scene.
23: Elopes with Jane Thornhill; they live in Little Piazza, Covent Garden, near the Thornhills. By end of year has finished large *Beggar's Opera* (Mellon

Collection) and is painting many conversation pieces (e.g., *Woodes Rogers Family*) including comic variants (e.g., *Christening* and *Denunciation*).

1730 Continues to turn out conversations (*Wollaston Family*, etc.); collaborates with Thornhill on group of *The House of Commons*. Paints first sketch for *Harlot's Progress*, followed by the whole six.
March: Mary and Anne H. move their shop to Little Britain, and W. H. engraves their shopcard-announcement.

1731 W. H. and Jane move into the Thornhill house, Great Piazza, Covent Garden; Thornhill is making copies of the Raphael Cartoons.
January: Makes list of conversations commissioned but not yet delivered. In February Joseph Mitchell's *Three Poetical Epistles* (one to W. H.) published, and in March the subscription for the *Harlot's Progress* initiated, with *Boys Peeping at Nature* as subscription ticket. Searches for engravers but eventually does the job himself. Frontispiece to Henry Fielding's *Tragedy of Tragedies* published.

1732 April 10: *Harlot* engravings delivered to subscribers; followed by piracies and these by an authorized cheap set to catch the pirates' market. On the 22nd W. H. is commissioned to paint *A Scene from 'The Conquest of Mexico'*, which includes a portrait of the Duke of Cumberland.
May 29: With cronies goes on a five-day peregrination to Kent.
December 18: Subscription announced for *Midnight Modern Conversation* engraving.
Paints *Cholmondeley Family* and other conversations, and *Duke of Cumberland*. Thornhill retires, resigns Serjeant Paintership in favour of son John.

1733 March: *Midnight Modern Conversation* delivered; once again piracies follow.
10: Sarah Malcolm, a notorious murderess, executed; W. H. paints her in her cell and publishes etching. Commissioned to paint a conversation of the royal family; paints two *modelli*.
October: Receives permission to paint the marriage of Anne, Princess Royal, but is thwarted by William Kent and his patron, the Duke of Grafton; and the royal conversation also discontinued. By now the Hogarths have settled at the Golden Head, Leicester Fields. On the 9th W. H. announces the subscription for *Southwark Fair* and *Rake's Progress*.

1734 Year devoted to *Rake* and perhaps one or two conversations.
February: Offers to paint murals over the staircase of St Bartholomew's Hospital.
May 4: Death of Thornhill.
July 25: W. H. elected a Governor of St Bartholomew's Hospital.

1735 January 11: Founding member of Sublime Society of Beefsteaks, with John Rich and other theatrical folk.
February: At his instigation an Engravers' Copyright Act is drafted and introduced in the House of Commons. *Rake* engravings finished but held till the Act is passed.
May 15: Act receives royal assent. On the 10th W. H.'s mother, who was living with Anne and Mary, dies.
June 3: Piracy of *Rake* published.
26: Act goes into effect and the *Rake* is delivered.
October: Founds St Martin's Lane Academy, a guild for professional artists and a school for young artists. Also during this year has started work on *Pool of Bethesda* for St Bartholomew's Hospital.

1736 Paints *Distressed Poet*, undertakes *Strolling Actresses dressing in a Barn* and *Four Times of Day*.
April: *Pool of Bethesda* finished and in place at St Bartholomew's Hospital. Publishes engravings of *Sleeping Congregation* (October) and the indoors *Before* and *After* (December).

1737 Publishes *Scholars at a Lecture* (January) and *Distressed Poet* and *Company of Undertakers* (March).
May: Announces subscription for *Strolling Actresses* and *Four Times of Day* engravings; devotes rest of the year to the engraving.
June 2: *Daily Post* attacks Thornhill's paintings, and a week later W. H. replies with his 'Britophil' essay defending Thornhill and English art.
July: *Good Samaritan* painting finished and installed in St Bartholomew's.
December: J. B. Van Loo arrives from Paris to set up as portraitist, driving some English artists out of business.

1738 W. H. paints *Lord Hervey and his Friends*.
May: *Strolling Actresses* and *Four Times*

delivered. W. H. paints *Western* and *Strode* families.

1738–42. Beginning as a response to Van Loo's success, W. H. paints a great many single portraits; the first ambitious full-length portrait is of Thomas Coram, founder of the Foundling Hospital.

1739 October 17: Serves as a Founding Governor of the Foundling Hospital.

1740 May: Presents *Captain Coram* portrait to the Foundling.
June 25: Subscribes £120 to Foundling.
November: Asked by Samuel Richardson to illustrate *Pamela*; nothing comes of it.

1741 March 25: Present at the opening of the Foundling Hospital.
November: Publishes *Enraged Musician*. On the 20th Mary H. dies.

1742 Paints *Graham Children* and probably *Mackinnon Children*; *Taste in High Life* for his patroness Mary Edwards; and undertakes *Marriage à la Mode*. In February Fielding publishes *Joseph Andrews*, with its prefatory comments on W. H.'s 'comic history-painting'. Anne H. moves in with the Hogarths in Leicester Fields.

1743 April: Begins subscription for *Marriage à la Mode*.
May: Travels to Paris to hire engravers. About this time paints large *Bishop Hoadly* (Tate version).

1744 March 31: Proclamation of war with France delays engraving of *Marriage à la Mode*. Portrait of Archbishop Herring.

1745 February 28: Auction of comic history paintings (with *Battle of the Pictures* as ticket for admission).
May: *Marriage à la Mode* delivered; the paintings subsequently exhibited by Cock the auctioneer but not sold. About this time W. H. is completing his *Self-Portrait with Pug (Trump)*, painting *Garrick as Richard III*, and undertaking the paintings that have been called his *Happy Marriage* cycle. In the autumn paints *Captain Lord George Graham in his Cabin*; in October finishes *Garrick as Richard III*.

1746 April: André Rouquet's *Lettres de Monsieur** (a commentary on W. H.'s prints for the continental public) published.
July: *Garrick as Richard III* engraving

published; vacation with Garrick at Hoadly's house at Alresford.
August: Visits St Albans to sketch the rebel leader Lord Lovat. Etching published on the 25th.
Autumn-winter: Paints *Moses brought to Pharaoh's Daughter*. And on December 31 announces his project at the Foundling Governors' meeting for artists to donate paintings to hang in the new building.

1747 February: *Moses* and other Foundling paintings (by Hayman, Highmore, etc.) finished.
April: *Moses*, etc. unveiled in the Court Room of the new Foundling Hospital.
June: a General Election announced on the 18th and W. H.'s satire, *Stage Coach* or *Country Inn Yard*, on the 26th.
October 15: Twelve plates of *Industry and Idleness* published.
November 5: First annual dinner of the Foundling artists.
December: Receives commission from the Benchers of Lincoln's Inn for a history painting *(Paul before Felix)*.

1748 June: *Paul before Felix* finished (but not yet hung).
August: Undertakes a trip (with cronies) to Paris; is expelled from Calais for 'spying'; returns to London and paints *Gate of Calais* on the subject.

1749 March: Publishes engravings of *Gate of Calais* and *Self-Portrait with Pug (Gulielmus Hogarth)*.
September: Buys country house in Chiswick.

1750 Paints *March to Finchley*, probably in 1749–50.
March: Begins subscription for engraving of *March to Finchley*.
April 30: Sells the painting by lottery, which is won by the Foundling Hospital. In the summer or autumn Rouquet's *Description du Tableau de [March to Finchley]* is published.

1751 January 3: Engravings of *Finchley* delivered.
February: Publishes popular prints, *Beer Street* and *Gin Lane*, *The Four Stages of Cruelty* (synchronized with publication of Fielding's *Enquiry into the late Increase of Robbers*). Woodcuts commissioned but not used.
April: Participates with Benjamin Wilson in the Rembrandt etching hoax satire on gullible collectors).

May 9: Publishes his own Rembrandt satire, *Paul before Felix Burlesqued*, and announces subscription for engravings of *Paul* and *Moses brought to Pharaoh's Daughter*.

June 7: Auctions the paintings of *Marriage à la Mode*; receives only £120, and angrily takes down his shop sign.

1752 February: *Paul* and *Moses* engravings delivered after a successful subscription. 26: Elected Governor of Bethlehem Hospital (had been consulted about an altarpiece in February 1751). March: Announces subscription for his art treatise, *The Analysis of Beauty*.

1752–53 Writes his *Analysis*.

1753 March: Illustrative plates for the *Analysis* issued to subscribers. (On 22nd a test case for the Engravers' Act loses in the Court of Chancery, revealing a loophole.) October: A group of artists attempts to set up a new public academy and secede from the St Martin's Lane Academy; W. H. counter-attacks, prepares a written response.

November: *Analysis* published. Personal attacks on W. H. and the *Analysis* follow in December in the newspapers; the reviews are mostly favourable, and a German edition is published. The last part of the year probably spent by W. H. on the *Election* paintings.

1754 March 19: Announces subscription for *An Election Entertainment*, and for *Four Prints of an Election*. In April the Society of Arts is founded and the General Election (to which W. H. alludes in his prints) takes place.

1755 February 22: *An Election Entertainment* published; other plates delayed. An anonymous *Plan for an Academy* is published, heralding further agitation for a state art academy. The artists (but not W. H., who opposes the plan) approach the Dilettanti Society for support, but negotiations have collapsed by December. May: W. H. commissioned to paint a triptych altarpiece for St Mary Redcliffe, Bristol.

October: Rouquet's *State of the Arts in England* (written with help from W. H.) published (the French edition, 1754). December: W. H. elected member of the Society of Arts; judges one of their drawing competitions.

1756 By this year W. H. has become an inspector of the Foundling's boarded children in Chiswick. He attends Society of Arts meetings and on January 28 addresses the Society, recommending changes of their art policies. March: In response to the fears of French Invasion, publishes *The Invasion*, a pair of recruiting prints. August: St Mary's altarpiece finished. Has begun to paint single portraits again, notably one of John Pine.

1757 Drops the Society of Arts, dissatisfied with its treatment of the arts of painting and engraving. In February the engraving of *Election 2* is finished but not published; on the 24th an advertisement announces W. H. will paint no more histories, only portraits. March: Invited to join Imperial Academy of Augsburg. April: Paints *Garrick and his Wife*. June: Appointed Serjeant Painter to the King; paints *Hogarth painting the Comic Muse*. September: Death of John Thornhill, brother-in-law and ex-Serjeant Painter. November 12: Death of Lady Thornhill, who had been living with the Hogarths. Sometime this year Lord Charlemont approaches W. H. about painting one last comic history for him (*Lady's Last Stake*).

1758 March: Last three *Election* plates published; also an engraving of *Hogarth painting the Comic Muse*. April 26: Sir Luke Schaub's sale, at which a *Sigismunda* by 'Correggio' (actually Furini) brings £404 5s. September: Publishes *The Bench*. November: Asked by William Huggins to illustrate his translation of Dante but refuses. In the autumn he paints Huggins's portrait (to match his father's of the 1740s). By now he has more or less finished *The Lady's Last Stake* for Charlemont and has accepted a similar commission from Sir Richard Grosvenor. The subject, chosen by himself: *Sigismunda*.

1759 April: Joseph Warton's *Essay on . . . Pope*, with a criticism of W. H.'s talents as history painter, is published. June: *Sigismunda* is shown to Grosvenor, who demurs. July-August: W. H. writes poem on Grosvenor and *Sigismunda*; finishes *Lady's Last Stake*.

September-October: Reynolds satirizes W. H. in *Idlers* Nos. 76, 79, 82.
December: Publishes *The Cockpit* and adds inscriptions to the prints of *Paul* and *Moses* replying to Warton. He begins the engraving of *Enthusiasm Delineated* and the writing of *An Apology for Painters*, another work on the role of painters in eighteenth-century England.

1760 January: Charlemont pays for *Lady's Last Stake*; W. H. intends to have it engraved but gives up this first attempt.
April: The St Martin's Lane artists exhibit their paintings with the Society of Arts, but W. H. abstains. Draws design for *Tristram Shandy*, vol. I (later in the year for vol. III).
July: Draws frontispiece for Kirby's *Brook Taylor's Perspective*.
October 25: Accession of George III encourages artists to agitate again for an academy; W. H. responds with a *Letter to a Nobleman*, which does not get beyond MS.

1760–61 Illness, probably between April 1760 and March 1761.

1761 February: Exhibits *Sigismunda* at Langford's.
March: Publishes *Time smoking a Picture*; attempts a subscription for *Sigismunda*.
April: Plans a supplement to the *Analysis*; draws frontispiece and tailpiece for the catalogue for the Society of Artists' exhibition. Its members have abandoned the Society of Arts and planned their own exhibition in Spring Gardens; W. H. joins and contributes seven paintings.
May 5: Is painting a portrait of Henry Fox and writing his *Apology for Painters* (interview recorded by Horace Walpole). On the 9th the Artists open their exhibition at Spring Gardens.
September 22: Coronation of King George III; followed in October by Pitt's resignation and Bute's appointment to succeed him as first minister.
November: Publishes *Five Orders of Periwigs*.
December 15: Elected to the committee of the Society of Artists. An Italian edition of the *Analysis* is published.

1762 January: The Cock Lane Ghost and Warton's 2nd edition of his *Essay on . . . Pope*, with apologies to W. H.
March: Satirizes the Cock Lane Ghost, and utilizes the unfinished plate of *Enthusiasm Delineated*, in *Credulity,*

Superstition and Fanaticism.
April 20-May 17: With Bonnell Thornton sponsors a signpainters' exhibition, designed to ridicule the Society of Arts exhibition.
May 17: Society of Artists exhibition opens, but W. H., who seems to have broken off again, is not represented. Some time after April he plans a raffle for the *Election* paintings but is prevented by Garrick's purchase. Draws portraits of Thomas Morell and Fielding for frontispieces.
September 9: Despite warnings from pro-Pitt friends and enemies, W. H. publishes an anti-war satire, *The Times, Plate 1*, which is immediately followed by virulent attacks. On the 16th he calls on John Wilkes, one of his pro-Pitt 'friends', but misses him, and on the 25th Wilkes' *North Briton* No. 17 prints a personal attack. He suffers a serious illness in October and November.

1763 Works on *The Times, Plate 2*, dealing with peace negotiations, but stops after Bute's resignation on April 7.
May 6: Sketches Wilkes at Westminster Hall, where he is being arraigned for publication of seditious matter in the *North Briton*. The print, *John Wilkes, Esq.*, is published on the 21st.
June 30: Charles Churchill publishes his *Epistle to William Hogarth*, an attack.
July: Suffers a paralytic seizure.
August 1: Publishes *The Bruiser*, a reply to Churchill; is writing notes for an autobiography and commentary on his prints.
October 1: Publishes a revision of *The Bruiser*.

1764 January: Makes another attempt at engraving *Sigismunda*.
April: Publishes *Tailpiece: The Bathos*, his last print.
June: Has turned *Sigismunda* over to James Basire to engrave. Receives a letter from Benjamin Franklin ordering a set of prints; too ill to respond.
August 16: Signs will.
September: Too ill to carry on duties as Serjeant Painter; in Chiswick restoring, revising copperplates.
October 25: Returns to Leicester Fields; begins reply to Franklin. Dies during the night.
November 2: Buried at St Nicholas Churchyard, Chiswick.

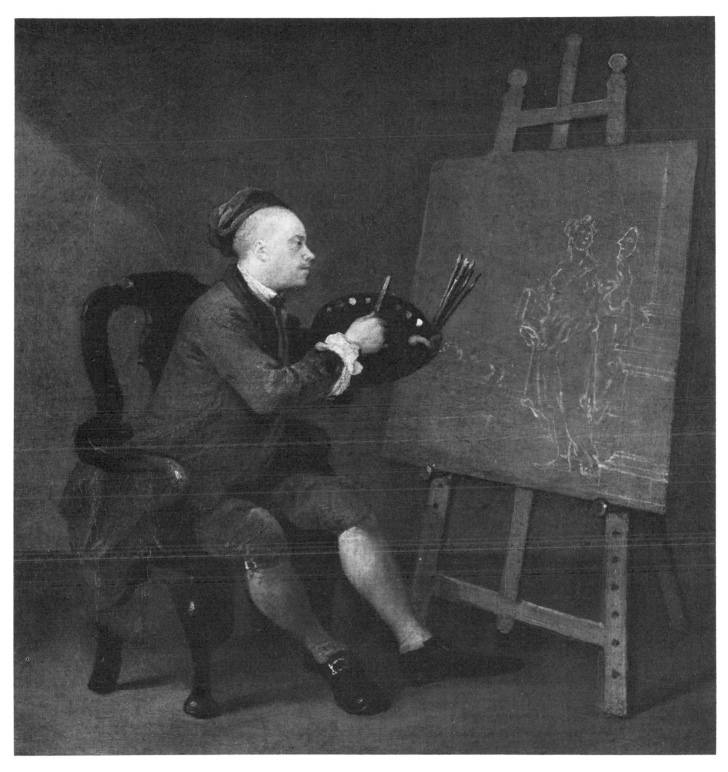

1. *Self-Portrait : The Artist painting the Comic
 Muse. c.*1758. Oil on canvas, $15\frac{1}{2} \times 14\frac{3}{4}$ in.
 London, National Portrait Gallery

Hogarth painted this small *modello* to be engraved
as frontispiece for folios of his engraved works.
The emblematic figure he has drawn on his
canvas-within-the-canvas holds the mask,
ivy-wreath and sandals of Thalia, the Muse of
Comedy; but also the book of Polyhymnia, the
Muse of Rhetoric, ordinarily inscribed 'Suadere'.
This is Hogarth's way of saying that in *his* art
comedy has a moral function.

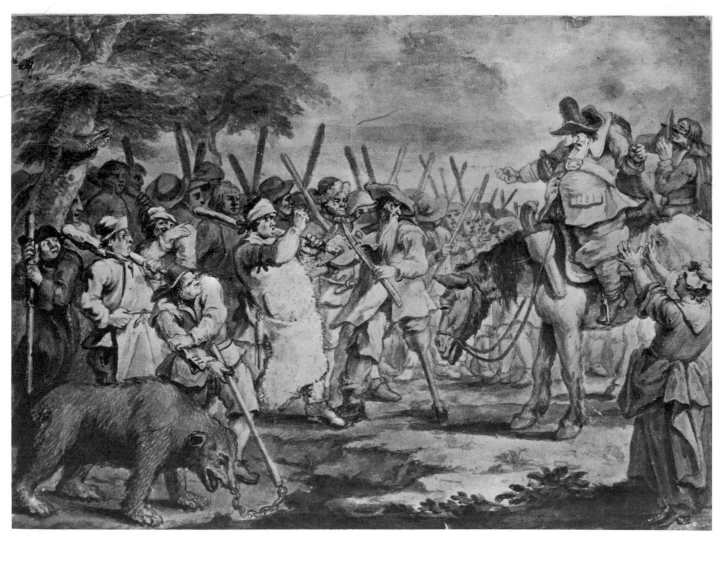

2

3

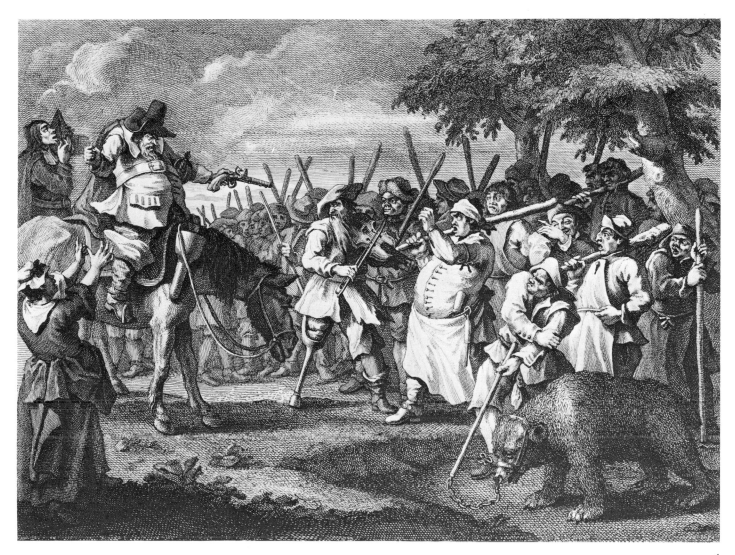

2. *Hudibras' First Adventure*. 1725. Brush drawing
 in grey, $9\frac{1}{2} \times 13\frac{1}{4}$ in. Windsor Castle, Royal
 Library

3. *Hudibras encounters the Skimmington*. 1725. Pen
 with brown ink and grey wash, heightened with
 white on brownish paper, $9\frac{3}{4} \times 17\frac{1}{8}$ in. Windsor
 Castle, Royal Library

4. *Hudibras' First Adventure*. 1726. Engraving,
 $9\frac{1}{16} \times 13$ in. Caption not reproduced. London,
 British Museum

The drawings were made for the engravings—
twelve in all—that Hogarth executed to illustrate
Samuel Butler's *Hudibras* (first published, 1663–78).
Hogarth's accomplishment was to find a visual
equivalent in the heroic compositions of baroque
battle-scenes and triumphal processions for the
mock-heroic diction of Butler's satiric poem. The
heroic shapes depicting rustic clowns are a reflection
of Hudibras' crazy perception; he is a fanatic
Presbyterian on a quixotic quest, and this is the way
he sees himself in his surroundings. The full wash
treatment of *Hudibras' First Adventure* (Plate 2) is
the earliest example of Hogarth's work with paint.

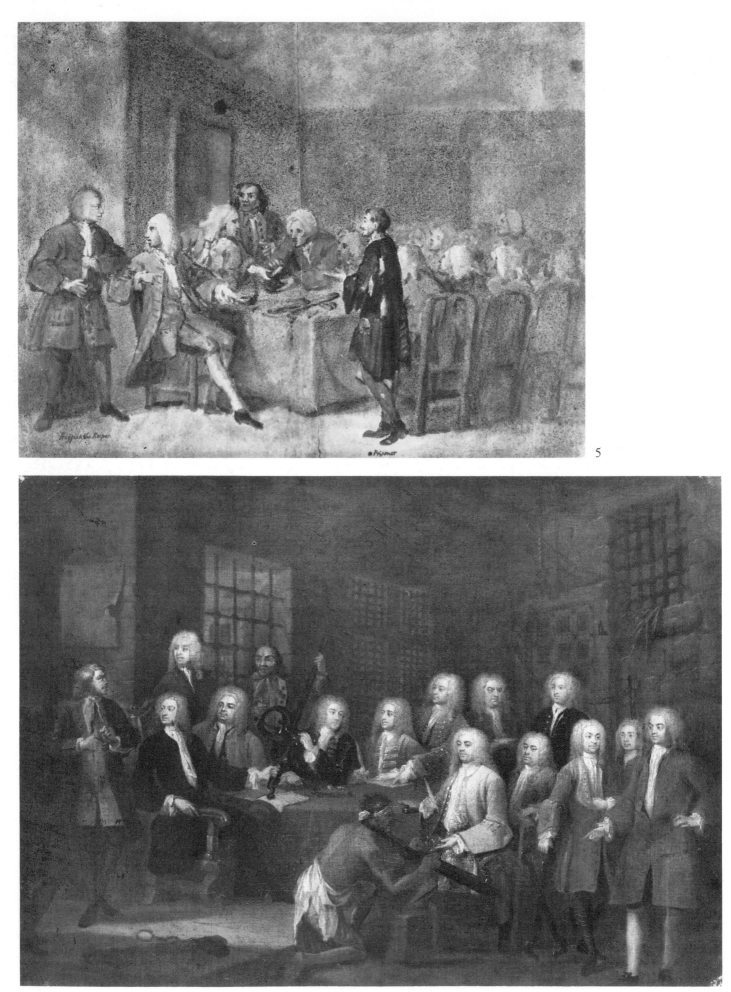

5

6

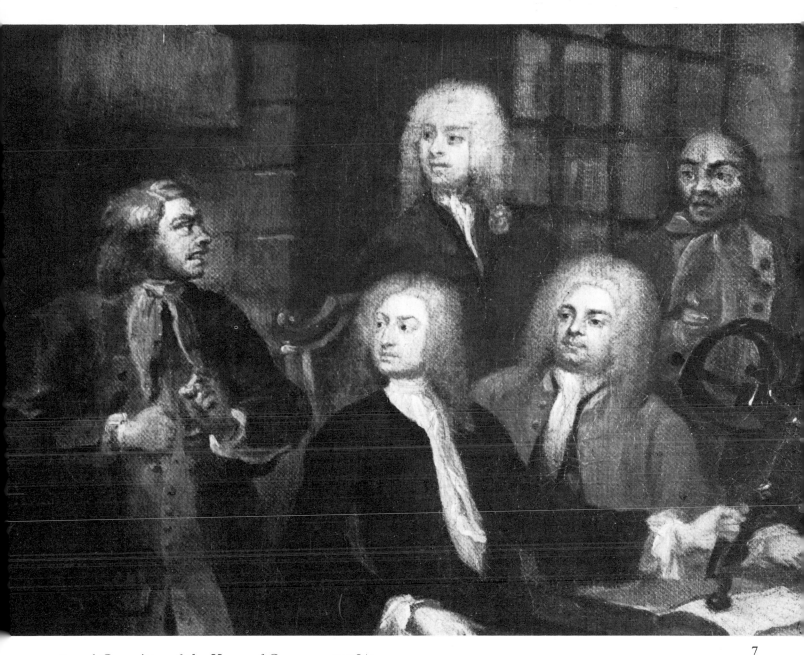

5. *A Committee of the House of Commons.* 1728/9.
Oil sketch on paper, $18\frac{1}{2} \times 23\frac{1}{2}$ in. Cambridge,
Fitzwilliam Museum

6. *A Committee of the House of Commons.* 1728/9.
Oil on canvas, 20×27 in. London, National
Portrait Gallery

7. Detail of Plate 6

A parliamentary committee led by the M.P. James
Oglethorpe uncovered shocking corruption and
cruelty in the treatment of debtors in the Fleet
Prison. These were not criminals but poor
unfortunates like Hogarth's own father, who had
been confined in the Fleet for several years.
Hogarth, who accompanied the committee to one of
its hearings inside the Fleet, made an oil sketch of

the scene (Plate 5), and from this *modello* developed
(on commission) at least two finished paintings. He
shows the warden, Thomas Bambridge, confronted
by one of his prisoners before the assembled
committee. These are among Hogarth's earliest
attempts to paint in oils and produce the group
portraits known as 'conversation pieces'.

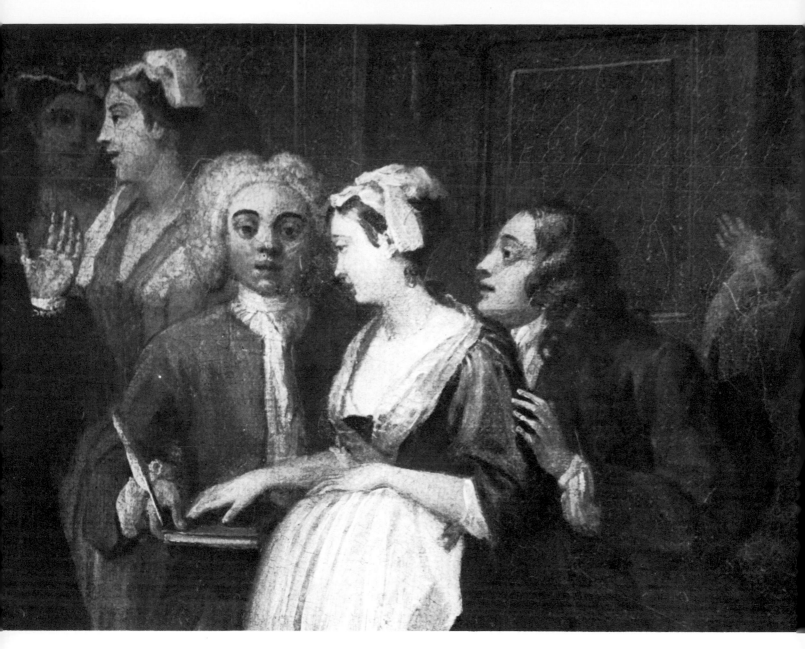

8. Detail of Plate 9

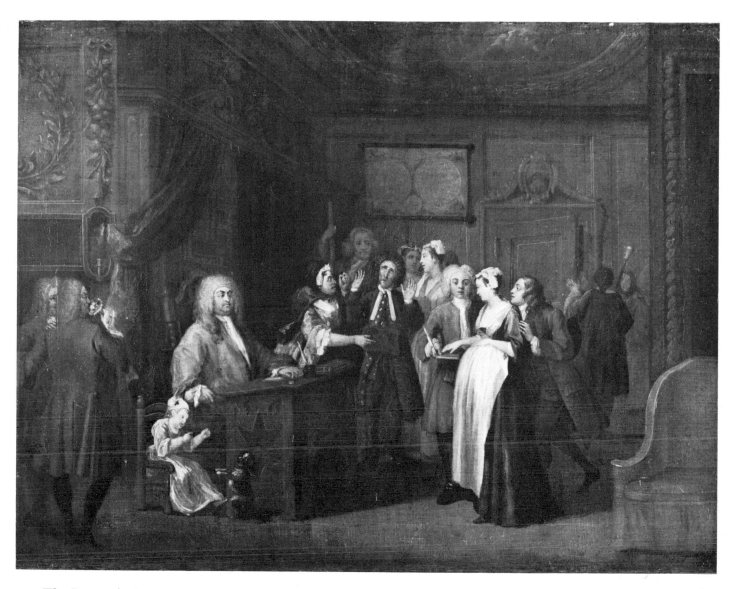

9. *The Denunciation*, or *A Woman swearing a Child to a Grave Citizen*. 1729. Oil on canvas, 19½ × 26 in. Dublin, National Gallery of Ireland

Before he turned to painting, Hogarth's reputation had been based on his engravings of current events, mostly satirical. For him it was an easy transition from a 'conversation piece' which portrayed particular contemporaries in some characteristic activity to a scene in which one or two notorious contemporaries participated in a comic morality. Hogarth was, throughout his career, noted for his ability to catch likenesses, and it is probable that the magistrate in *The Denunciation* was recognized by contemporaries (as Thomas De Veil, who appeared again later in *Night*, Plate 55), and the 'grave citizen' may also have been. The pregnant girl,

swearing the old man is the father of her child while being coached by the real culprit, makes a little scene that is observed (judged) by the pompous magistrate. The grave citizen's wife is offering an immediate response by her threatening gestures, and the supporting figures—ranging from other litigants to detached spectators (two fops at the left smile knowingly)—respond as well. The baby teaching its spaniel to sit up is a Hogarthian parallel to the pregnant girl and her lover.

The prototype for such scenes as this and *A Committee of the House of Commons* (Plates 5, 6) was *The Beggar's Opera*, Hogarth's earliest known oil

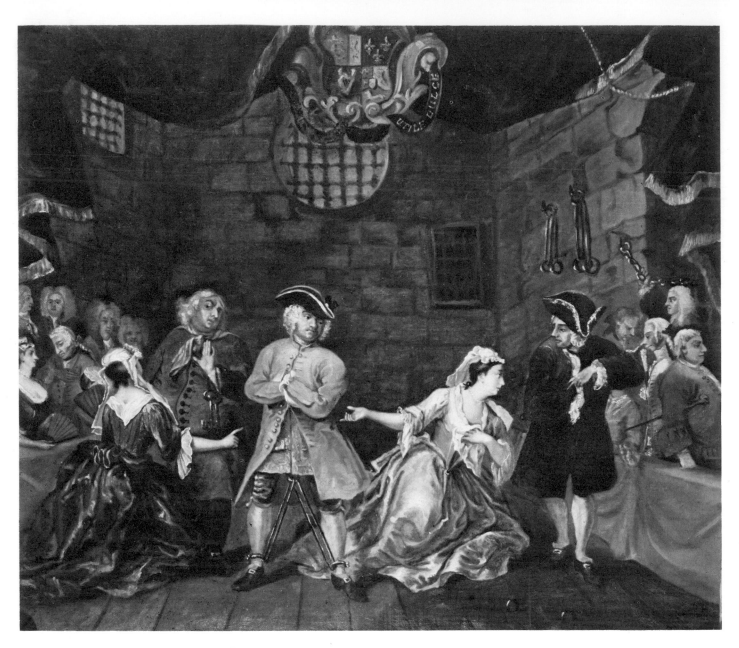

10. *The Beggar's Opera.* 1728. Oil on canvas,
18 × 21 in. Farmington, Connecticut, The
Lewis Walpole Library

painting (Plate 10). John Gay's *Beggar's Opera* was
first produced in January 1728. Hogarth made a
pencil sketch on the spot (Royal Library) and in
quick succession produced at least five versions,
culminating in Plate 11 (repeated a bit later in the
version which is now in the Tate Gallery). The play
offered Hogarth a paradigm that influenced his
'modern moral subjects' (as he called them) of the
1730s: a scene involving actors (Lavinia Fenton,
Thomas Walker) playing roles of characters (Polly
Peachum, Captain Macheath) who themselves are
playing socially determined roles (romance heroine,
gentleman of the road); and these are being
applauded by spectators, here shown on the stage
itself, who are the models for the sort of behaviour
they are witnessing, and are themselves involved in

the same sort of subterfuges. In the final version
(Plate 11) Lavinia-Polly's right arm is turned away
from Macheath and her gaze is directed away from
her stage lover to her real lover, the Duke of Bolton,
the man at the far right who is returning her gaze
(in which role?).
The relationship between actors and spectators is
underlined by Hogarth's use of colour. The black
suit and hat of Peachum are connected by colour,
texture, and cut with that of a standing figure among
the audience on the stage (John Rich, the theatre
manager, or Gay according to early identifications);
the brown suit of Lockit connects him with another
man in the audience (Sir Robert Fagg), and the
salmon suit of Macheath with another (Major
Paunceford). The moral correspondence between

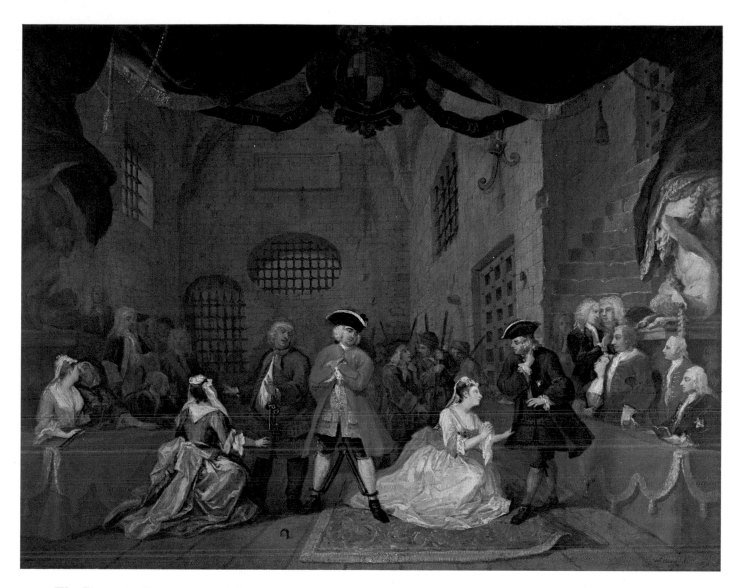

11. *The Beggar's Opera.* 1729. Oil on canvas, $23\frac{3}{4} \times 28\frac{7}{8}$ in. Collection of Mr and Mrs Paul Mellon

the two groups is further emphasized by the inscription over the stage, 'Velute in speculum' (even as in a mirror).

The scene portrayed, III.11, is in Newgate Prison and shows Macheath in the pose of the Choice of Hercules ('Which way shall I turn me?' he sings, '—How can I decide?') between his two 'wives', Lucy Lockit and Polly Peachum, who in turn are beseeching their fathers (respectively warden and fence-thief-taker) to save Macheath from the gallows. Mr Peachum and Polly are shown in what would have been recognized by connoisseurs as a *Noli me tangere* pose, struck by Peachum, who sees himself in relation to Polly (who, disobedient, has married Macheath) as a Christ in relation to Mary Magdalen, saying, 'Don't touch *me*, I'm all spirit.'

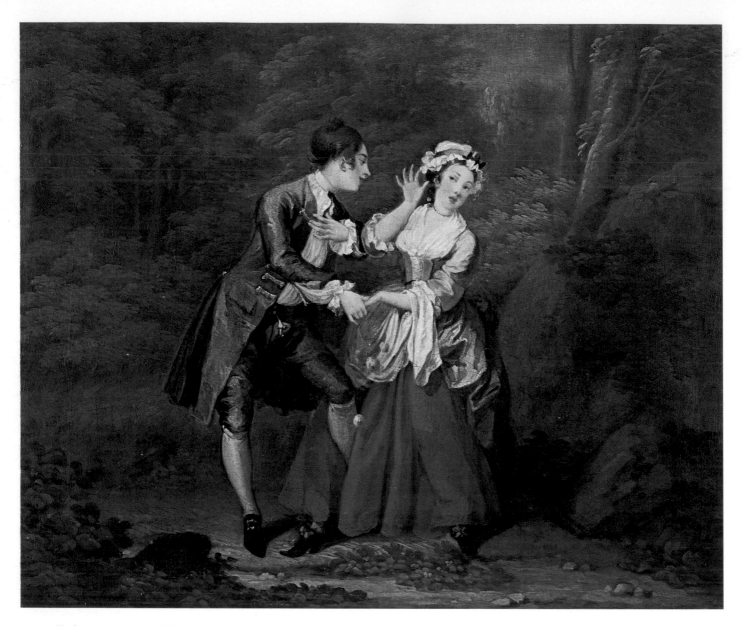

12. *Before*. 1730–1. Oil on canvas, 14 × 17½ in.
Cambridge, Fitzwilliam Museum

In *Before* and *After* Hogarth juxtaposes two actions at different points in time and produces for the first time the sort of graphic narrative that came to be associated with his name. The relationship basic to all his narratives is the simple one of action followed by consequence, but in this pair only the contrast matters. (For commentary, see the Introduction, pp. 43–4.) The pair also represents another aspect of Hogarth's reputation: for the sort of picture a libertine lord might commission to hang in his cabinet. A few years later Hogarth produced another, indoor version of *Before* and *After* on commission (J. Paul Getty Collection), in which the simple reliance on expression has been replaced by a reliance on symbolic objects to tell the story (a copy of Rochester's poems next to *The Practice of Piety* in the lady's dresser drawer; a picture on the wall of a rocket taking off). It is significant for an understanding of the relationship between Hogarth's paintings and his engraved moral works that he only engraved the second, 'readable' version of *Before* and *After*.

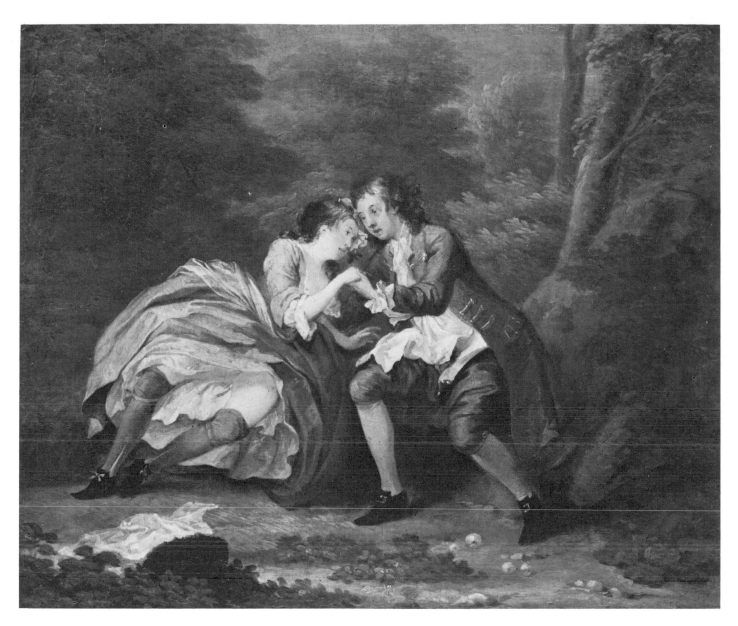

13. *After*. 1730–1. Oil on canvas, 14 × 17½ in.
Cambridge, Fitzwilliam Museum

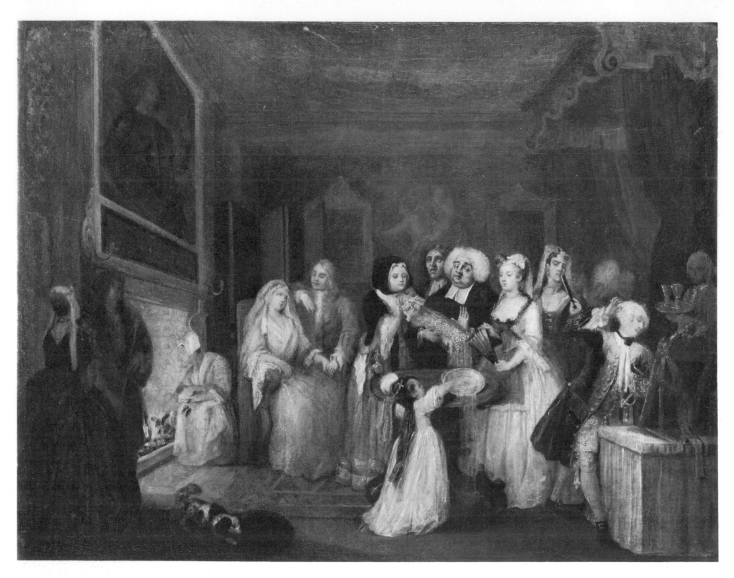

14. *The Christening,* or *Orator Henley Christening a Child.* 1729? Oil on canvas, $19\frac{1}{2} \times 24\frac{3}{4}$ in.
Private Collection

Another comic 'conversation piece' painted around the same time as *The Denunciation, The Christening* looks ahead to the first scene of *Marriage à la Mode* (Plate 75). The clergyman (Orator Henley or some other well-known contemporary) is officiating at a christening, while the child's mother at one far end of the room relaxes in a chair being friendly with a young man, and the child's father is seated at the

other end regarding himself in a mirror. An older child is tipping the baptismal font, and the clergyman's eyes are wandering from the object of his duty, anticipating the clergymen in *A Harlot's Progress,* 6, and *The Sleeping Congregation* (Plates 28, 59). The midwife and the clerk stand behind the clergyman; the prudish-looking woman with fan to mouth appears again in *Morning* (Plate 52). As usual

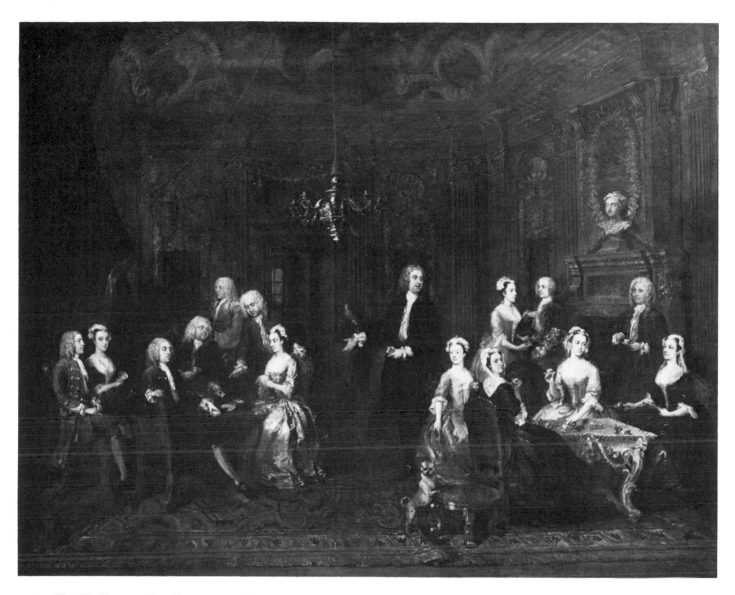

15. *The Wollaston Family*. 1730. Oil on canvas,
39 × 49 in. Leicester Museums and Art Gallery
(on loan)

in these scenes, the lap-dog is gnawing the rose on a
hat fallen from one of the participants.

Only the dog carries over into the sober version of a
conversation picture, *The Wollaston Family*. Unlike
the picture of a central scene being responded to by
spectators, the composition here is built of two
triangular groups of guests (the apex of one the
mirror on the back wall and of the other the bust

atop the fireplace), with the host dominating the
scene and connecting them, as if he were
introducing one to the other. The host is William
Wollaston, of Finborough Hall, Suffolk, with his
wife Elizabeth and various relatives and friends,
probably together in their town house in St James's
Square.

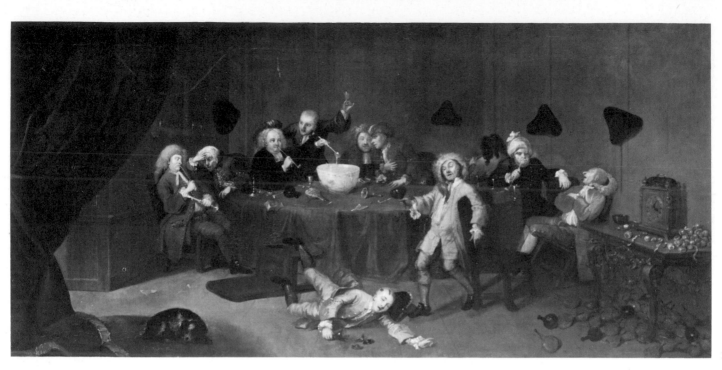

16

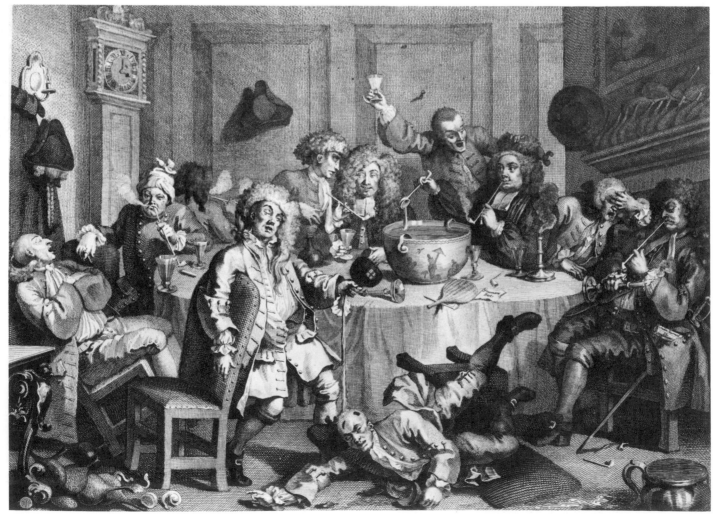

17

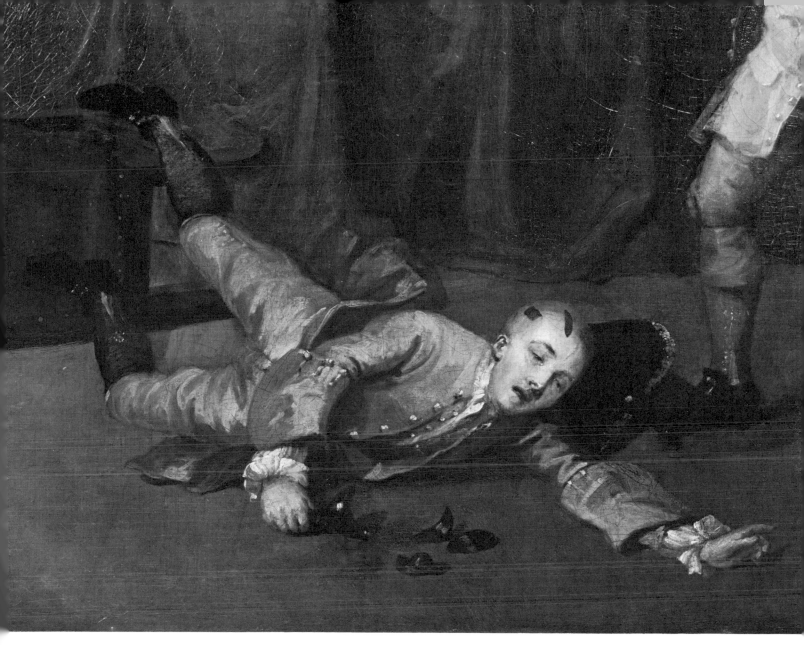

16. *A Midnight Modern Conversation*. 1730–1?
Oil on canvas, 31 × 64 in. Collection of Mr and
Mrs Paul Mellon

17. *A Midnight Modern Conversation*. 1732/3.
Engraving, 12 $\frac{15}{16}$ × 18 in. Caption not
reproduced. London, British Museum

18. Detail of Plate 16

One of the group portraits related to the
conversation picture was the drinking scene. It is
never obvious at what point such a convivial group
becomes an admonitory emblem. Hogarth's general
conception derives from a painting like Jordaens'
Bean-Feast (Vienna, Kunsthistorisches Museum),
with its inscription, 'No one is more like a madman
than a drunk'; Hogarth takes over the vomiting man
straight from Jordaens. When he engraved the
subject at the end of 1732 (as usual, the reverse of
the painting), he brought the figures up close to fill
the picture space and added the ironic title '*A
Midnight Modern Conversation*' which sets the
figures in perspective. Though an anatomy of
drunkenness (or non-'conversation'), it is no more a
denunciation than Jordaens' scene.

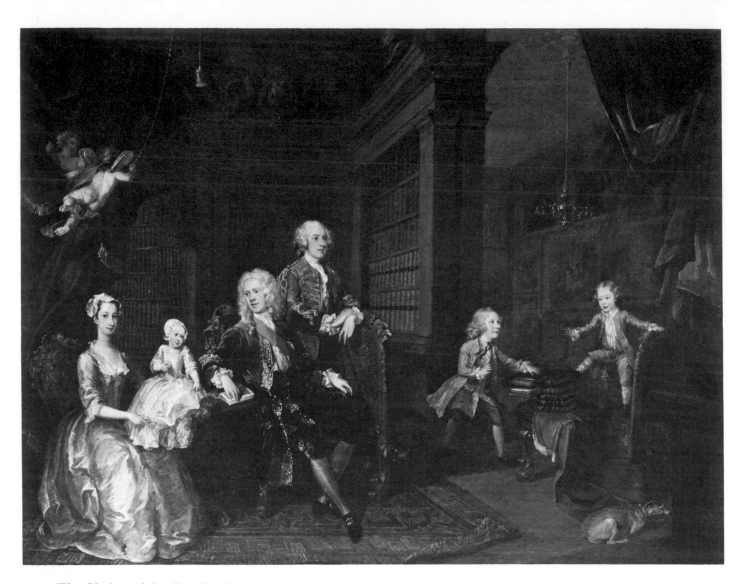

19. *The Cholmondeley Family*. Dated 1732. Oil on
canvas, $28 \times 35\frac{3}{4}$ in. The Marquess of
Cholmondeley

This conversation, again with theatrical curtains
(cf. Plates 15, 16), shows George Cholmondeley,
Viscount Malpas, with his family and his brother
James, who had been created a lieutenant-colonel in
1731. His wife Mary had died abroad at the
beginning of 1732; the angels hovering over her
head are iconographical representations of her dead
children. She barely touches the baby seated on the
table. Indeed, she is painted in a different
convention from the other members of the family;
her stiff, slightly out-of-scale figure is one end of a
spectrum extending to the husband and the older
members of the family, who are alive and yet staid,
to the right of the picture where the terribly alive
young boys balance their spectral mother and
siblings.

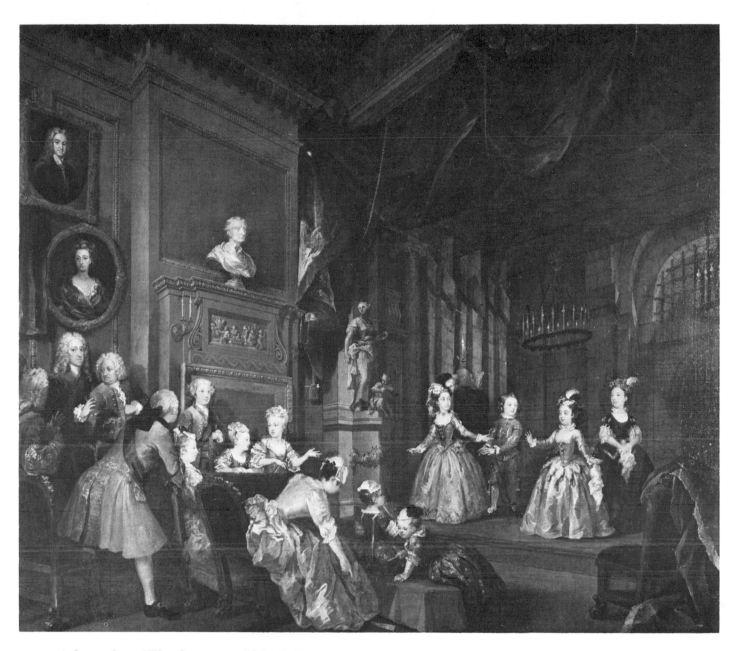

20. *A Scene from 'The Conquest of Mexico'*. 1732.
Oil on canvas, $51\frac{1}{2} \times 57\frac{3}{4}$ in. Lady Teresa
Agnew

One of Hogarth's few brushes with the royal family, this conversation includes Prince William, Duke of Cumberland (standing against the fireplace; cf. Plate 84), and his sisters the Princesses Mary and Louisa. The picture was commissioned by John Conduitt, Master of the Mint, whose daughter Kitty plays Alibech in the children's production of Dryden's *Conquest of Mexico*. Very close to the *Beggar's Opera* scene, this one shows act IV, scene 4, where Cortez is 'discovered bound' and the rivals for his love, Cydaria and Almeria, debate over him as Lucy and Polly did over Macheath (similarly fettered). The great Cortez and the two princesses in Dryden's heroic play are shown being acted by children, with their parents as spectators.

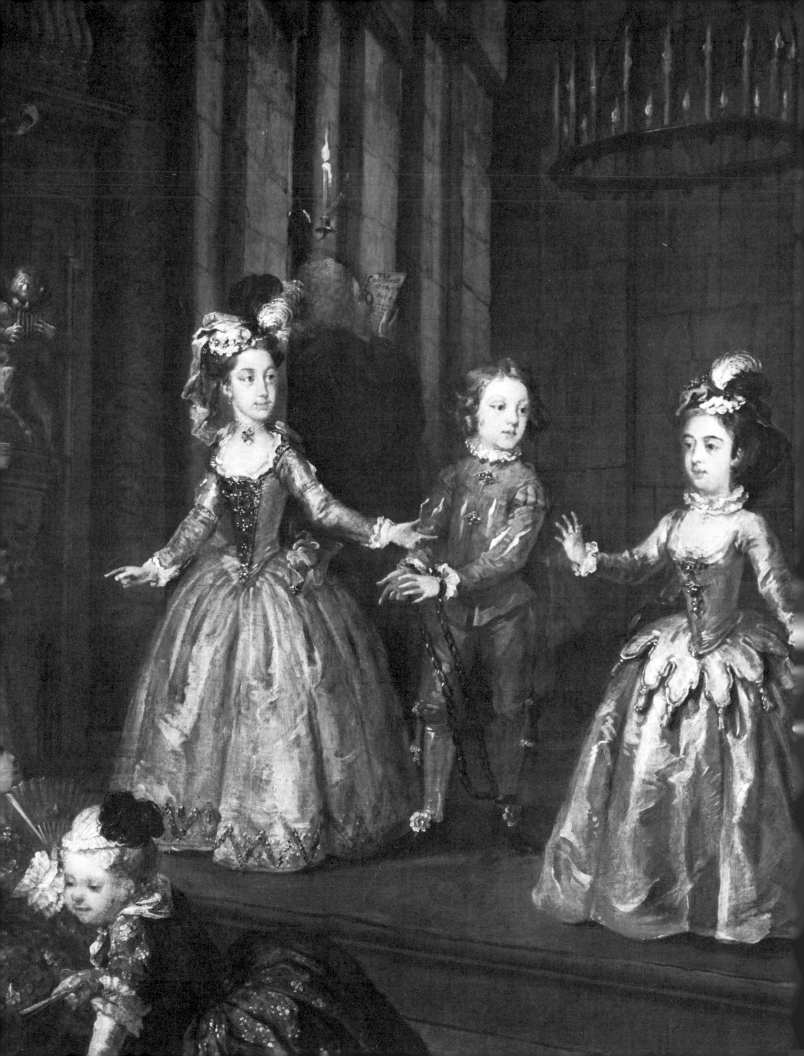

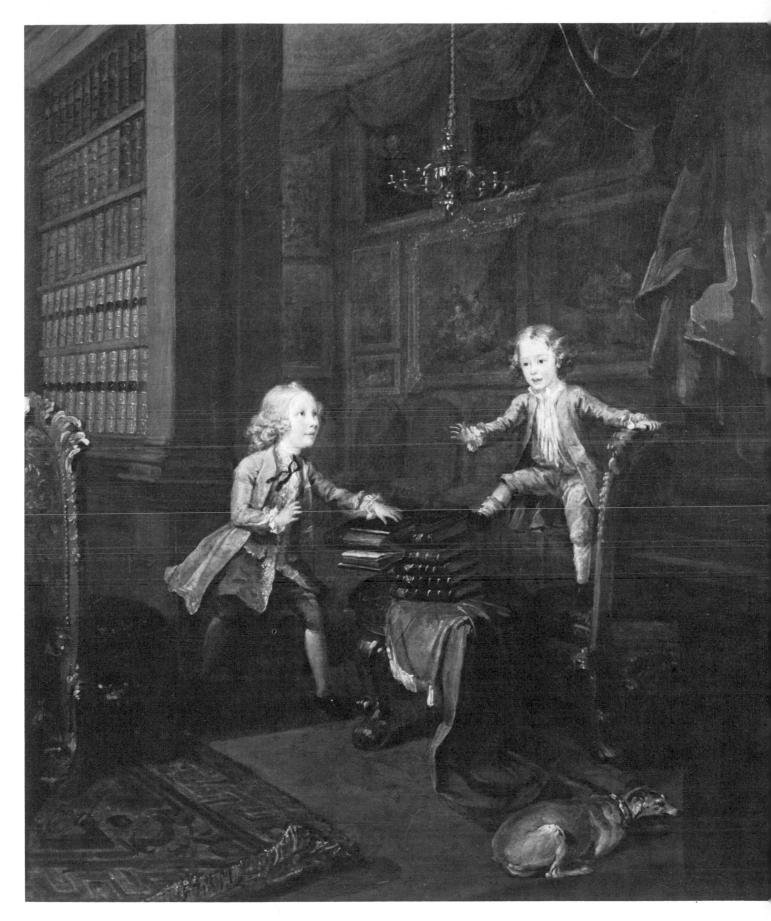

22. Detail of Plate 19

21. Detail of Plate 20

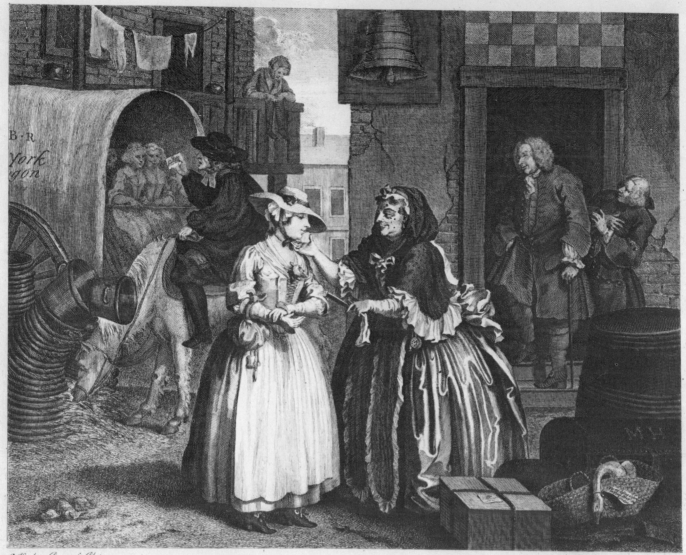

A Harlots Progress Plate 1.

W.ᵗ Hogarth inv.ᵗ pinx.ᵗ et sculp.ᵗ

23. *A Harlot's Progress*, Plate 1. 1732. Engravings, approx. 11½ × 14½ in. each. London, British Museum

Based on paintings (destroyed in 1755), these engravings established Hogarth's reputation as the great master of graphic expression and morality. The engravings are almost books, communicating by a graphic sign system that includes words. The inscriptions tell us that the young girl from the north ('York [Wa]gon') has come to London expecting to be met by her 'Lofing Cosen in Tems Stret'; she *should* be shepherded by the clergyman whose back is turned as he reads the address of the Bishop of London, the dispenser of ecclesiastic preferment. Among the Londoners who *are* paying her attention, contemporaries would have recognized the elderly woman as a notorious bawd and the man in the doorway as a convicted (but pardoned) rapist of young girls secured for him by hired bawds at coach stations. The animal symbolism suggests parallels between the horse toppling a pile of buckets in order to fill its stomach and the place-hungry clergyman; and the heads of the dead goose and the young girl.

The second scene establishes the young girl's error. 'Aping', 'masking', and role-playing are present verbally and metaphorically. On the level of story

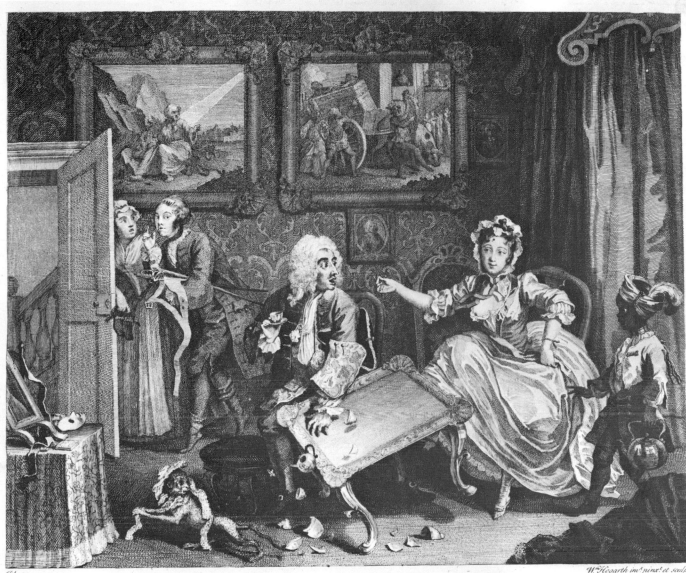

24. *A Harlot's Progress*, Plate 2

the mask alludes to a masquerade as the place where she has met her new lover: she has *worn* this mask. The monkey too is a fashionable acquisition, like the black slave-boy, made either by her or by the Jewish merchant whose mistress she is; it is itself aping fashion, trying on attire that resembles the Harlot's before a dressing table; and its expression of surprise at her kicking over the table (to divert her keeper from the retreat of her new lover) is parallel to the Jew's. The monkey's aping of fashion applies to both: she with her clothes and lover, a 'lady'; he with his pictures and Christian mistress, a

'gentleman'. And, as in all his later series, Hogarth uses the pictures on the wall to comment on the scene and define the roles assumed by their collectors. In this case they predict the harsh Old Testament judgement the Jewish merchant is going to impose by casting her out into abject prostitution. In the other four plates (overleaf) the Harlot's affectation brings her punishment far in excess of her crime; in Hogarth's society the respectable people (the spectators at *The Beggar's Opera*) are both models for such as the Harlot and her judge and executioner.

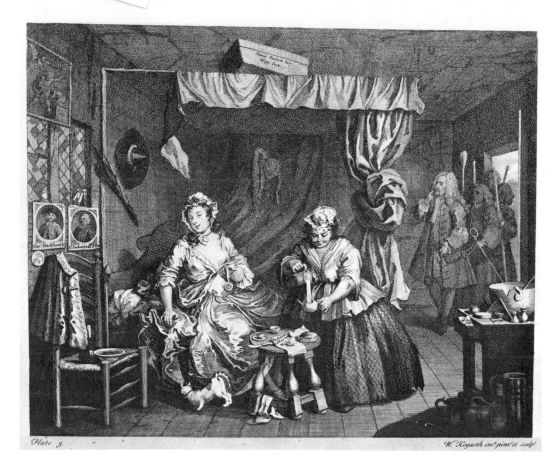

25. *A Harlot's Progress*, Plate 3

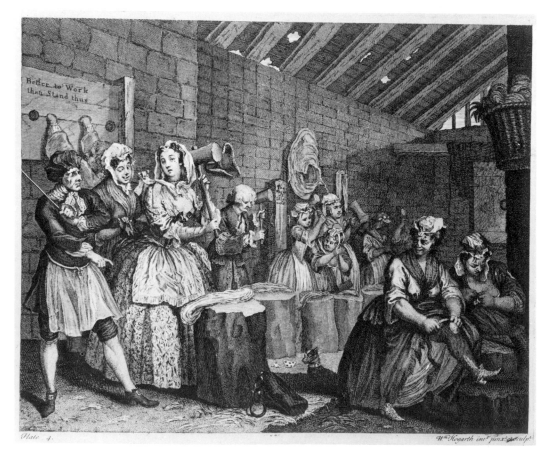

26. *A Harlot's Progress*, Plate 4

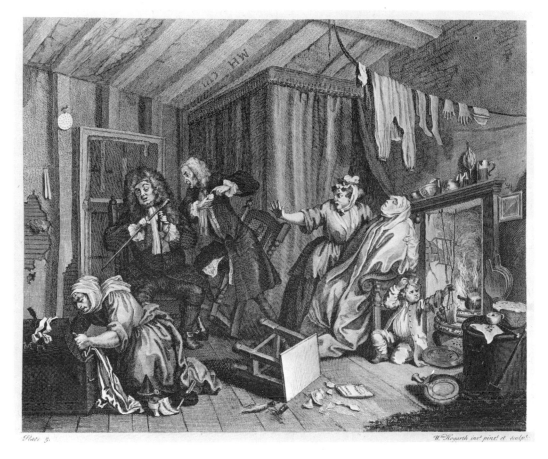

27. *A Harlot's Progress*, Plate 5

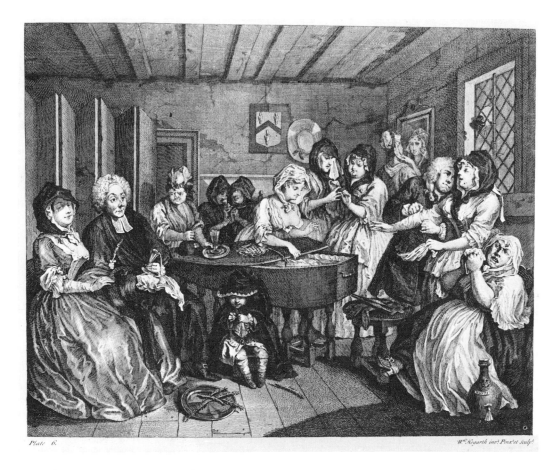

28. *A Harlot's Progress*, Plate 6

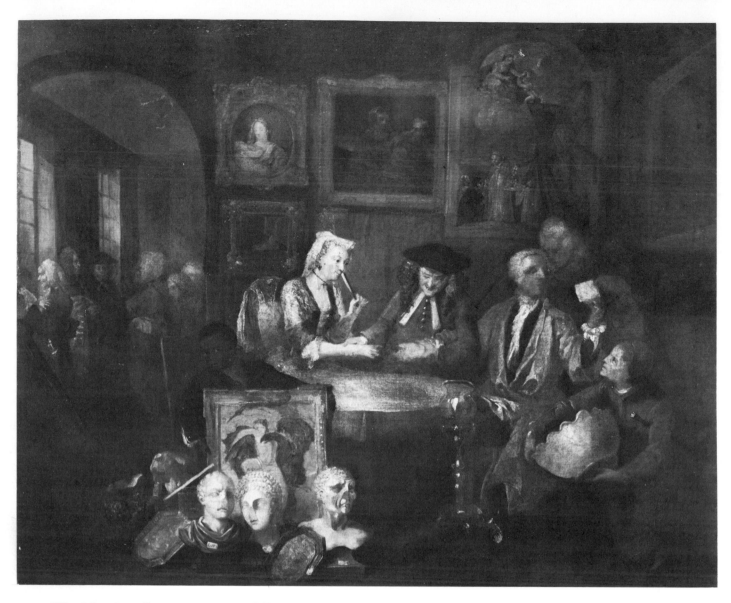

29. *The Marriage Contract. c.*1733. Oil on canvas,
24¼ × 29¼ in. Oxford, Ashmolean Museum

This sketch contains many of the elements that went into the *Rake's Progress* (in particular 2, but also the marriage in 5; Plates 31, 36). The emphasis is on collecting and connoisseurship, to be supported by the wealth of an old wife, with the young husband's thoughts already elsewhere (like the Rake in 5 or the young wife exchanging letters with her lover in *Analysis*, 2 [Plate 126]). Among the old master paintings above the husband is one of a transub-stantiation machine, which takes in Holy Infants at the top and gives out holy wafers at the bottom—presumably in analogy to the process going on in the marriage contract. Among the busts on the floor, Cicero is exchanging looks with Julia, while poor old Germanicus is looking away. The picture behind these busts is of Jupiter stealing Ganymede (which reappears in *Marriage à la Mode*, 4; the whole scene also, of course, anticipates *Marriage à la Mode*, 1).

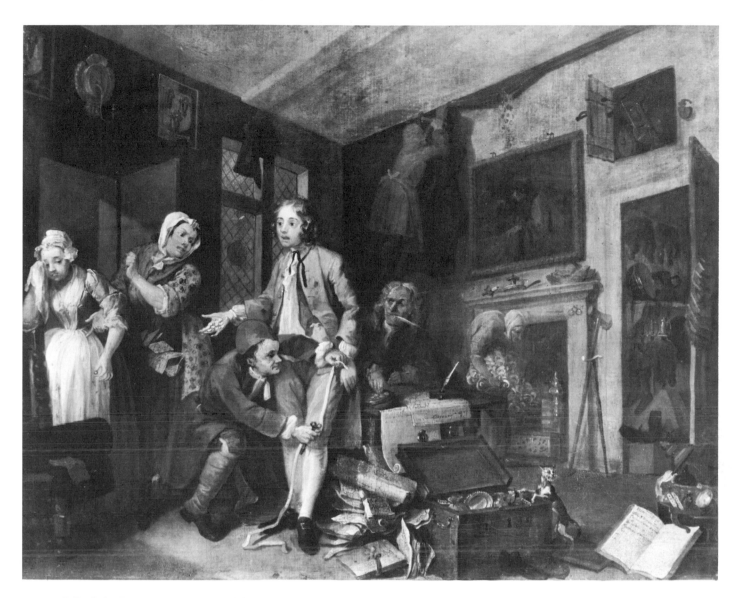

30. *A Rake's Progress*, 1. 1735. Oil on canvas,
$24\frac{1}{2} \times 29\frac{1}{2}$ in. each. London, Sir John Soane's
Museum

As with the *Harlot's Progress*, the paintings were engraved and sold by subscription and were a great success: so great that the threat of pirated copies led Hogarth to propose and see passed an engravers' copyright act to protect himself. His second 'progress' is about a miserly merchant's son who tries to use his father's money to set up as a rake—casting off mistresses from the lower classes, collecting art, debauching, getting into debt, marrying for money, gambling himself into debtors' prison, and ending in Bedlam. In the first scene the objects in disrepair or disuse, unharmoniously jumbled, in unresolved motion, all foreshadow his final madness. And already, as his foil, appears Sarah Young, the exemplar of work, thrift, loyalty, family, and Christian charity—an anticipation of the balance of the industrious apprentice against the idle in *Industry and Idleness* (1747).

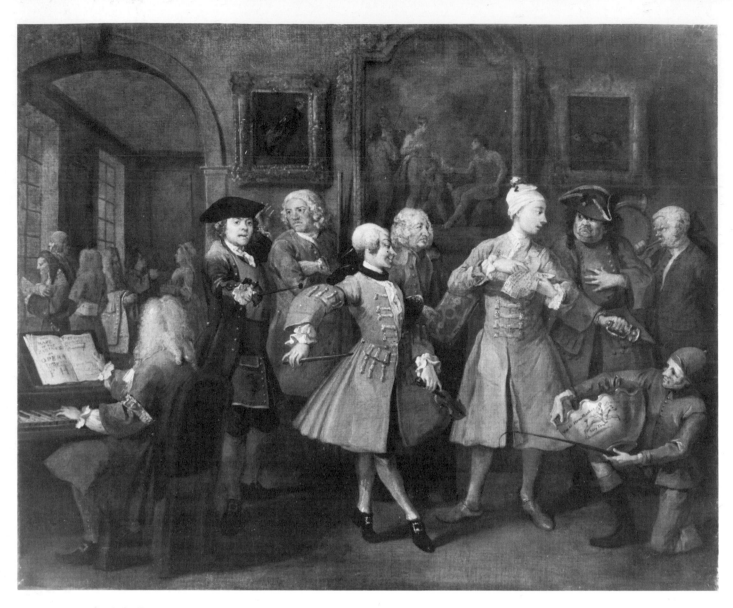

31, 32. *A Rake's Progress, 2*

The Rake is in the familiar pose of the Choice of
Hercules, as he was also in the first scene, and (as
usual when Hogarth employs this topos) the choice
has been made or is irrelevant. Here it matters little
whether he chooses the dancing master or the
gardener or the hired bruiser. But, having
disavowed his identity as miser's (or merchant's)
son, he poses beneath a picture of Paris, and like
him chooses Venus (Pleasure) over Juno and
Minerva (Wisdom), as becomes evident in the next
scene. (See Introduction, p. 23)

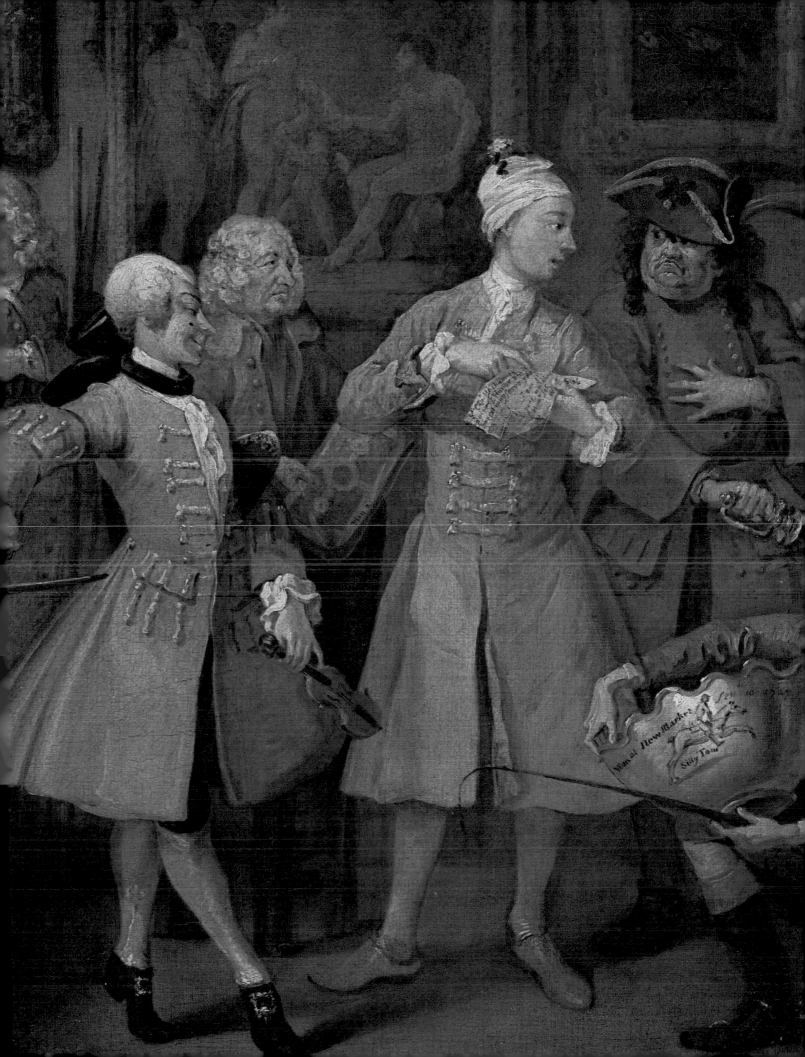

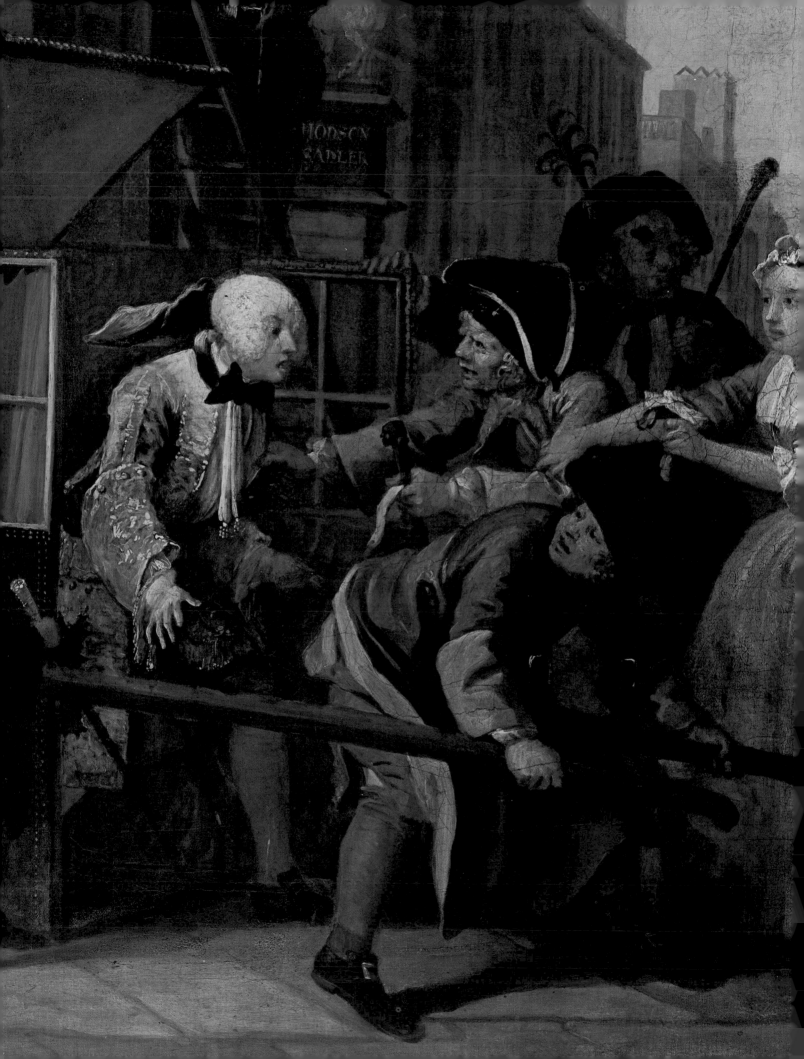

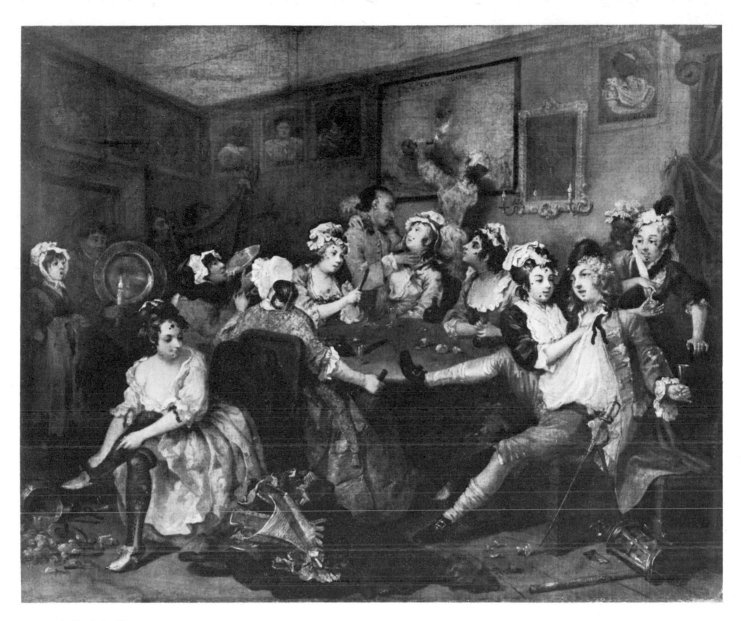

34. *A Rake's Progress*, 3

The third scene is discussed in some detail in the
Introduction (pp. 23–4). But analysis of such a
composition is not soon exhausted. For example, in
conjunction with the dancing girl and the platter, on
which she will dance, the beheaded portraits suggest
the iconography of Salome and the platter on which
John the Baptist's head was served up. The Rake, in
this scene, is going to be both Herod, for whom she
dances, and John, whose head she serves up. He is
still the judge of the *Judgement of Paris* (on the wall
in 2) and Nero; but he is also being cheated, robbed,
gulled, and literally 'burnt up' (like the 'totus
mundus' the whore is setting afire) by the syphilis
he will catch from the whores.

33. Detail of *A Rake's Progress*, 4 (Plate 35)

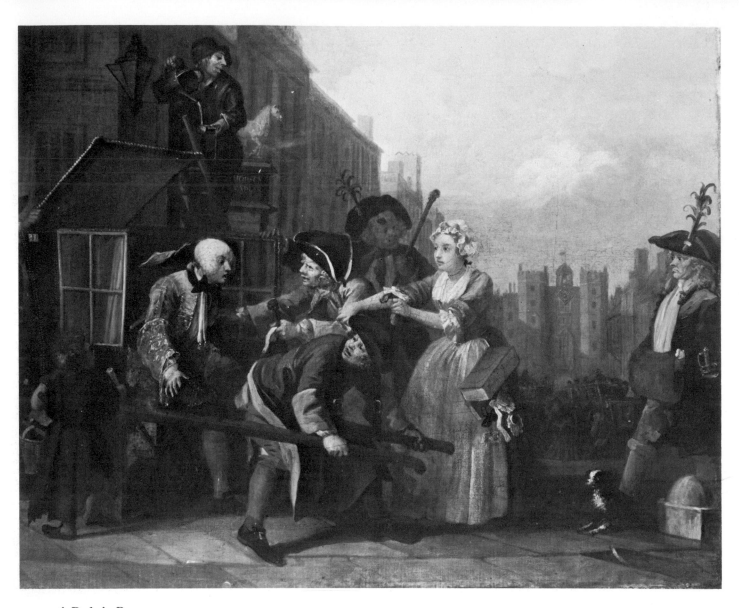

35. *A Rake's Progress*, 4

Having wasted all his inheritance and being in debt, the Rake is on his way (concealed in a sedan chair) to St James's Palace to seek patronage at the Queen's birthday levee: as the presence of leeks in Welshmens' hats proves, it is 1 March, St David's Day and the Queen's birthday. St David of Wales recalls King David's harp in the brothel scene, and in the engravings (the reverse of the paintings) the blind harpist of 3 is back-to-back with the observant Welshman in 4. Since the bailiffs are also Welsh, it appears that the first Welshman, whose belligerent stance is echoed by his dog's, is probably the creditor. Hogarth, who knew Shakespeare well, may have remembered Fluellen and the leek he forced upon the braggart Pistol (who called him 'base Trojan'; *Henry V*): 'You called me yesterday mountain-squire, but I will make you to-day a squire of low degree.' Here sturdy Welshmen arrest the effete Englishman on their saint's day, while he is on his way to celebrate not the birthday of a

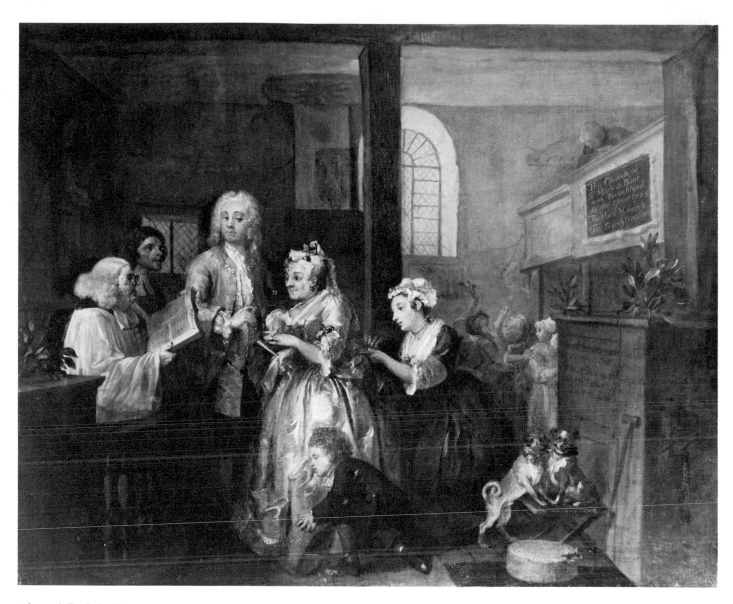

36. *A Rake's Progress*, 5

native saint but that of a foreign (German) queen.

Sarah Young has appeared just in time to pay the Rake's debts and save him from prison. The oil that overflows the lamplighter's tin appears to be annointing the Rake's head: a metaphorical equivalent of Sarah's 'angelic' intercession, which provides him the opportunity to repent, and recalls the 'old man's' words to Doctor Faustus: 'I see an angel hover o'er thy head, / And with a vial full of precious grace, / Offers to pour the same into thy soul, / Then call for mercy, and avoid despair' (xiii, 74–7; cf. *Merchant of Venice*, IV.i.184–6). But he does not repent, and in the fifth scene he is retrenching by an advantageous marriage with a one-eyed old woman, with a pair of dogs nearby as silent commentary. In the background Sarah Young is clamouring against the marriage with her infant in her arms. The squalor of the transaction is reflected in the desuetude of the church.

38. Detail of *A Rake's Progress*, 5 (Plate 36)

37. Detail of *A Rake's Progress*, 2 (Plate 31)

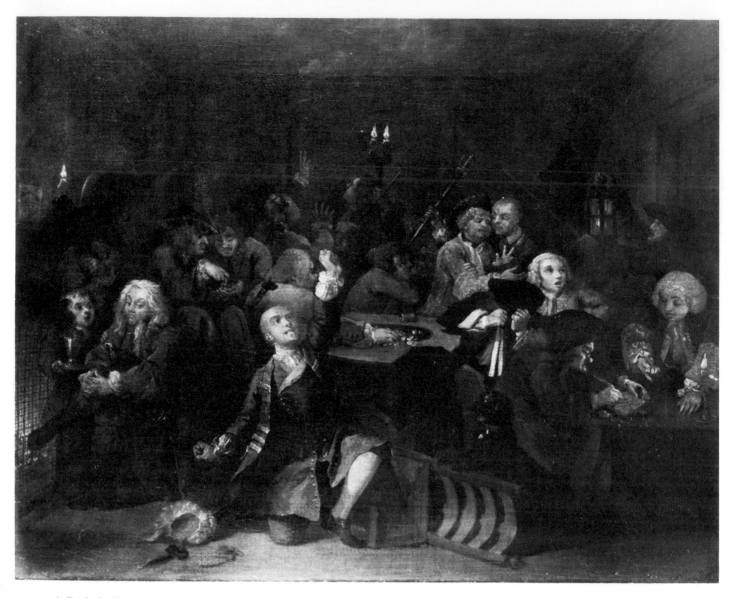

39. *A Rake's Progress*, 6

In the sixth scene the Rake has gambled away all his money from his marriage and is cursing his fate, while around him other gamblers are reacting to their own losses and the whole house is going up in flames (cf. the fire of the 'totus mundus' in 3). In the last two scenes the Rake is confined in debtors' prison and then in Bedlam. He and his old wife are joined in the Fleet Prison by Sarah and her child, whose age shows that a couple of years have passed (Plate 40). Sarah may be there for debt (going back to the money she gave the Rake?), or perhaps she is just *there*, the Rake's good angel always present and always rejected, as again in the last scene.

The Rake began by denying the miserliness of his father and ends in equally miserly rags in Bedlam (Plate 41); he represents the middle-class paradigm of the individual whose life is a flight from origins, a disavowal of the father and a search for a new self,

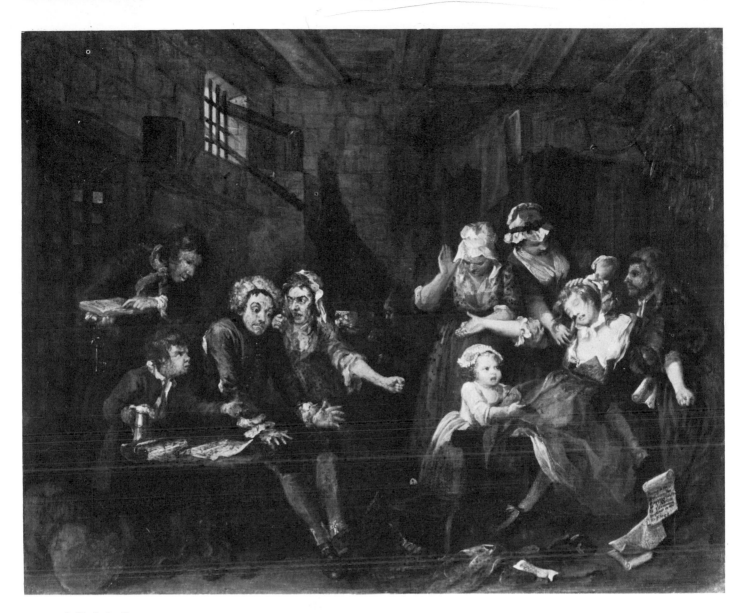

40. *A Rake's Progress*, 7

which ends with a return to the position that has never been left. His nakedness recalls the clothes imagery that began with the tailor in the first scene. With him in Bedlam are the same types who appeared at his levee in 2—the tailor, the poet, and the musician. Two of the cells are occupied by a man who thinks he is a king and one who thinks he is God. On the latter's walls are portraits (legible in the engraving) of Athanasius, whose fanatical pursuit of the Trinitarian doctrine Gibbon was later to notice, and St Lawrence, whose words 'I'm done on this side, you can turn me over' recall the gridiron the Rake brought with him to prison in the previous scene (and which, in the context of the two 'wives', may have the same connotations as the gridiron with St Lawrence over the bridegroom's head in *Marriage à la Mode*, 1 [Plate 75]). See also Introduction, p. 34.

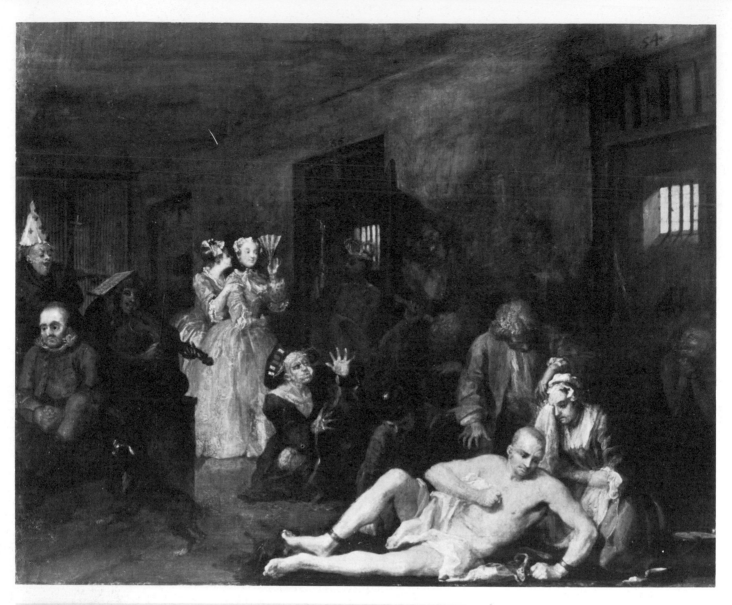

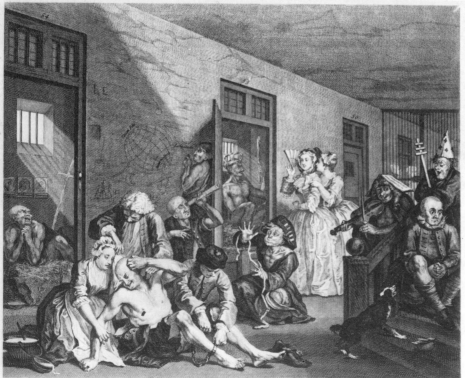

41. *A Rake's Progress*, 8

42. *A Rake's Progress*, 8
(engraving, $12\frac{7}{16} \times 15\frac{1}{4}$ in).
Caption not reproduced.
London, British Museum

43. Detail of Plate 41

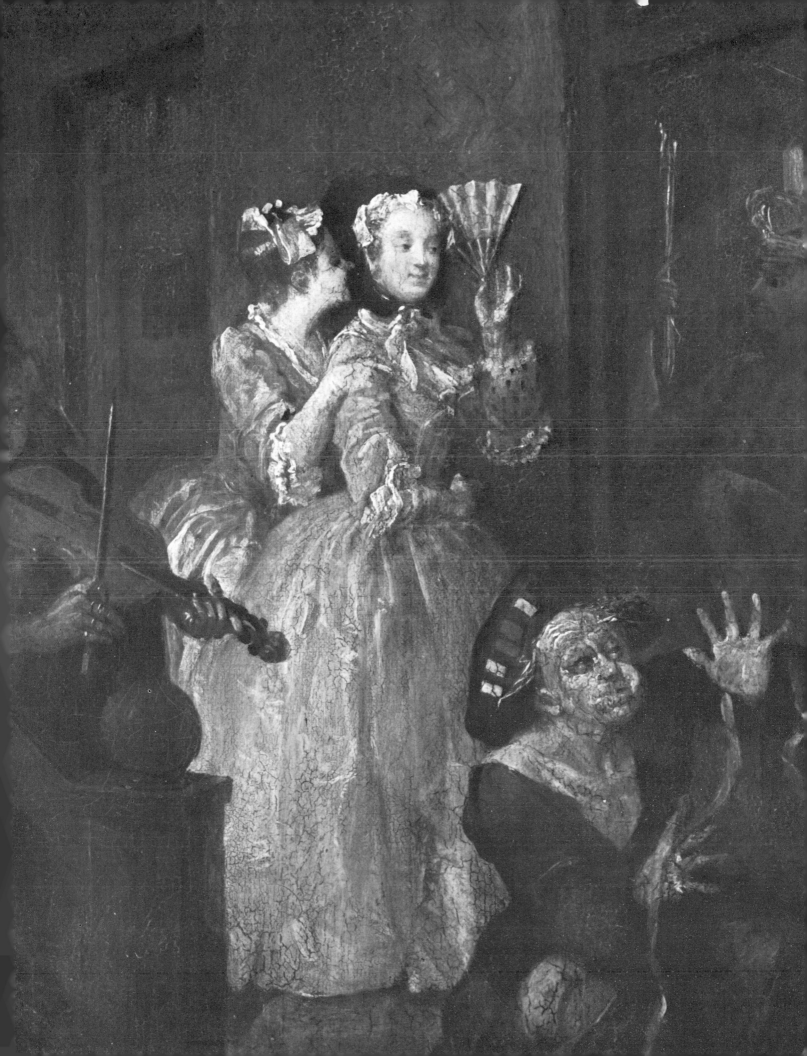

44. *The Pool of Bethesda.* 1736. Oil on canvas,
164 × 243 in. London, St Bartholomew's
Hospital

45. *The Good Samaritan.* 1737. Oil on canvas,
164 × 243 in. London, St Bartholomew's
Hospital

Learning that the Italian Jacopo Amigoni was about to be commissioned to paint religious panels to decorate the great staircase of the newly completed wing of St Bartholomew's Hospital, Hogarth volunteered to paint the pictures for nothing. The daunting task—his first attempt at a Biblical subject in the grand style—took him three years to complete. For commentary, see the Introduction, pp. 47–8; also John 5:2–9 and Luke 10:30–7. Perhaps the most interesting parts of the work, as

pure painting, are the three grisaille panels beneath the stories of the Good Samaritan and the Pool of Bethesda. These reddish designs, in imitation of bas-relief, are painted in Hogarth's freest manner (anticipating the oil sketches of the 1740s, e.g. Plate 123). They tell the story of Rahere, the founder of the hospital. A jongleur or public entertainer who recounted tales of comic heroes, sang, tumbled, and led dancing bears, Rahere rose from humble origins and little education to be the king's favourite

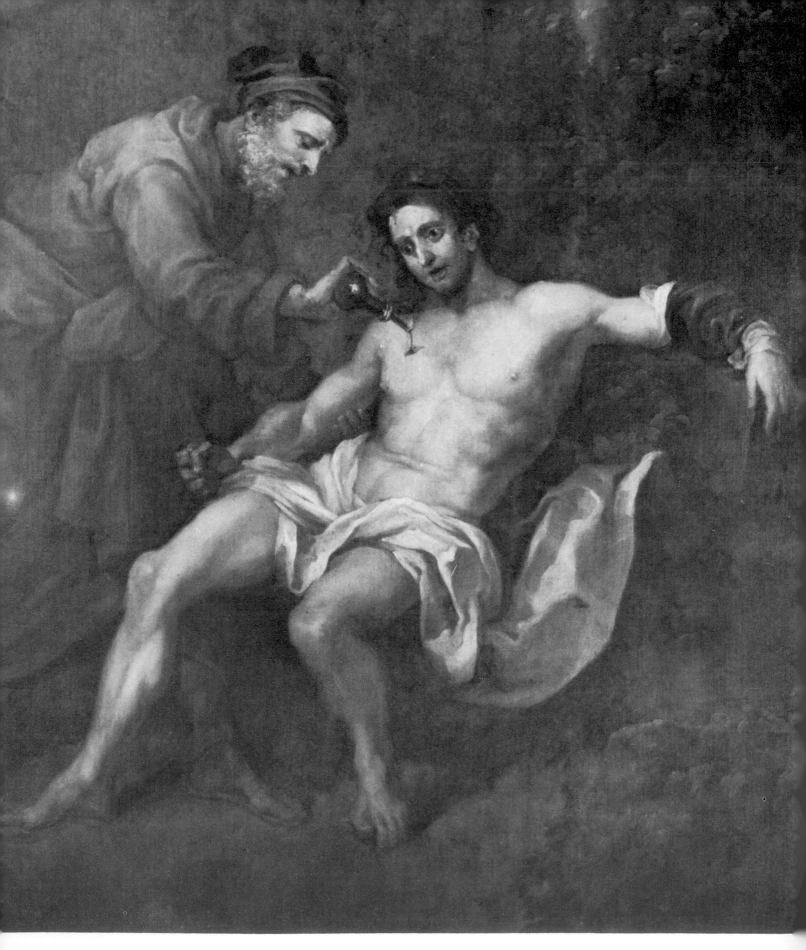

46. Detail of Plate 45

entertainer. The first panel shows him on his way home from a pilgrimage to Rome (on which he fell sick and vowed if he recovered to found a hospital for the poor) being instructed by St Bartholomew to found both hospital and church in Smithfield— to bring a hospital out of the marshy, muddy, filthy land where thieves were hanged. Hogarth, brought up in the shadow of St Bartholomew's hospital and church (where Rahere is buried), may have seen a parallel to his own career; and while he painted the public message of Charity—his own and his age's primary virtue—depicted larger than life above, he added his private message, in monochrome, below. The panel reproduced (Plate 47), of Rahere's hospital for the poor, is the human version of the divine Charity in *The Pool of Bethesda* above it. The curious dog connects the panels (see Plate 44). In the grisaille Rahere, the prior of the Augustinians who administered the hospital, greets a patient brought in on a stretcher. The cripple at the right is taken from a figure in Raphael's *Healing of the Lame Man*—one of Hogarth's many references to the Raphael Cartoons.

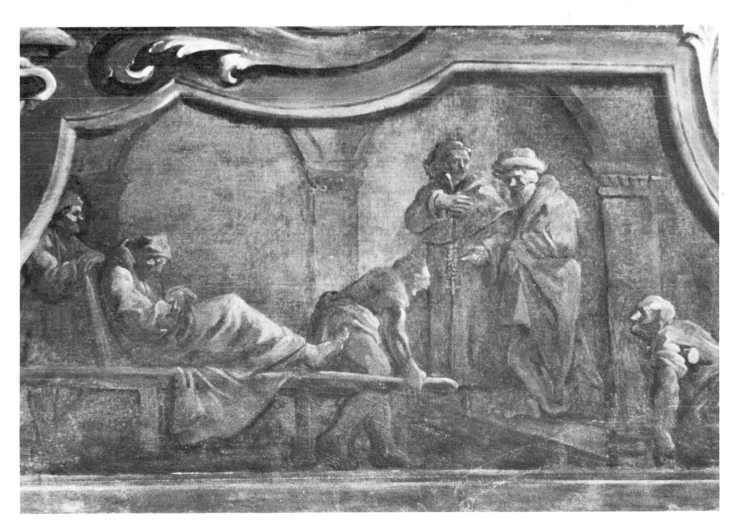

47. Grisaille panel, detail of Plate 44

48. *Southwark Fair*. 1733/4. Engraving,
$13\frac{1}{2} \times 17\frac{13}{16}$ in. London, British Museum

Southwark Fair was painted in 1733 (Lady Oakes Collection) and engraved and published early in the next year, as part of the subscription of *A Rake's Progress*. The painting has suffered from recent overpainting of the highlights, and so the engraving is reproduced. It is one of Hogarth's few outdoor scenes, portraying the annual fair held on 7, 8, and 9 September, which he has turned into a 'Vanity Fair'. *Strolling Actresses*, painted a year or so later, was destroyed by fire in the nineteenth century, and only the engraving survives. Both works are among Hogarth's clearest statements of the metaphor of life as a stage. The hero of a play like *The Fall of Bajazet* is arrested by bailiffs for debt or comes tumbling down (literally a 'fall') off a rickety stage. Young women playing gods and goddesses are

49. *Strolling Actresses dressing in a Barn.* 1738.
Engraving, $16\frac{3}{4} \times 21\frac{1}{4}$ in. London, British
Museum

shown (as Fielding was to put it a few years later in
Tom Jones) 'behind the scenes of this great theatre of
Nature'. Around them are typical *Vanitas* emblems:
crowns, orbs, mitres, heroes' helmets, being used in
the most earthy and realistic way (cf. Plate 137);
they are brought down to the level of humanity in
much the way that Diana, goddess of Chastity, is by
the disarray of the young girl playing the role (and

being observed through a hole in the barn roof by
her rustic Actaeon). Particularly in this second
picture, Hogarth is in the process of demytholo-
gizing conventional history painting by dissociating
its gestures and costumes from its people, by
bringing its attributes down to contemporary
Londoners (sometimes recognizable ones).

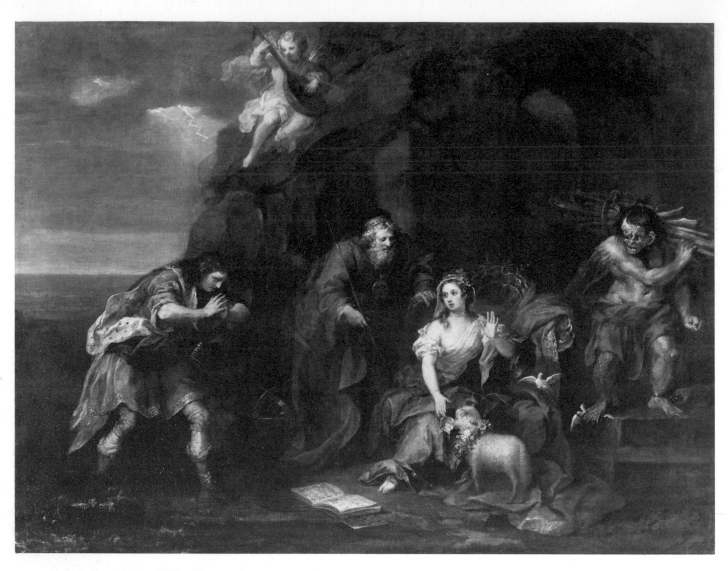

50, 51. *A Scene from 'The Tempest'. c.*1735. Oil on
canvas, 31½ × 40 in. Major the Lord St
Oswald

Here, as a complement to *Southwark Fair* and
Strolling Actresses, Hogarth attempts to find history
in a scene from classical English drama, which
nevertheless takes the form of another family group
or conversation piece: Ariel, Prospero, Miranda, and
Caliban, with the suitor Ferdinand at some distance
making a gesture of homage just short of connection
(the V-shaped separation between the groups,
familiar in the conversation pieces, appears at this
point). If Miranda is the protagonist, Hogarth has
arranged the composition to emphasize the contrast
between her true lover and her pseudo lover
Caliban, who weaves fantasies of raping her, and the
structure of choice is here a true and not a parody
one, since all indications point to Miranda's making
the proper judgement.

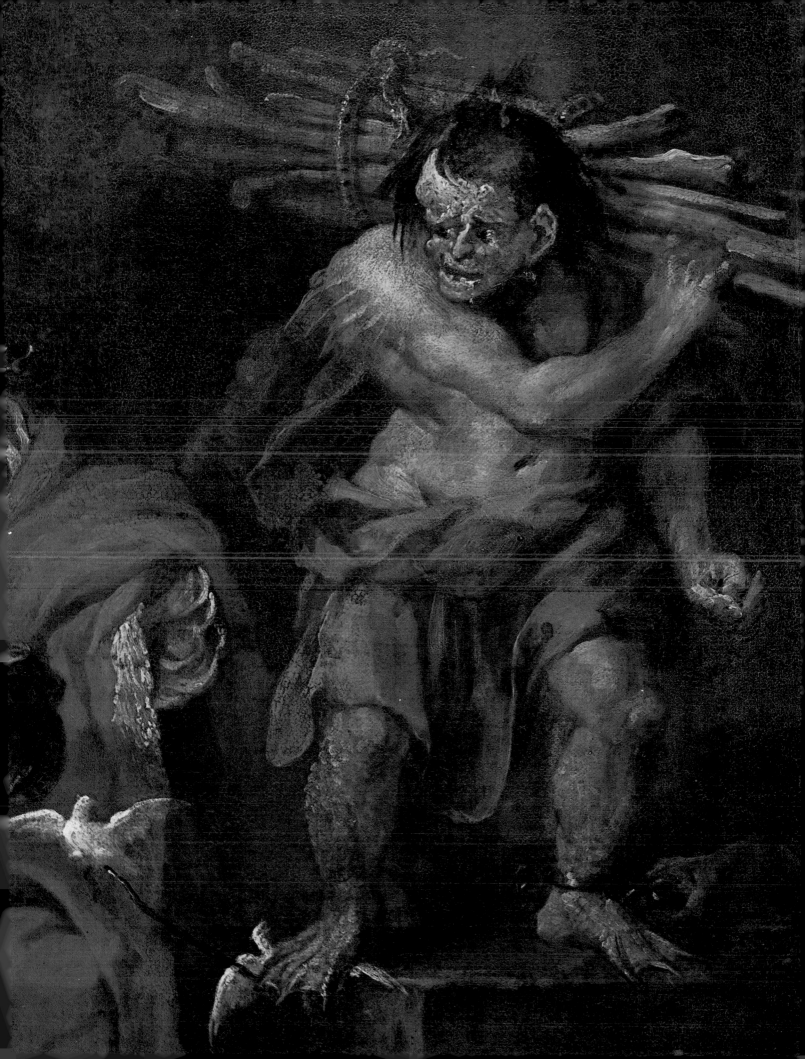

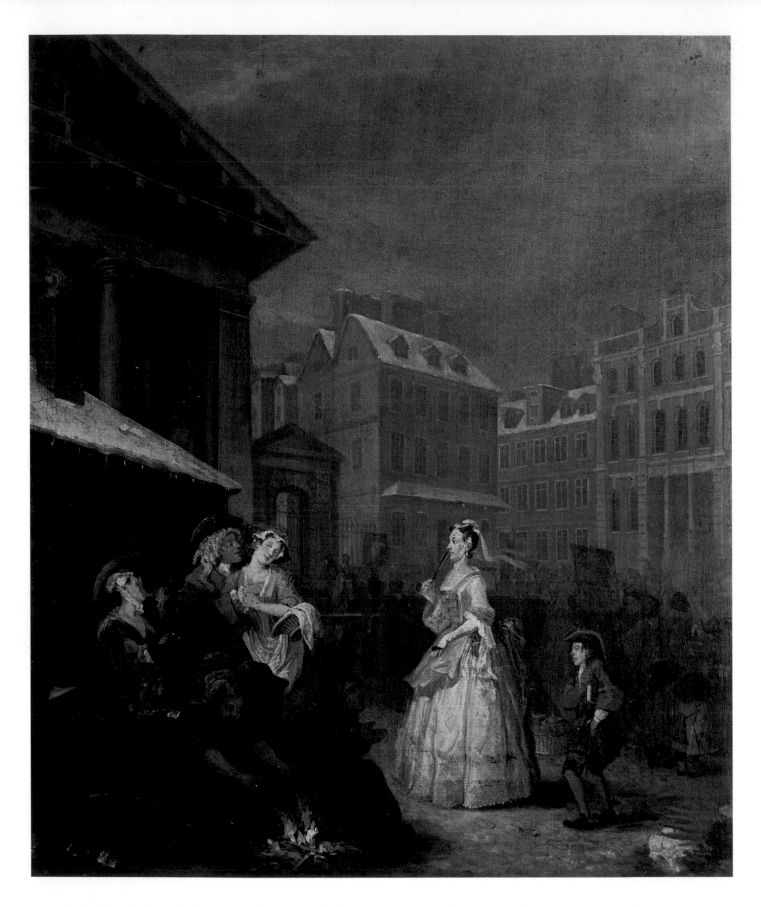

52. *The Four Times of Day: Morning.* 1738. Oil on canvas, 29 × 24 in. Upton, The National Trust, Bearsted Collection

These four paintings, finished and engraved in 1738, may be Hogarth's most balanced representation of his world. The pull of consequences has been replaced by the calm juxtaposition of opposites, without judgement on either party. An analogue for paintings like these would be something like Bruegel's *Battle of Carnival and Lent* (Vienna, Kunsthistorisches Museum).

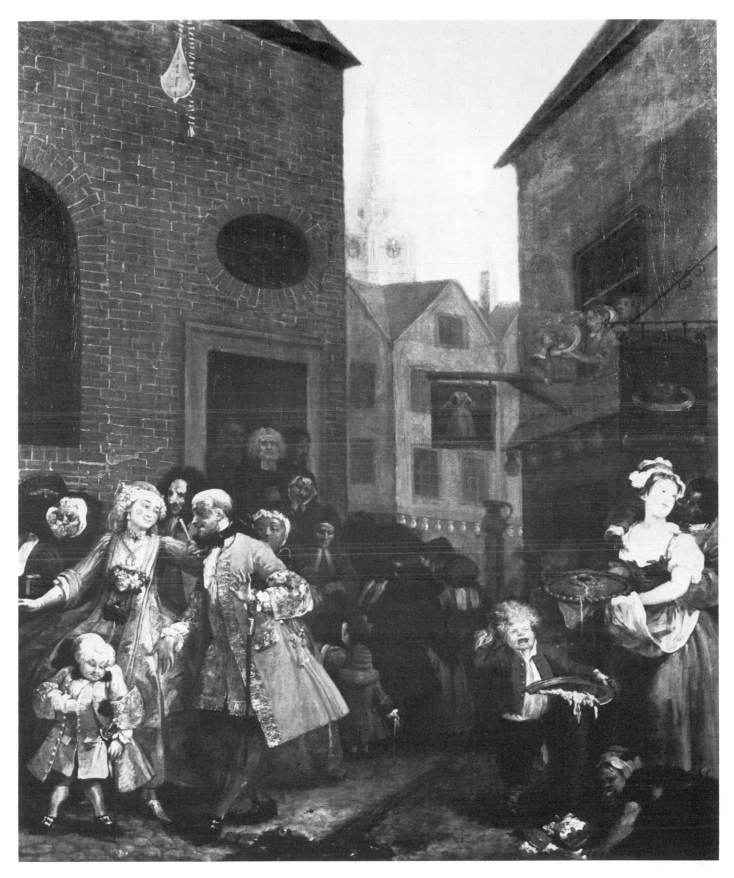

53. *Noon*. Oil on canvas, $29\frac{1}{2} \times 24\frac{1}{2}$ in. Private
Collection

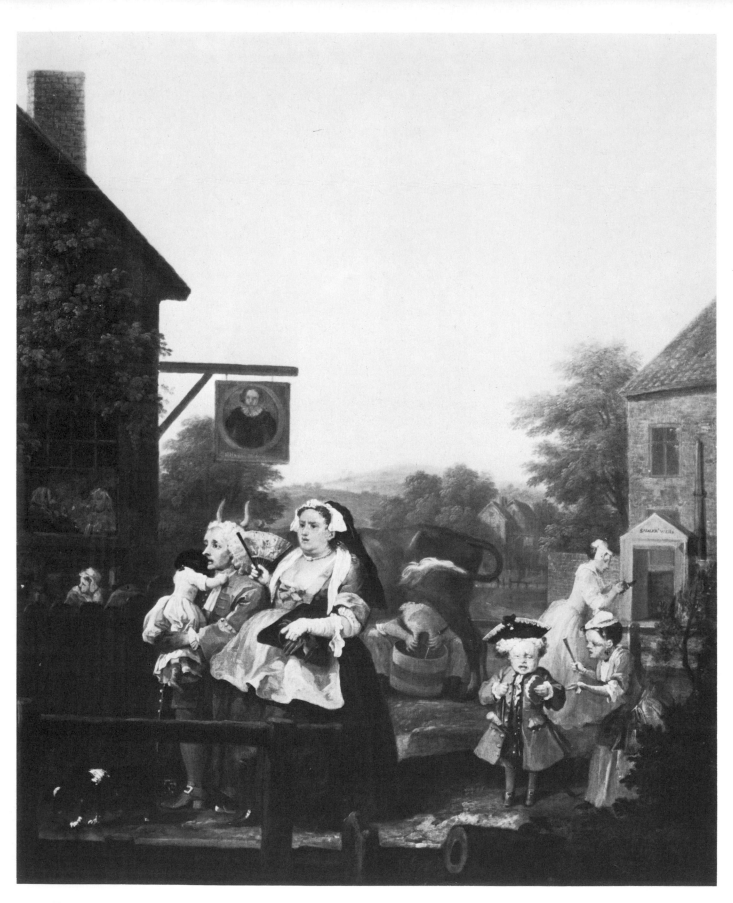

54. *Evening*. Oil on canvas, $29\frac{1}{2} \times 24\frac{1}{2}$ in. Private
Collection

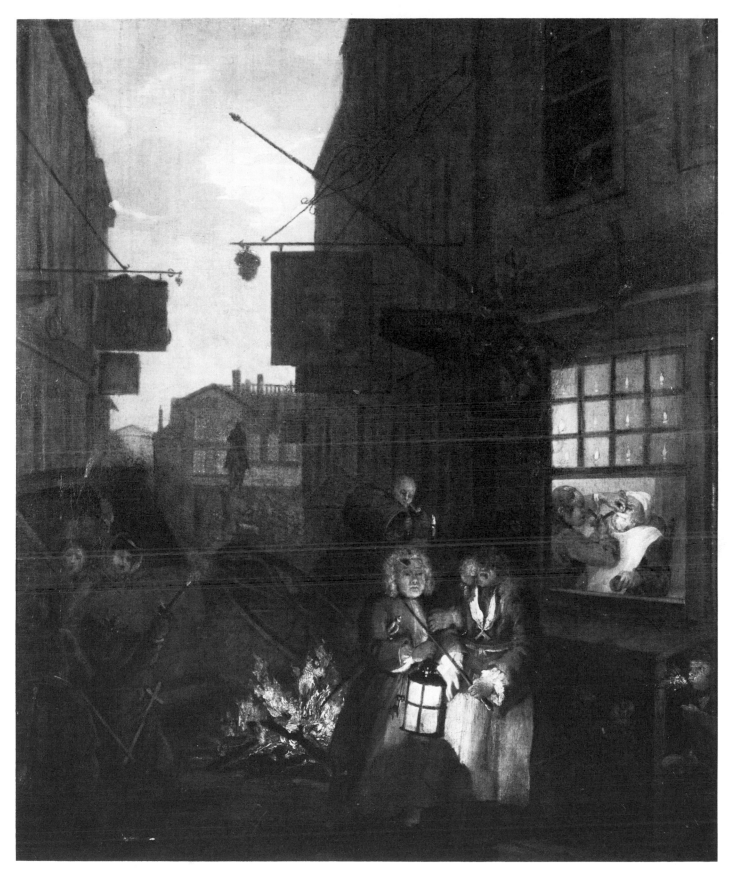

55. *Night*. Oil on canvas, 29 × 24 in. Upton, The
National Trust, Bearsted Collection

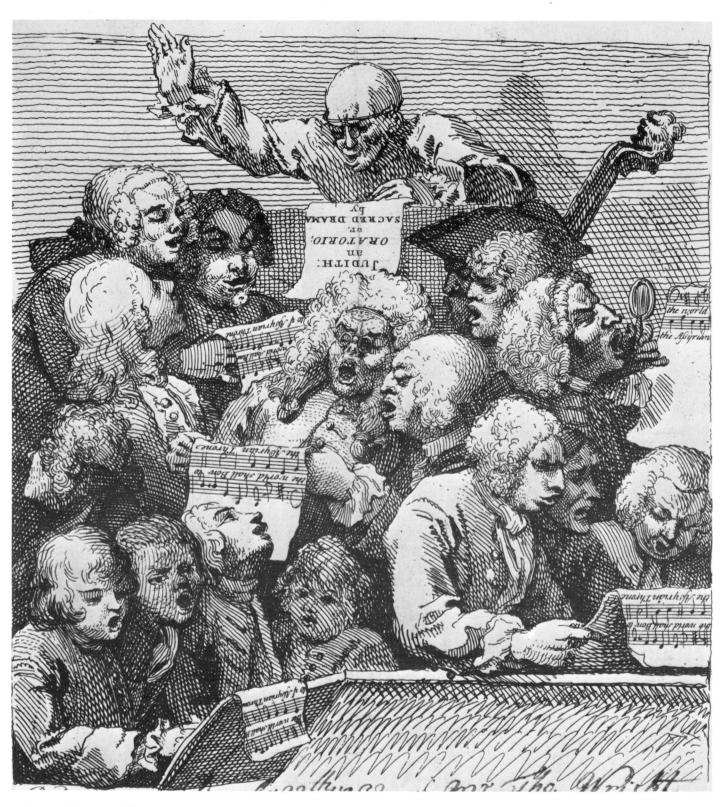

56. *A Chorus of Singers*. 1732. Etching,
11 $\frac{13}{16}$ × 14 $\frac{7}{8}$ in. Caption not reproduced.
London, British Museum

57. *Scholars at a Lecture*. 1736/7. Etching,
 8 3/16 × 6 15/16 in. London, British Museum

58. *The Laughing Audience*. 1733. Etching,
 7 × 6¼ in. London, British Museum

These three prints, with *The Company of Undertakers*, were together issued by Hogarth in March 1736/7 as 'Four Groups of Heads'. They are all primarily studies in expression, the quality for which he was most famous in his lifetime; but which also led him frequently to be classified (to his dismay) as a caricaturist. In *The Laughing Audience* he has turned his theatrical metaphor in the direction of the audience: the shallow space, the false perspective, the figures in the foreground smaller than those in the background, all lead to the curious relationship in which the viewer seems to be observed, as part of the spectacle itself (cf. *Tom Jones*, VII.i). *Scholars at a Lecture* is constructed on the pun of 'Datur vacuum' (Vacation is given), which is also a verbal reflection of the emptiness in all the faces. And the *Chorus of Singers* depends on the mock-heroic discrepancy between the singers and the words of their song, '. . . the world shall Bow to the Assyrian Throne'.

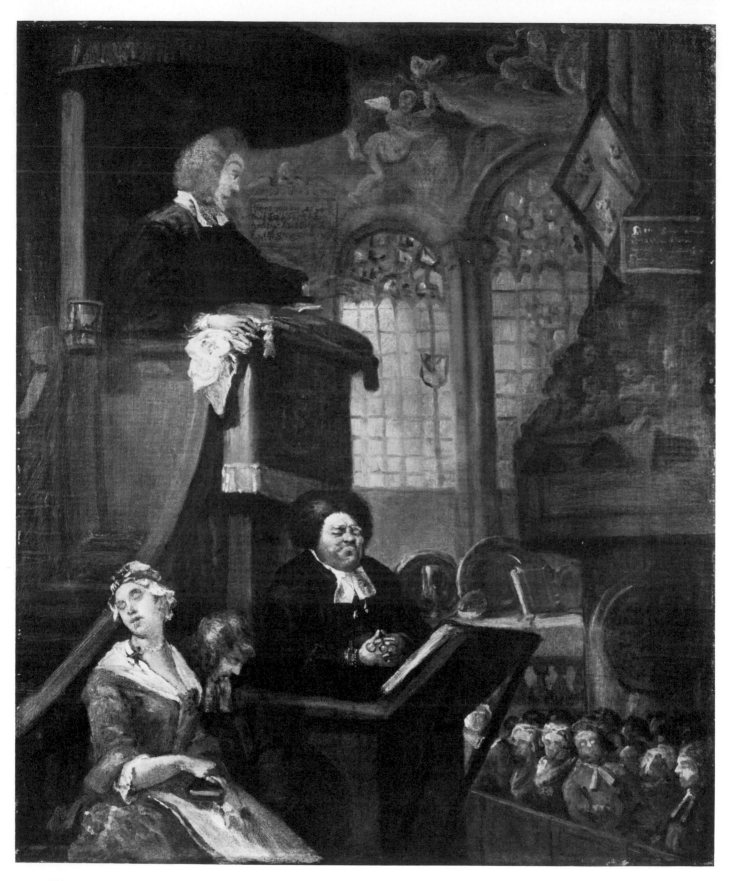

59. *The Sleeping Congregation*. Mid-1730s. Oil on canvas, $21 \times 17\frac{1}{2}$ in. Minneapolis Institute of Arts

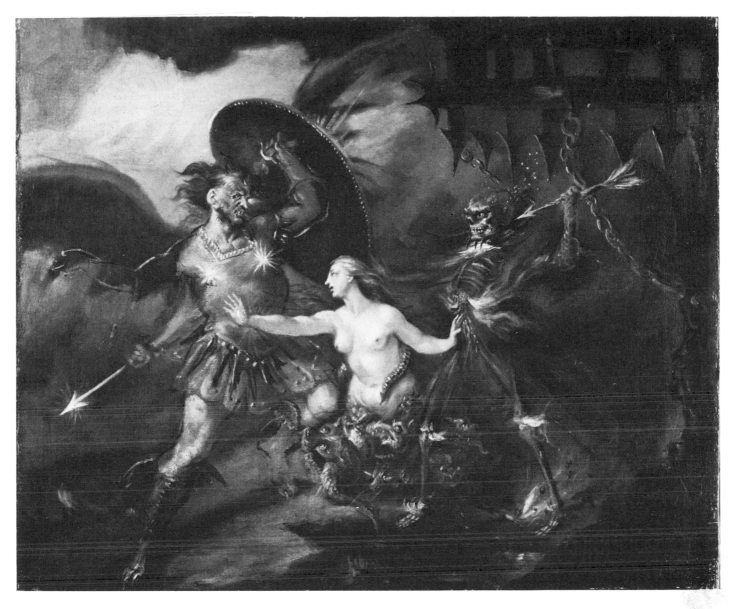

60. *Satan, Sin and Death*. Mid-1730s? Oil on
canvas, 24 × 29 in. London, Tate Gallery

Though the date 1729 appears on a scroll in the
church interior, *The Sleeping Congregation* has to be,
on stylistic grounds, from the mid-1730s: it is one of
Hogarth's most accomplished oil sketches. It was
engraved in 1736, with the addition of the
significant inscription on the pink pennant on the
back wall, '. . . et mon droit' ('Dieu' being absent in
this secularized church). The omission tells much
about the difference between a Hogarth painting and
engraving: we look at the painting for its immediate
expression and the quality of its paint; at the
engraving for intellectual structures.

Satan, Sin and Death is an unfinished sketch for a
history painting based on Milton's allegory (*Paradise
Lost*, Bk II), rendered in excited brushwork and
brilliant colours.

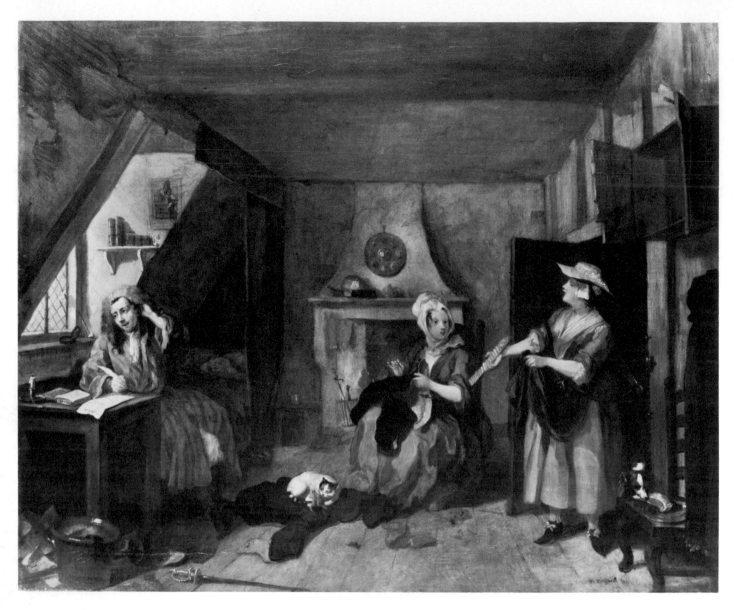

61, 62. *The Distressed Poet. c.*1735. Oil on canvas,
25 × 30⅞ in. Birmingham, City Museum and
Art Gallery

An engraving was published (in reverse) from the
painting in 1736. While the engraving is about the
poet, whose illusions of Parnassus and 'gold mines
in Peru' keep himself in rags and his family starving
(a dog who has entered with the milkmaid, seeking a
reckoning, is devouring the family's last chop), the
painting seems to be about his wife. With the
brilliant blue of her dress, her centrality, and the
garret's architecture, she seems to be a kind of
Madonna in the midst of a messy manger scene;
her situation is emphasized by the parallelism of
the cat with her kittens. The caricature pinned to
the wall above the Poet's head is of Alexander Pope,
the scourge of Grub-street poets.

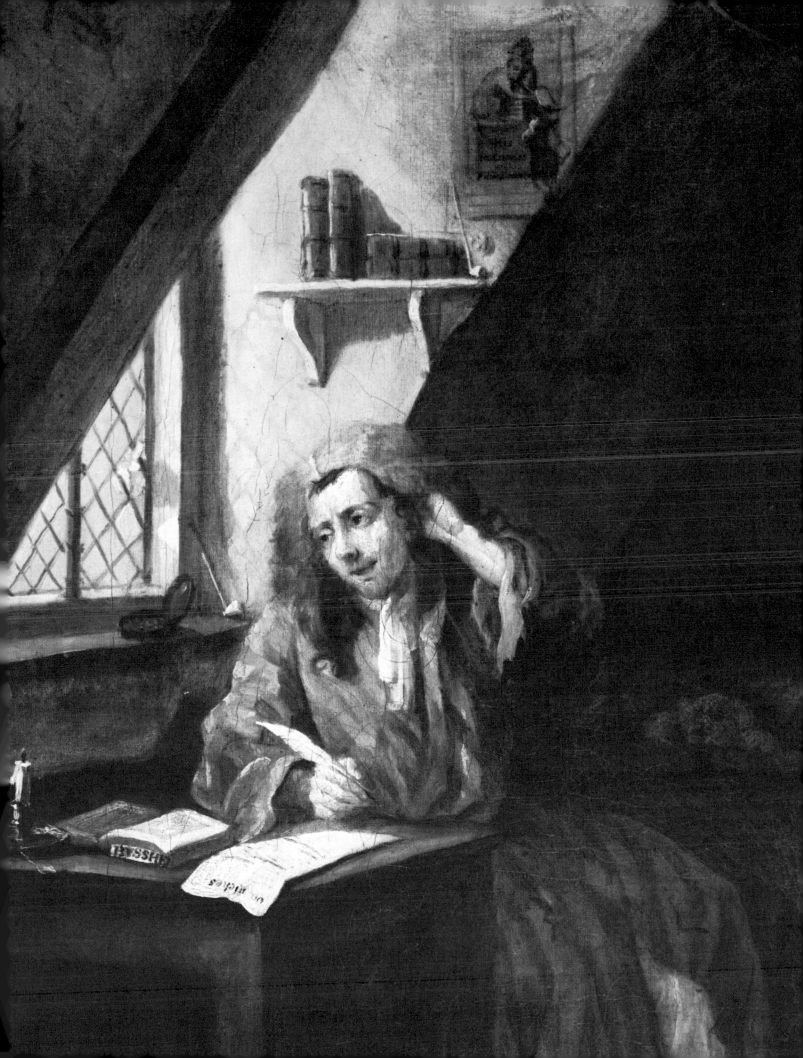

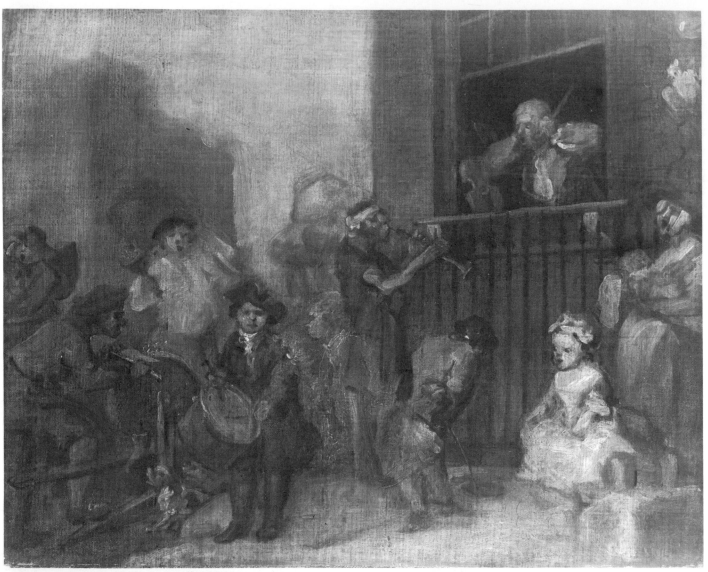

63. *The Enraged Musician.*
1741. Oil on canvas
(grisaille), $14\frac{3}{4} \times 18\frac{3}{4}$ in.
Oxford, Ashmolean
Museum

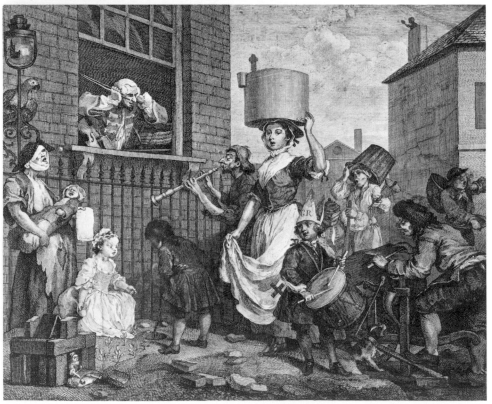

64. *The Enraged Musician.*
1741. Engraving (proof
state), $13\frac{1}{16} \times 15\frac{11}{16}$ in.
London, Chiswick
Public Library

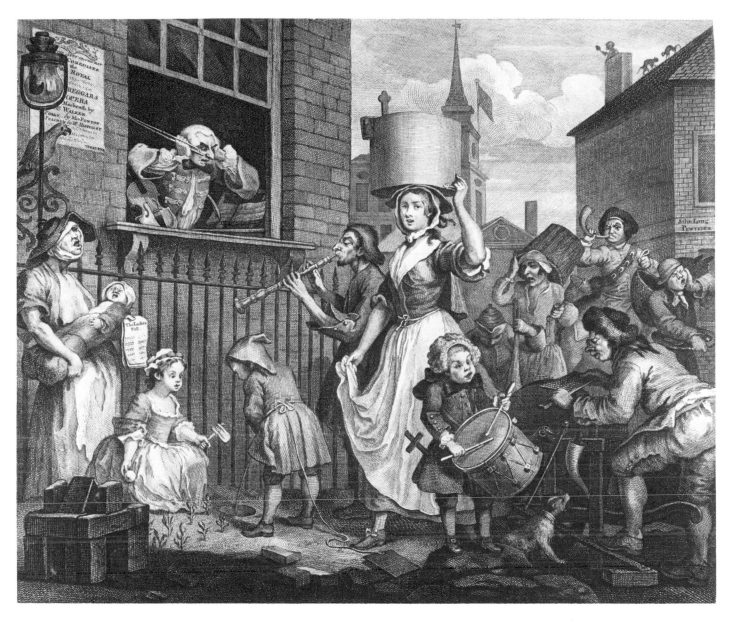

65. *The Enraged Musician.* 1741. Engraving
(finished). London, British Museum

The finished print is about noise and quiet, disorder and order, and the mediation (or formulation) of art. In the proof the analogy between the playhouse and a bird-catcher, between these and the girl gazing at the boy, introduced a domestic theme of not much relevance to the subject. The boy-grenadier, whose wandering eye made him the third party in a potential triangle, and perhaps even the syphilitic dustman, contributed to the same theme. Hogarth turned the boy's head, removed the grenadier's cap, and gave him a plain face; he removed the doll and restored the dustman's nose. He retained only the girl's interested regard for the little boy's method of noise-making and placed in her hand a rattle. To further underline the subject of noise he added a playbill for *The Beggar's Opera*, a sow-gelder on horseback, a church spire with a flag to show that the bells will be ringing this day, and on the house at the right both a pewterer's sign and howling cats. There are many other small variations between the proof and the finished engraving.

66. Detail of Plate 67

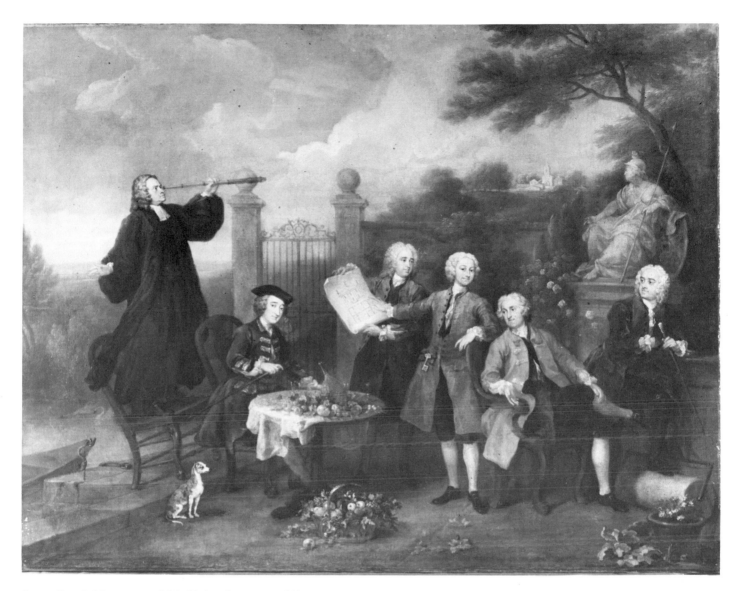

67. *Lord Hervey and his Friends.* 1738. Oil on
canvas, 40 × 50in. Ickworth, The National
Trust

Hogarth continued to undertake occasional
conversation pieces in the late 1730s, though
enlarging them. To commemorate the autumn of
1738, when John Lord Hervey and his friends
hunted and caroused together at the Foxes' shooting
box at Maddington, Hogarth painted this picture.
The Rev. P. L. Wilman is standing on a chair,
looking so intently through his spyglass at a church
steeple in the distance that he does not notice that
his chair is toppling him backwards into a pond.
The usual dog is present, and the Fox brothers
(Henry and Stephen), the third Duke of
Marlborough, and Thomas Winnington. Henry Fox
is holding up an architectural drawing to show
Hervey—perhaps a house at Maddington to replace
the shooting box.

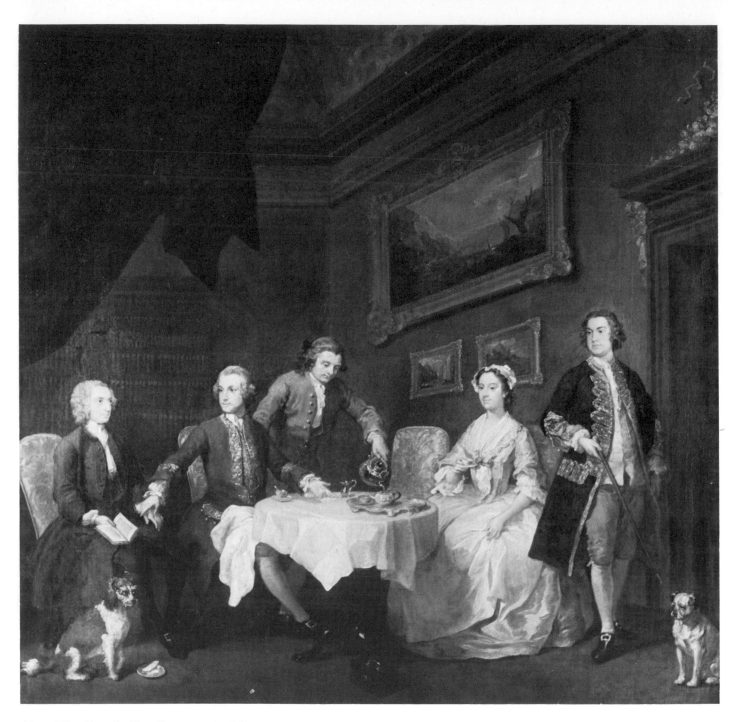

68. *The Strode Family*. *c*.1738. Oil on canvas,
34½ × 36 in. London, Tate Gallery

The Strode Family shows a group at tea: Dr Arthur Smyth, later Archbishop of Dublin; William Strode, M.P., of Ponsbourne Hall, Hertfordshire; his butler, Jonathan Powell; his wife, Lady Anne Strode; and his brother, Colonel Samuel Strode. The Strode and Hogarth dogs eye each other from opposite sides of the room. *The Mackinnon Children* shows Elizabeth and William Mackinnon, then aged seventeen and fourteen respectively. The sunflower between them was an emblem of devotion (in seventeenth-century emblem books devotion to the king).

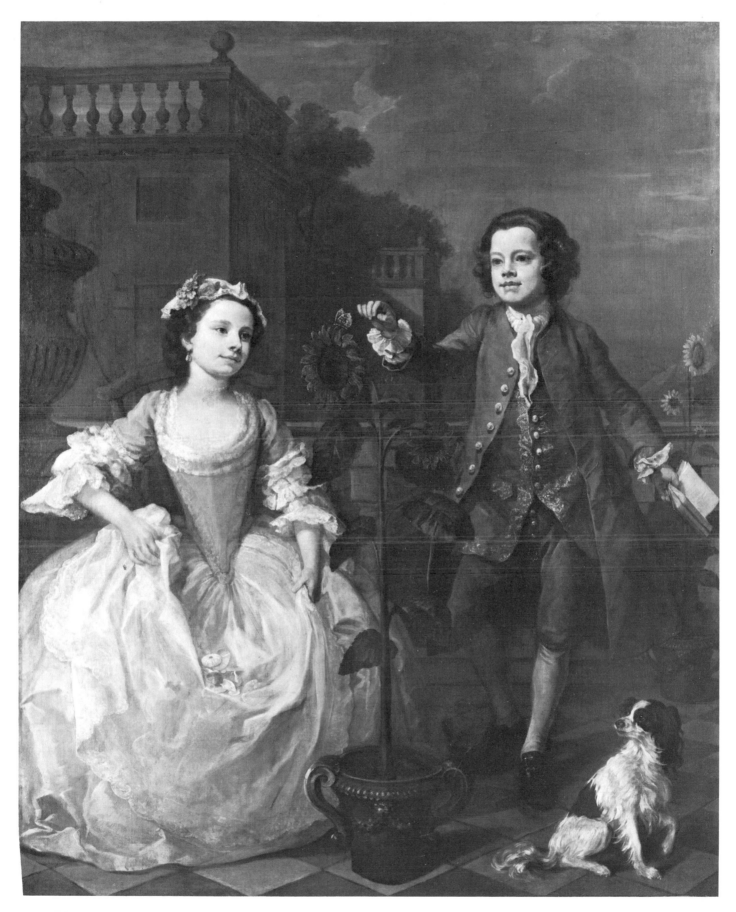

69. *The Mackinnon Children. c.*1742. Oil on canvas,
 71 × 56½ in. Dublin, National Gallery of Ireland

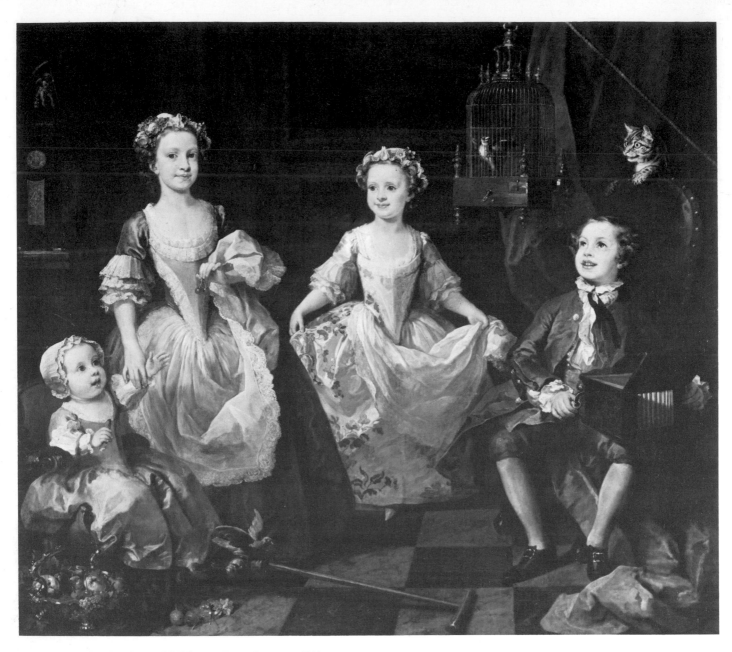

70, 71. *The Graham Children*. Dated 1742. Oil on
canvas, $63\frac{1}{4} \times 61\frac{1}{4}$ in. London, Tate Gallery

With *The Mackinnon Children* and *The Graham
Children* Hogarth enlarged the size of his
conversations and reduced the number of sitters,
producing monumental compositions equivalent to
that of *Captain Coram* (Plate 87) in the single
portraits. The setting still remains emblematic: a
Cupid as Time with his scythe stands atop a clock
and a bird is singing in its gilded cage with a hungry
cat in attendance. The boy is turning a hand organ,
which has a picture on its side of Orpheus charming
the beasts. Daniel Graham, the father of these
children, was apothecary to the Royal Hospital,
Chelsea.

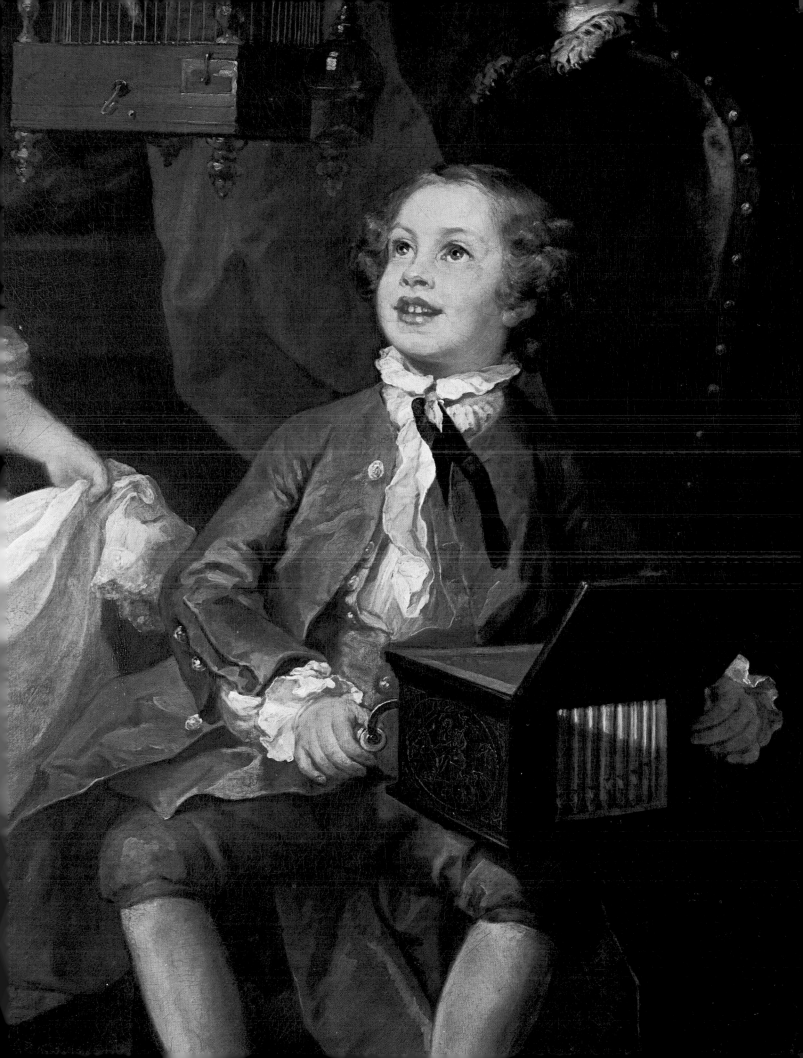

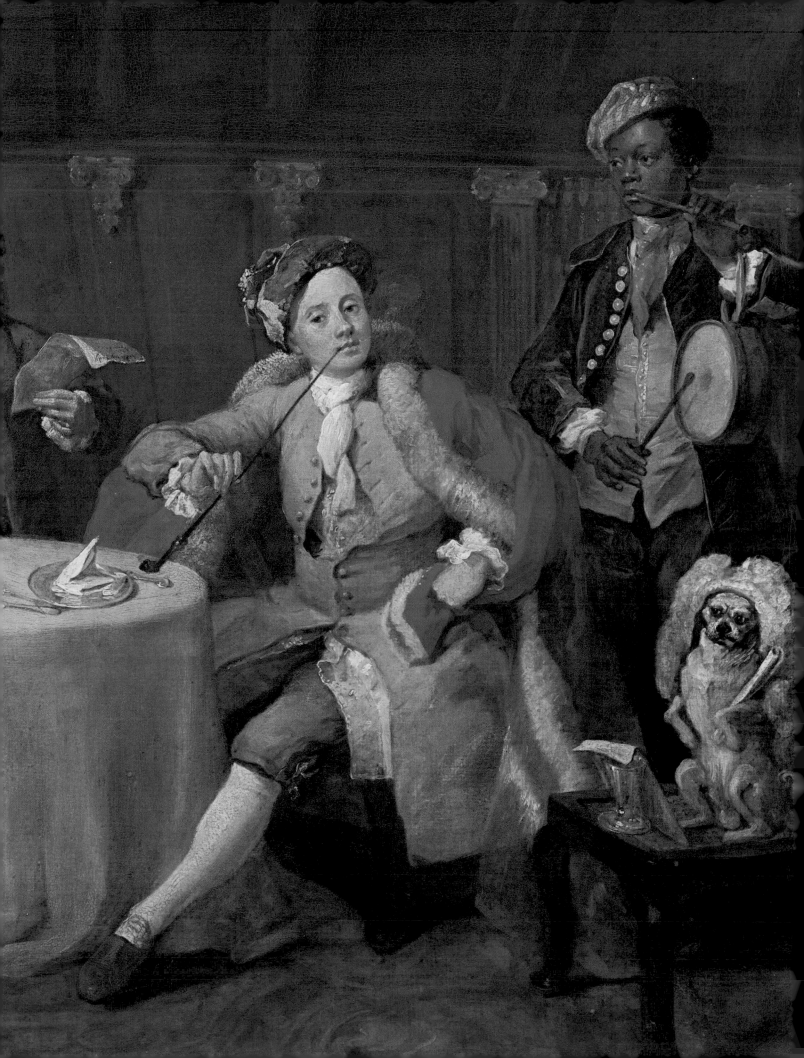

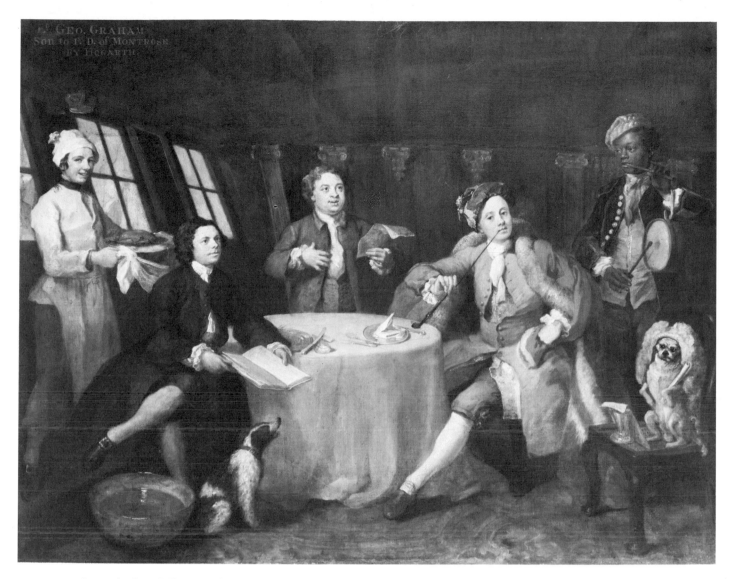

72, 73. *Captain Lord George Graham in his Cabin.*
1745. Oil on canvas, 28 × 35in. London,
National Maritime Museum

The picture was painted soon after Lord George
Graham in June 1745 pursued and attacked a
squadron of French privateers with a convoy of
prizes off Ostend. He was congratulated for his
successful action by the Admiralty and appointed to
command the large frigate *Nottingham*, in which
Hogarth shows him relaxing before dinner. His
chaplain and secretary are singing a catch to the
music of a drum and fife played by his black servant.
His dogs join in, one wearing his wig, with the
music supported by a wine glass. The steward
bringing in a roast duck pours the gravy down the
chaplain's back.

74.	*Taste in High Life,* or *Taste à la Mode.* 1742
	(dated on the picture at the back of the room).
	Oil on canvas, 24¼ × 29¼ in. Private Collection

skirt and her legs distorted by high-heeled shoes. A
cupid is shown kindling a fire made of a hoop, muff,
and bag with queue wigs. Another cupid in the
distance pares down the contours of a girl to make
her figure conform to the latest mode. The painting
on the right shows caps, hoops, solitaires, wigs,
muffs, and high-heeled shoes as emblems of the
fashion. On the fire screen is a woman being carried
in a sedan chair whose hoop rises dangerously on
either side of her (cf. Plate 116).

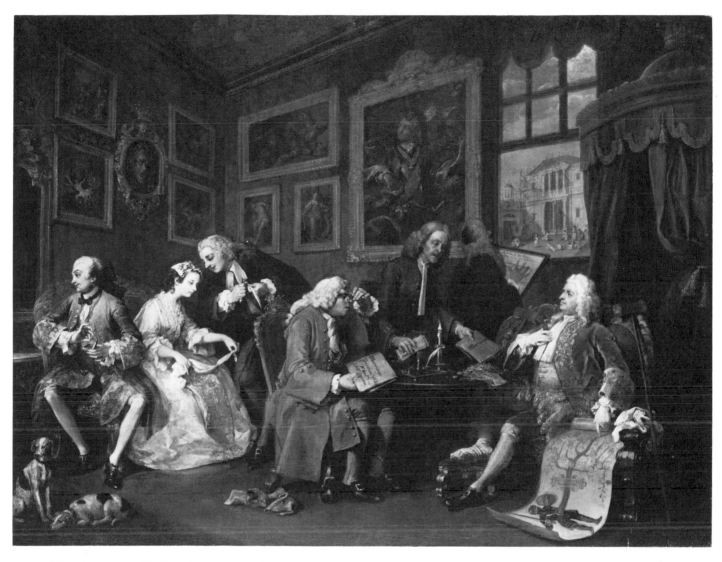

75. *Marriage à la Mode*, 1. 1743–45. Oil on canvas,
 27 × 35 in. each. London, National Gallery

s'. He

ntings

ntil

shows

's son;

irror)

on,

ed shoe
hoop,
in the
l to ma
he paint
, wigs,
of the
ing carr
usly on

HOYLE
OF
WHIST

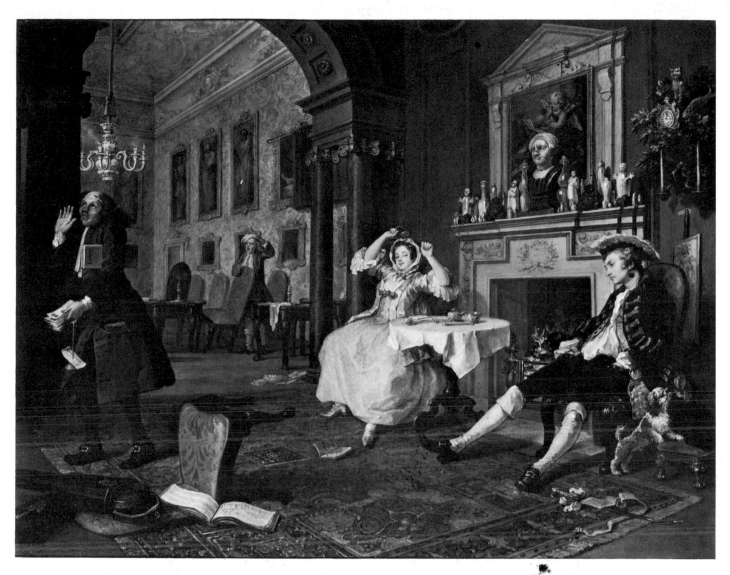

76, 77. *Marriage à la Mode, 2*

The wife now spends her nights at card parties, the husband with a mistress. This scene shows how Hogarth combines narrative with emblem. We see a lady's bonnet protruding from the husband's pocket and Hogarth makes its meaning unmistakable by having a dog sniff at it suspiciously and by showing the wife wearing *her* bonnet. This small detail tells a story of an encounter that night with another woman, of perfume, carelessness, and infidelity; but it also creates an emblem of the Unfaithful Husband. And this, combined with the far-off wife, the gaping fireplace between them, and the jumbled bricabrac on the mantel, becomes emblematic of a dissolving marriage. The Cupid, who should be playing a lyre, plays a bagpipe, with associations of cacophany, amid ruined pieces of masonry. This image of disharmony is part of the larger image of disharmony between husband and wife, carried out in all the differences between them, including the detail of the bonnet.

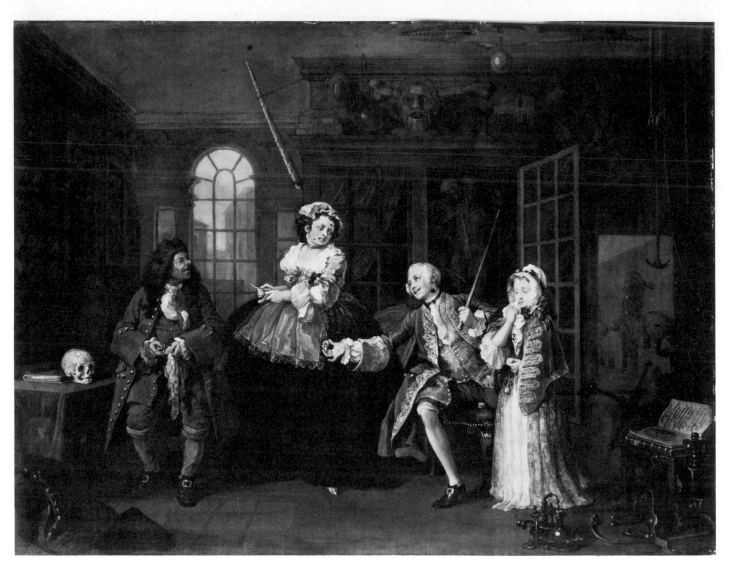

78. *Marriage à la Mode, 3*

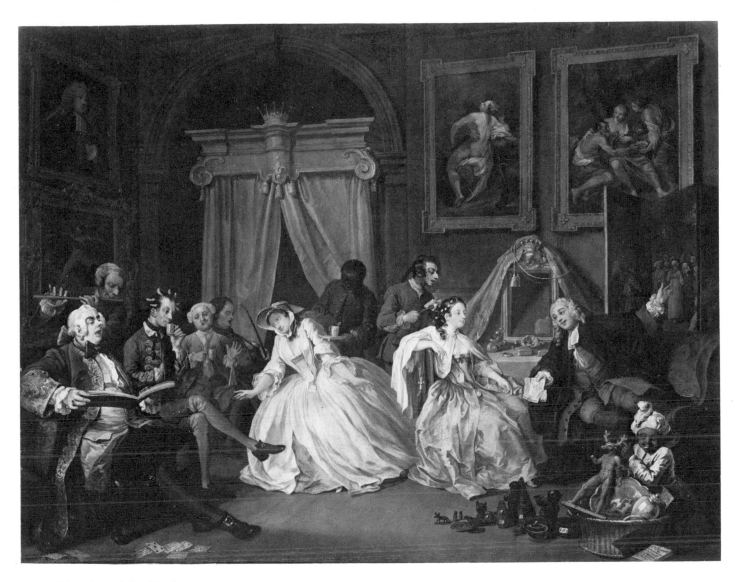

79. *Marriage à la Mode*, 4

The extra-marital activity of the merchant's daughter (contrasted with the Earl's slumming) is aspiration toward the fashionable and upper-class: i.e., she listens, among figures who might have appeared in *Taste in High Life* (Plate 74), to a castrato singer, collects the most decadent art objects, and arranges an assignation with Lawyer Silvertongue at a masquerade. Here again narrative and emblem are one: the lawyer holds out a ticket to the countess with one hand and points to the screen showing a masquerade with the other, telling us what will happen; and just in front of them a black servant boy points to the horns of a figure of Actaeon (see p. 18). The pictures on the walls, besides a portrait of Silvertongue, are of the Rape of Ganymede, the Rape of Io, and Lot's daughters getting him drunk in order to seduce him, all 'old masters'. They comment on her tastes, sexual and aesthetic, and the Ganymede is appropriately just above the head of the castrato singer.

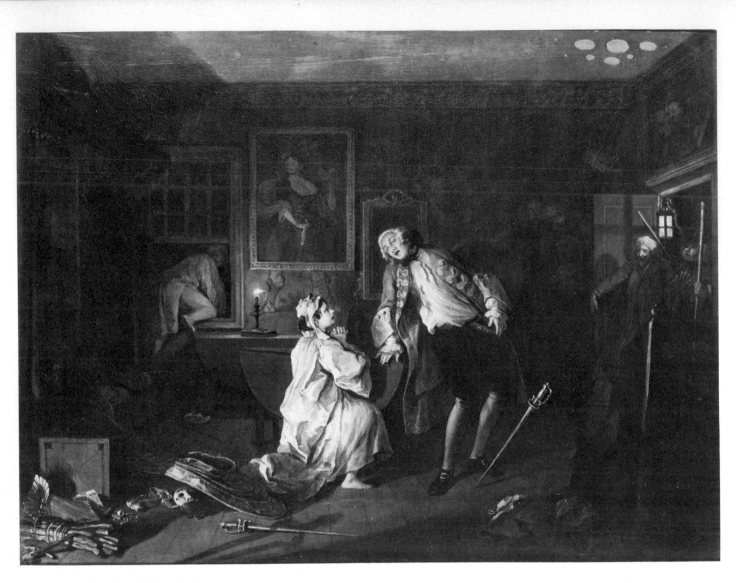

80, 81. *Marriage à la Mode, 5*

The masquerade is followed by adultery in a bagnio
and the intrusion of the injured party, the Earl. A
duel follows, ending in the Earl's death and the
lawyer's escape (in his nightgown) through a
window as the night-watch enters at the right.
Above the door, St Luke intently observes the scene
(like the Medusa in 1, the Roman bust on the mantel
in 2, the skeleton and stuffed man in 3, and
Silvertongue himself in 4); in fact, St Luke is
painting the scene—ironically, since he is supposed
to have painted the Virgin, who descended from
heaven to sit for him. The tapestry on the back wall
shows the Judgement of Solomon (I Kings 4), a wry
allusion to Silvertongue as Solomon, the countess as
the prostitute-mother, and the Earl as the sacrificial
babe. Also on the wall, apparently glancing at
Silvertongue's departure, is a prostitute posed as a
shepherdess in a pastoral scene, with the hefty legs
of a soldier showing beneath the frame. The Earl
expires, appropriately, with his head framed by a
mirror (cf. 1, Plate 75).

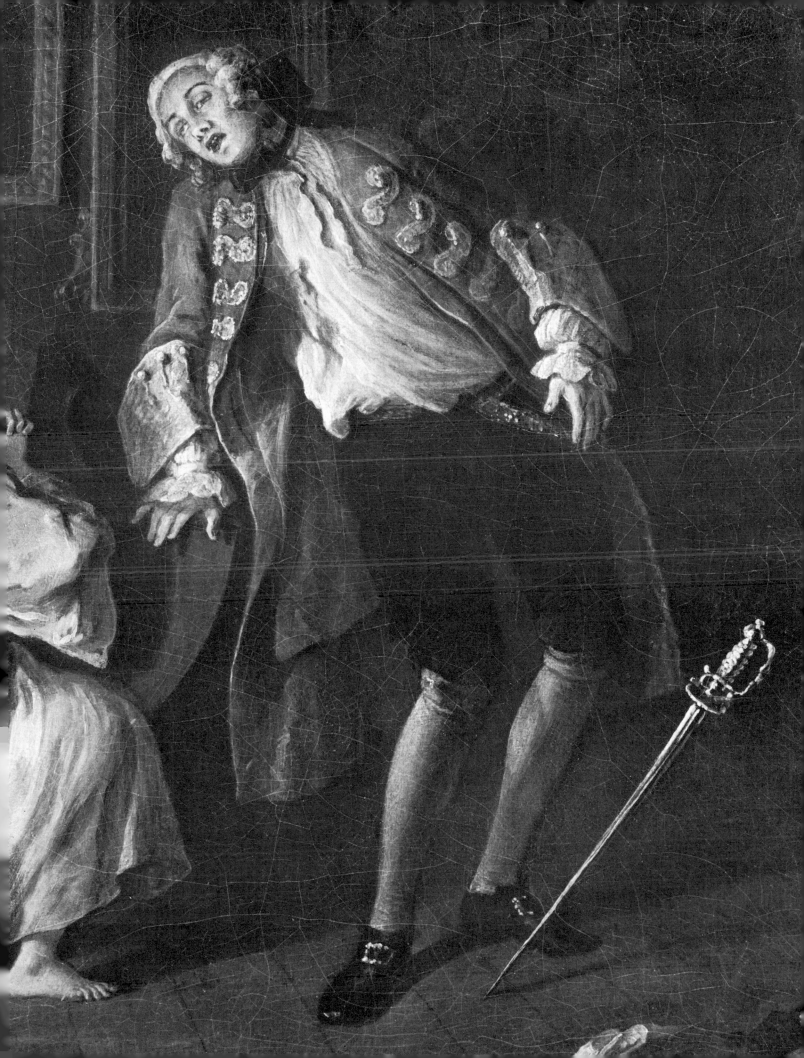

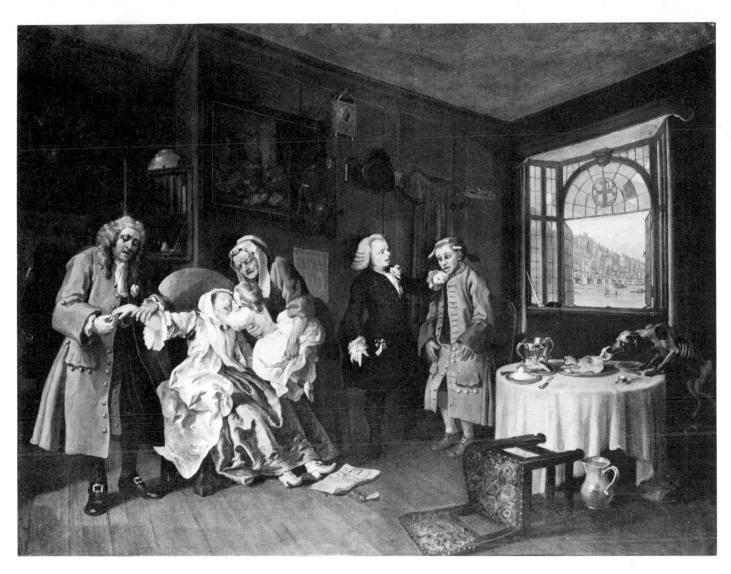

83. *Marriage à la Mode*, 6

From the paper on the floor and the bottle of
laudanum next to it, we see that Lawyer Silver-
tongue has paid for his crime and the Countess, in
despair, has poisoned herself. She is back in her
father's quarters, surrounded by his low-life Dutch
pictures and parsimonious habits. He removes the
wedding band from her finger, to salvage *something*
from the unfortunate transaction. The child of the
marriage—apparently a female (and so the
extinction of the Earl's line)—bears the congenital
marks of the father's beauty patch and a brace on
the leg. In every sense, in this series, the fathers'
sins have been visited upon the children.

82. Detail of *Marriage à la Mode*, 4 (Plate 79)

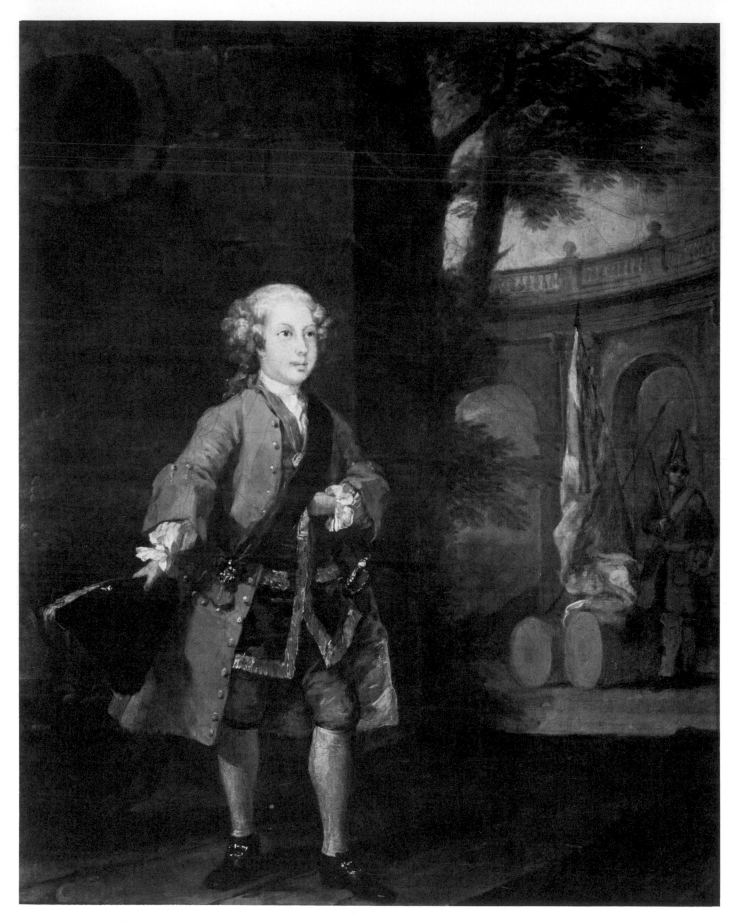

84. *H.R.H. William Augustus, Duke of Cumberland.*
Dated 1732. Oil on canvas, $17\frac{1}{2} \times 13\frac{1}{2}$ in.
Private Collection

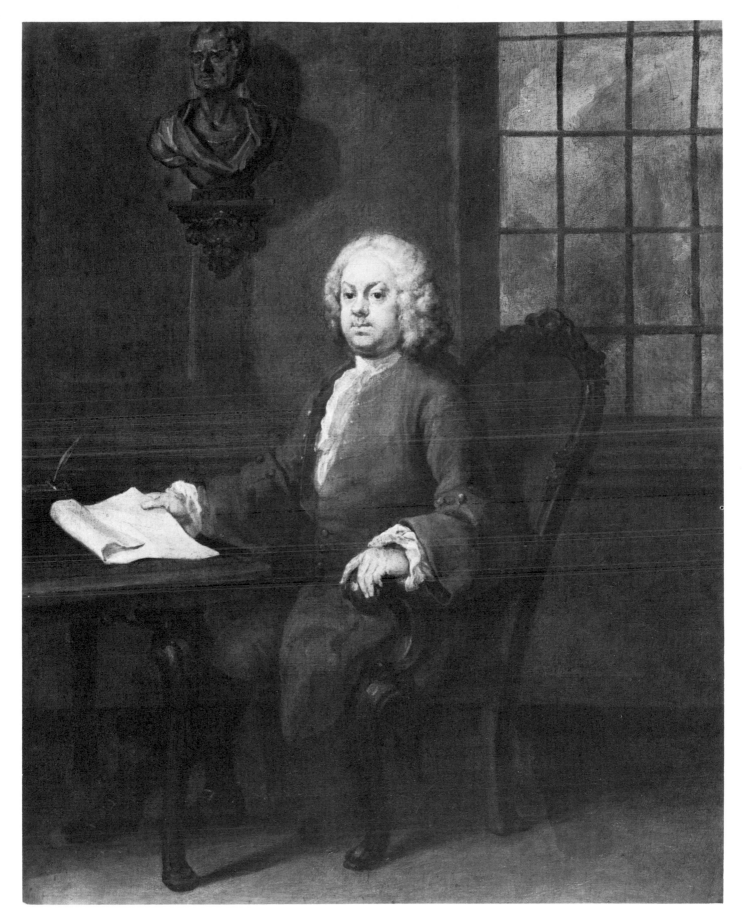

85. *Benjamin Hoadly, M.D. c.*1738. Oil on canvas,
22¾ × 18¼ in. Cambridge, Fitzwilliam Museum

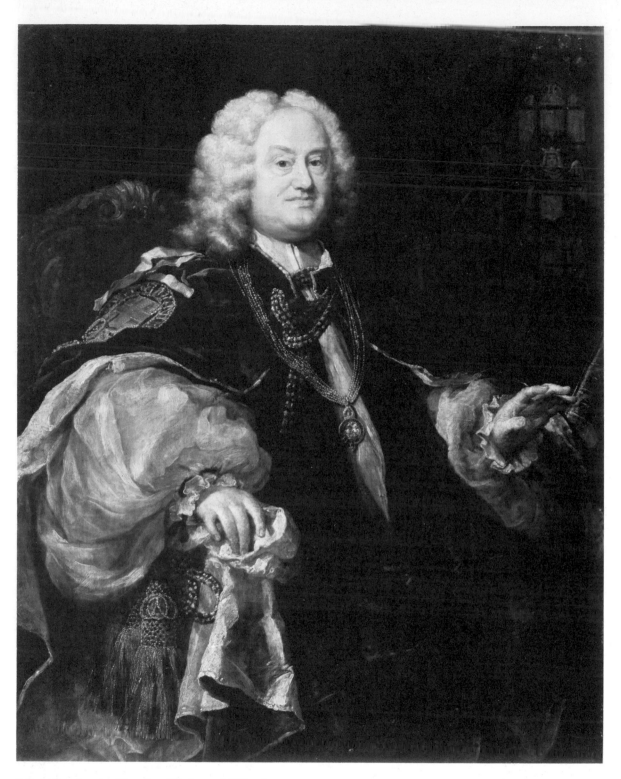

86. *Benjamin Hoadly, Bishop of Winchester. c.*1743.
Oil on canvas, $49\frac{1}{2} \times 39\frac{1}{2}$ in. London, Tate
Gallery

There were a few single portraits like the
Cumberland (Plate 84) in the early 1730s, but only
with the full-length of his friends Benjamin Hoadly
the younger (Plate 85) and Captain Coram (opposite)
did Hogarth get into the serious production of
portraits. The *Coram* is the most important of these,
boldly mixing the conventional props and attributes
of heroic portraiture with the representation of a
ship's captain, homely, oddly clothed, and with legs

hardly long enough to reach the ground. The
portrait of Coram is, indeed, directly parallel to the
progresses in which Hogarth introduced country
girls who became harlots and merchants' sons who
became rakes into the iconography of history
painting; but, in this case, with the intention of
redefining heroism in contemporary terms. The
globe shows the Atlantic, where Coram had done his
trading, and the east coast of America where he had

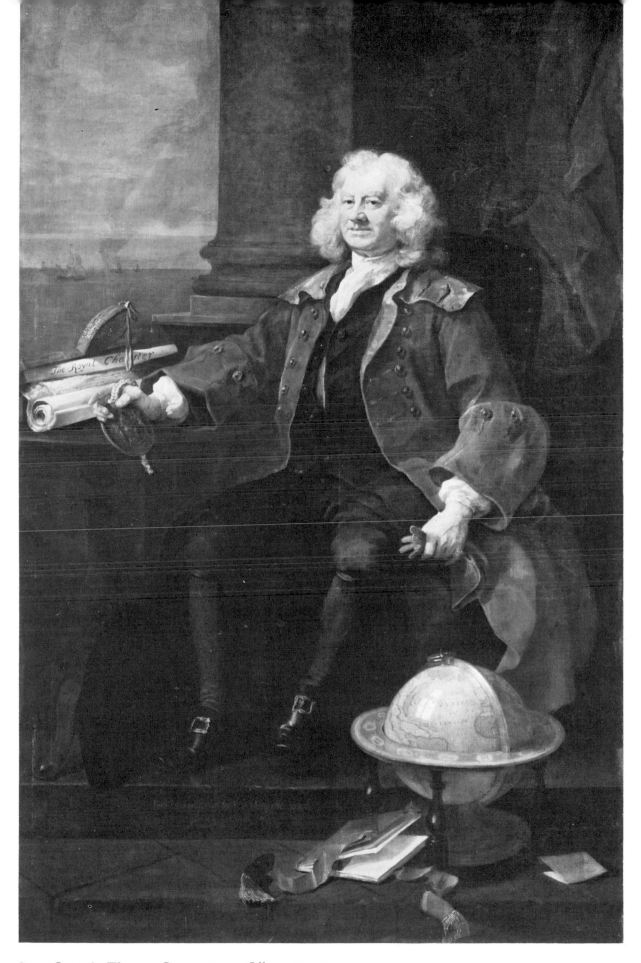

87. *Captain Thomas Coram.* 1740. Oil on canvas,
 94 × 58 in. London, The Thomas Coram
 Foundation for Children

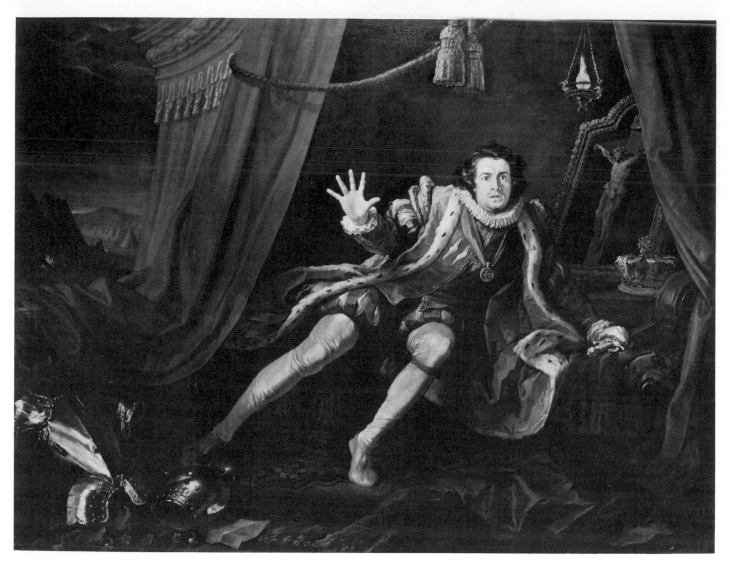

88. *David Garrick as Richard III*. 1745. Oil on canvas, 75 × 98½ in. Liverpool, Walker Art Gallery

been active in setting up Georgia as 'a charitable Colony' and in planning for the colonization of Nova Scotia. The shape behind him on the wall, barely visible in the painting but clear in Nutter's mezzotint (1796), is a plaque showing a Charity group. Coram's greatest achievement was the establishment of the Foundling Hospital in 1739; the charter lies next to his hand, which firmly clasps the seal. The large black hat on the floor alludes to the services he performed for the hatters of London, who felt they were getting unfair treatment in the trade with the Colonies. To express their gratitude they offered him a gift, but he would accept only a

hat—with which he was supplied whenever he needed a new one.

Garrick as Richard III is important both as a monumental portrait, which shows the simplification of forms carried out by Hogarth in the mid-1740s, and as an adaptation of native English history and drama (Shakespearean) to history painting. In 1746 Hogarth issued an engraving. Garrick, one of his closest friends, was painted again by Hogarth with his young wife Eva Maria Veigel (a dancer known as Mlle Violette).

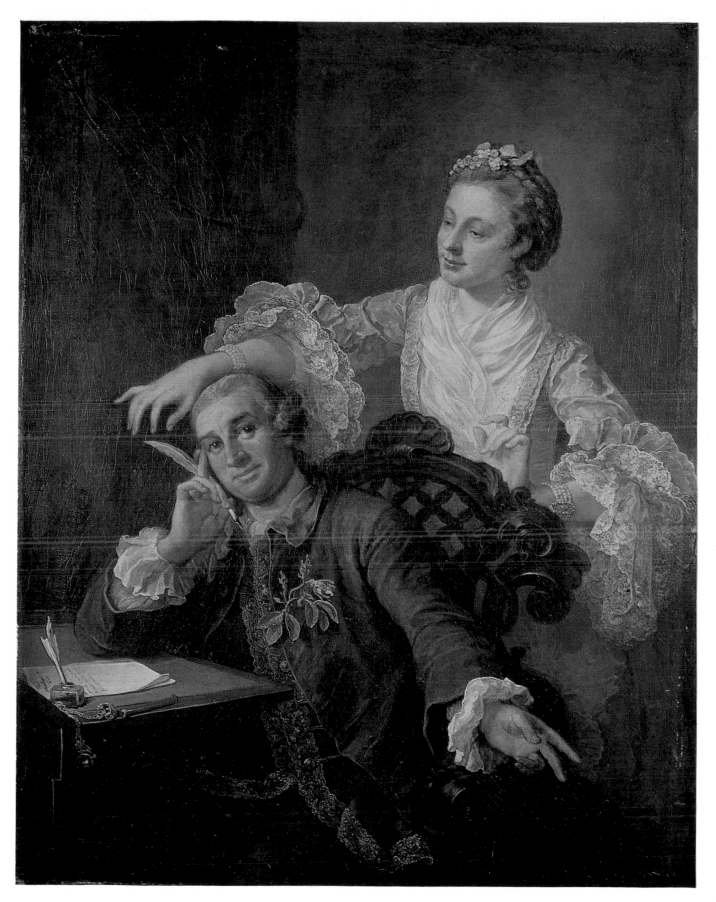

89. *Garrick and his Wife*. 1757. Oil on canvas,
 50½ × 39¼ in. Royal Collection

90, 91. *O the Roast Beef of Old England ('Calais
Gate').* 1748. Oil on canvas, 31 × 37¼ in.
London, Tate Gallery

In August 1748 Hogarth made a second trip to the
continent, and either upon arrival or upon his
return (it is not clear which) he was arrested for
sketching the French fortifications of Calais. He was
released when he proved he was only a 'caricaturist',
but was sent back home on the next packet, where
he set to work at once commemorating the event in
this painting, shortly thereafter issued in an
engraving. The artist (self-portrait in profile at the
left) is about to be clapped into prison: the threat of
this hangs over the scene, with nearby the
portcullised gate and behind it the confinement of
the French themselves within Calais—and beyond
that, the beautiful, clear, open sky.

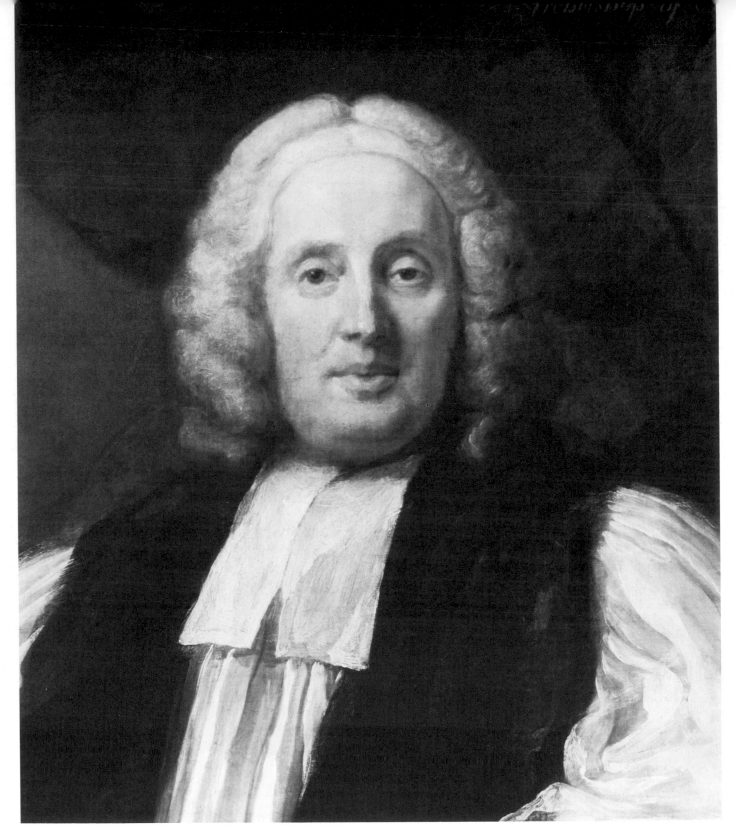

92. *Thomas Herring* (detail of Plate 97)

The portrait of Herring (Plate 97) seems to have have been largely repainted by Hogarth after his visit to Paris in 1743 (in connection with *Marriage à la Mode*). He had seen the work of Quentin de la Tour, which he later recommended to Alan Ramsay and others, and something of La Tour's pastel technique is conveyed by Hogarth's brushwork. He did not repeat the experiment, though the same quality of paint appears in the sleeves of *Bishop Hoadly* (Plate 86).

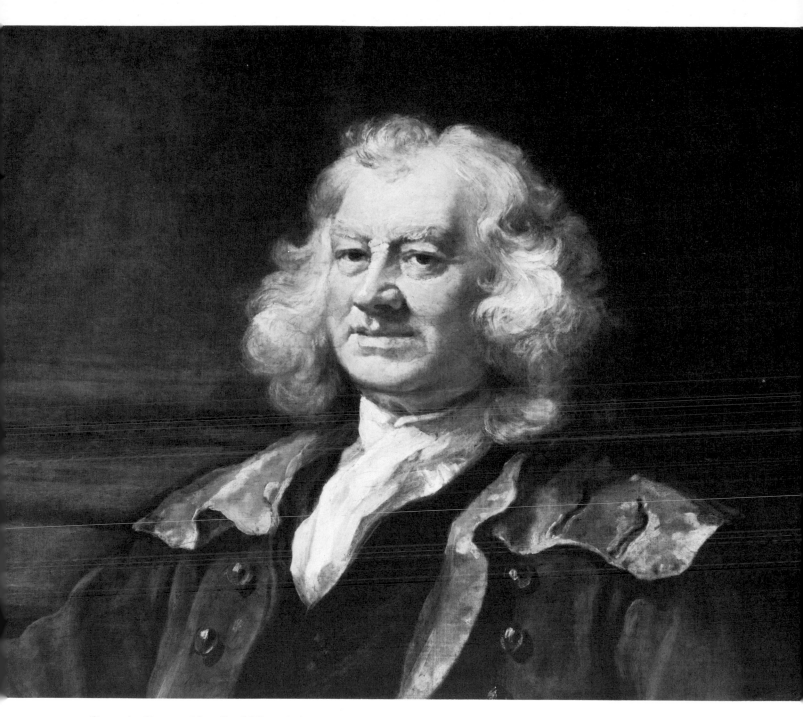

93. *Captain Coram* (detail of Plate 87)

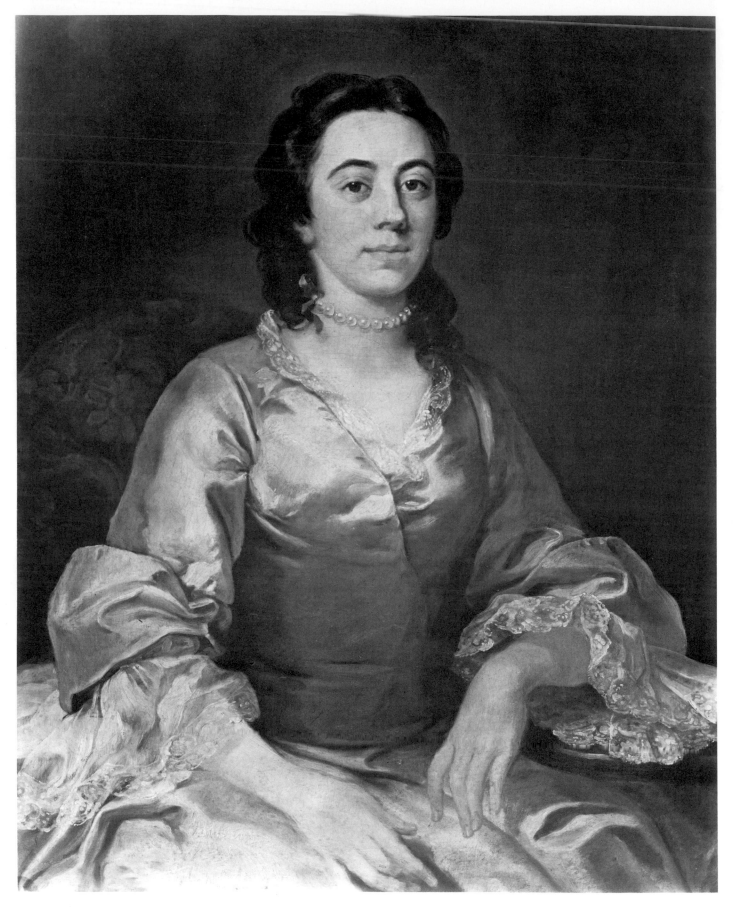

94. *Miss Frances Arnold. c.*1740. Oil on canvas,
 35 × 27 in. Cambridge, Fitzwilliam Museum

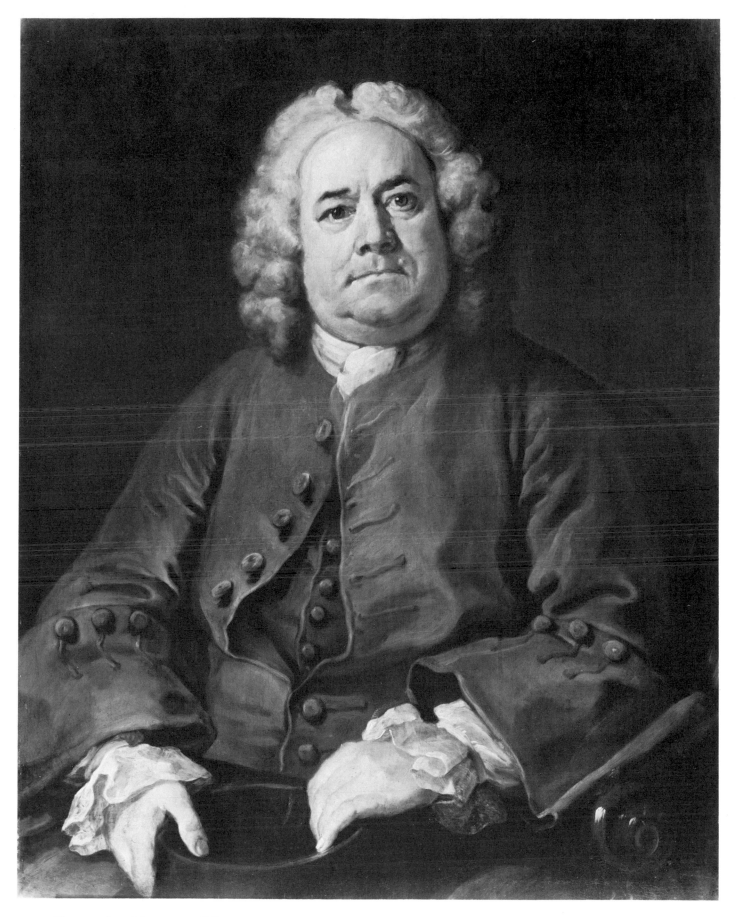

95. *George Arnold. c.*1740. Oil on canvas,
35 × 27 in. Cambridge, Fitzwilliam Museum

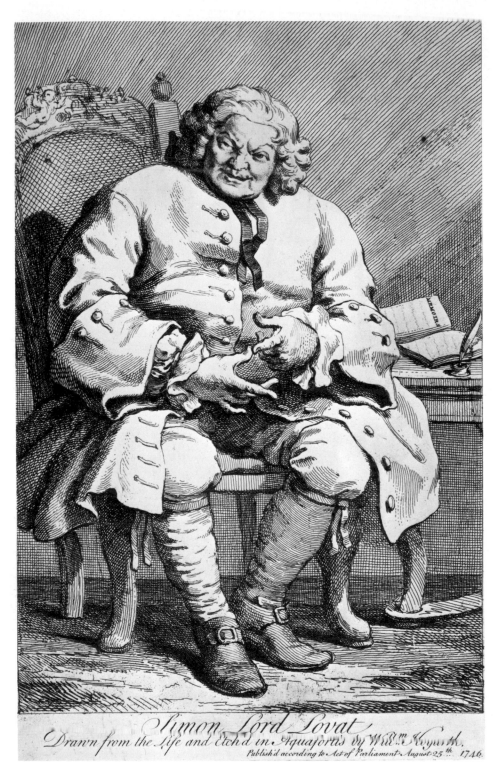

Simon Lord Lovat
Drawn from the Life and Etch'd in Aquafortis by Will.ᵐ Hogarth.
Publish'd according to Act of Parliament August 25.ᵗʰ 1746.

96. *Simon Lord Lovat.* 1746. Etching, $13\frac{3}{16} \times 8\frac{7}{8}$ in.
London, British Museum

Lord Lovat, the Scottish rebel and chief of the Fraser clan, fled after the Battle of Culloden, but was captured and taken to London. On 14 August 1746 Hogarth met him at St Albans, where he stopped briefly on his way to London, and sketched him counting off the Highland clans that had fought for the Pretender in the rebellion. The book on the table is his *Memoirs*, subsequently published in French. Hogarth issued this etching on the 25th, and such was Lovat's notoriety that, although the presses worked day and night, he could not keep up with the demand. Lovat's trial was the following spring, and he was executed on 18 March 1747.

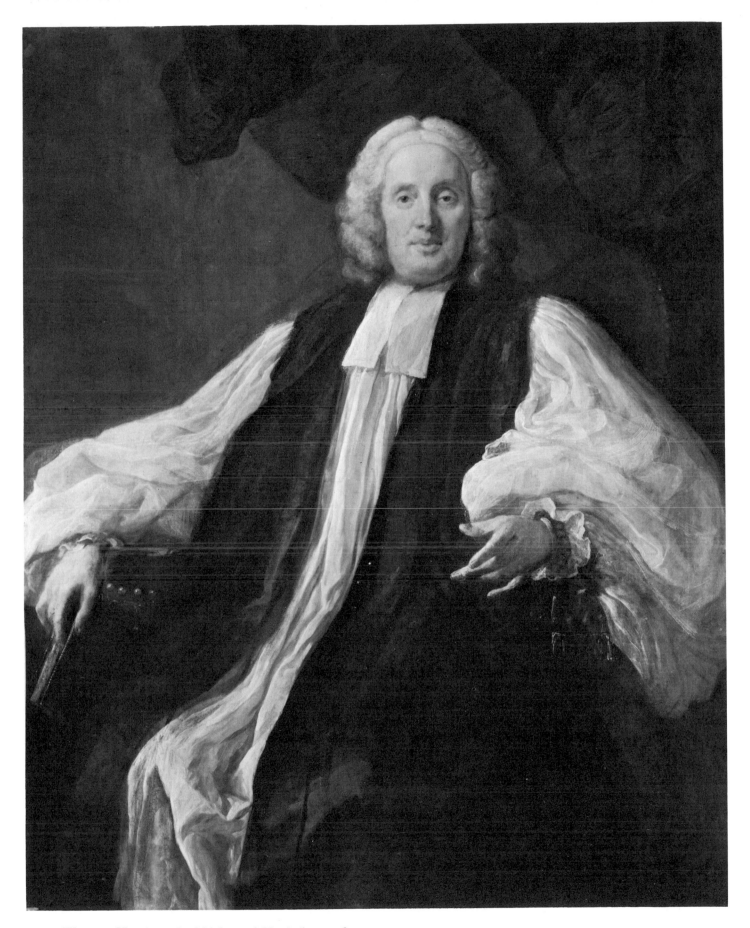

97. *Thomas Herring, Archbishop of York* (later of
 Canterbury). 1744. Oil on canvas, 49 × 40 in.
 Tate Gallery (on loan). See note to Plate 92.

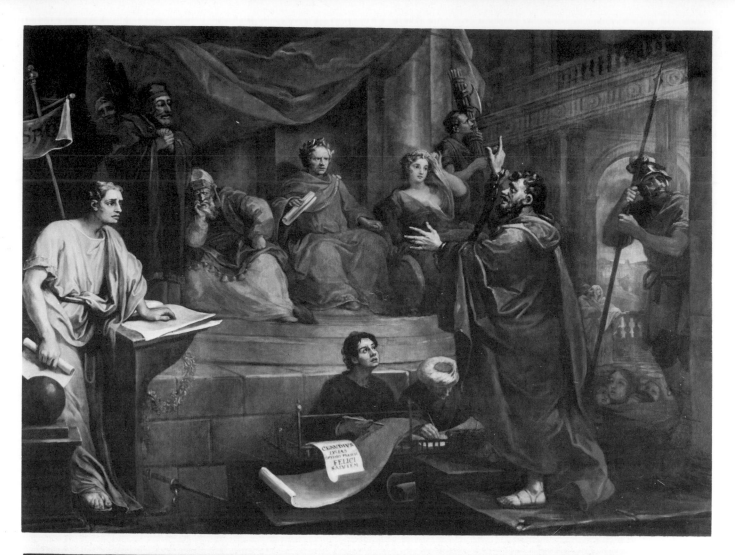

98.
Paul before Felix.
1748. Oil on canvas,
120 × 168 in. London
The Hon Society of
Lincoln's Inn

99.
Paul before Felix
(as retouched in 1751
and before cleaning
in 1970)

The text is Acts 24:25.
For commentary, see
Introduction, pp. 51–3.

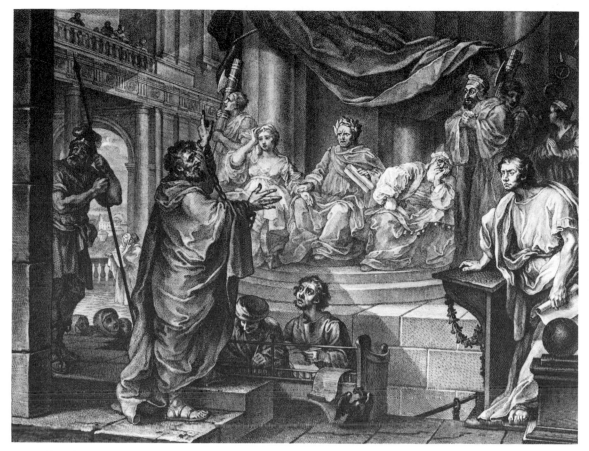

100. *Paul before Felix*. 1752. Engraving by Hogarth, $15\frac{1}{8} \times 20\frac{1}{16}$ in.
Caption not reproduced. London, British Museum

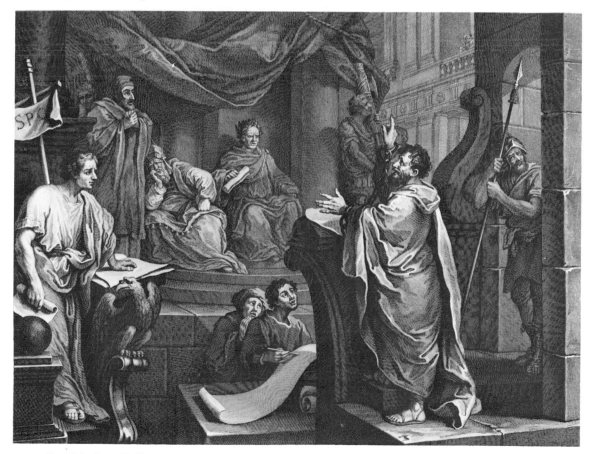

101. *Paul before Felix*. 1752. Engraving by Luke Sullivan,
$15\frac{1}{8} \times 19\frac{7}{8}$ in. Caption not reproduced. London, British Museum

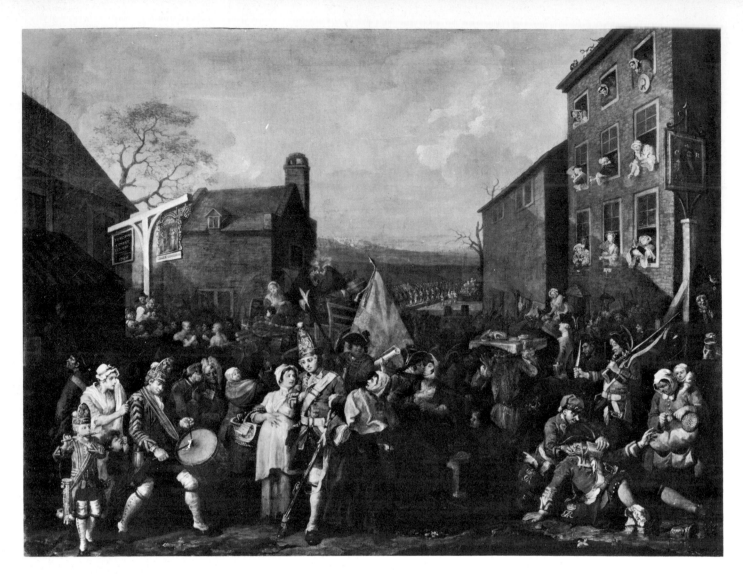

102, 103. *The March to Finchley*. 1749–50. Oil on canvas, 40 × 52½ in. London, The Thomas Coram Foundation for Children

Lottery chances for the painting accompanied the subscription for the engraving in the spring of 1750; the winning number was the Foundling Hospital's, and the picture went on permanent public display with *Captain Coram* and *Moses brought to Pharaoh's Daughter*. The picture is described, pp. 55–61. The 'Giles Gardiner' sign recalls the rout of Colonel (James) Gardiner's dragoons by the Jacobite forces at Prestonpans in September 1745, which produced the scare that culminated in panic in London (6 December) and the subsequent dispatch of reinforcements to Finchley. Hogarth also puns on 'gardener', the Adam and Eve sign, and the 'nursery' where trees are raised (the Tree of Knowledge) but also the 'nursery' that does a thriving business across the street from a brothel. Our eye moves from the 'Adam and Eve' to the Cain and Abel fighting beneath and to the result of the Fall, promiscuity and disorder.
The central group is a Choice of Hercules, between Protestant-English-Hanoverian and Catholic-French-Jacobite, tavern and brothel, and so on. The hand of Virtue is pointing not upward to remind the grenadier of the heroic path to wisdom but downward to remind him of the human problem of her condition and his obligation. The old hag, in the role of Pleasure, pulls him in the direction of the brothel, which would deprive the Protestant cause of men to strengthen the forces withstanding the Pretender. Pleasure, according to *Tatler* No. 98 (22–24 Nov. 1709), is a whore who will lead Hercules to a place where 'the affairs of war and peace shall have no power to disturb' him. 'The Remembrancer' she wields at the grenadier refers to James Burgh's popular *Britain's Remembrancer* (1746), a violent denunciation of 'our degenerate times and corrupt nation' and a warning that a 'legion of furies' was going to descend on England: these were 'venality, perjury, faction, opposition to legal authority, idleness, gluttony, drunkenness, lewdness, excessive gaming, robberies, clandestine marriages, breach of matrimonial vows, self-murders'—i.e. the chaos that extends between her gesture and the brothel, ending in such perversions of order as the parody of a Good Samaritan scene in the lower right corner (see Frontispiece).

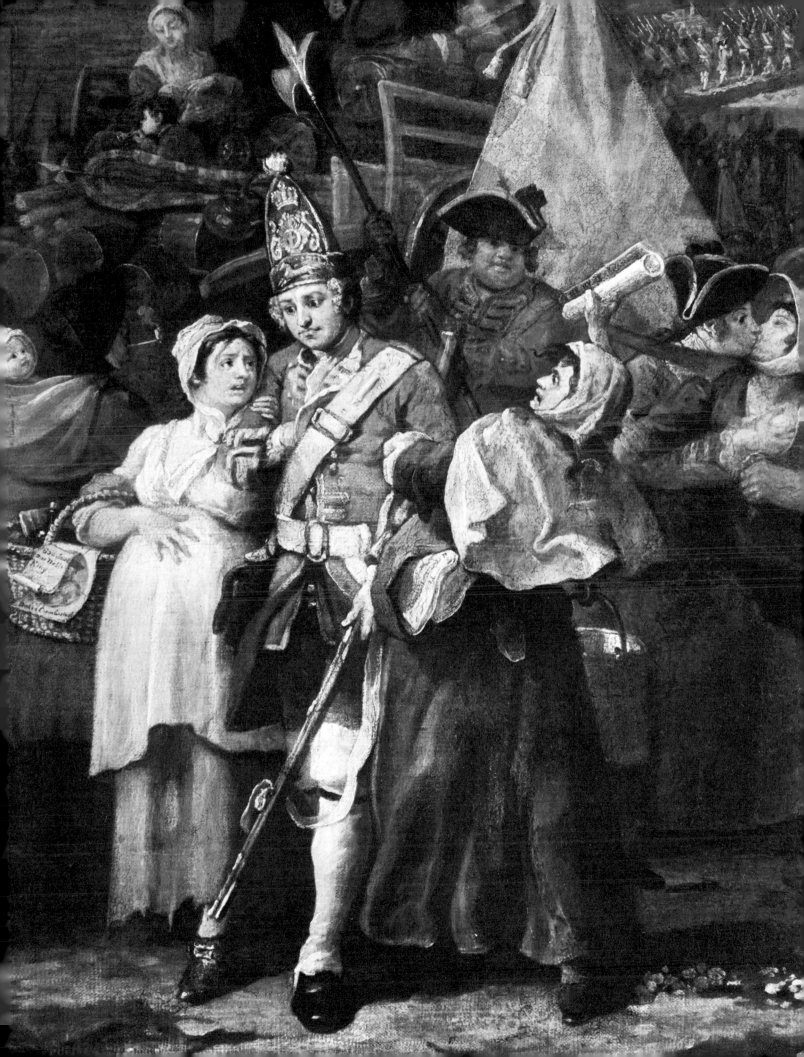

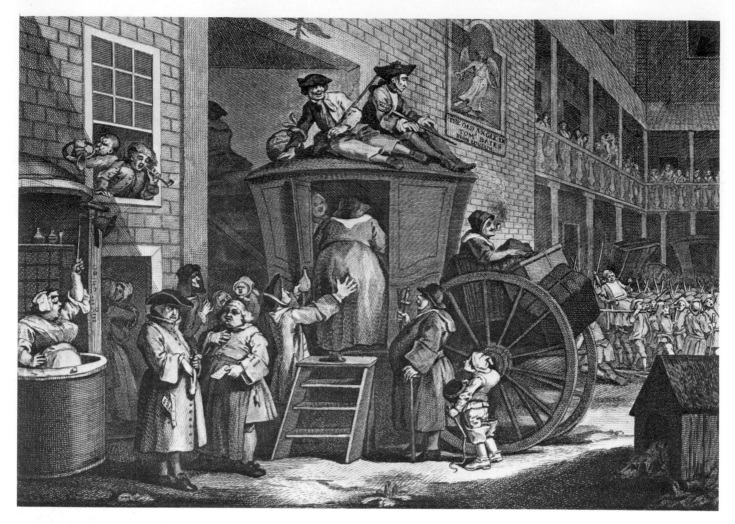

104. *The Stage Coach*, or *The Country Inn Yard*.
1747. Engraving, $8\frac{1}{8} \times 11\frac{7}{8}$ in. London, British
Museum

The Stage Coach was etched and published just
before the General Election of 16 June 1747. The
scene is outdoors but completely enclosed (no sky as
in the Harlot's innyard), and people are being
crammed into a stage coach. A dog is in its
doghouse, only its head protruding; a pair of lovers
inside a doorway; a refreshment-seller in her booth.
The comedy is one of containment and the
impossibility (as with the coach) of containment.

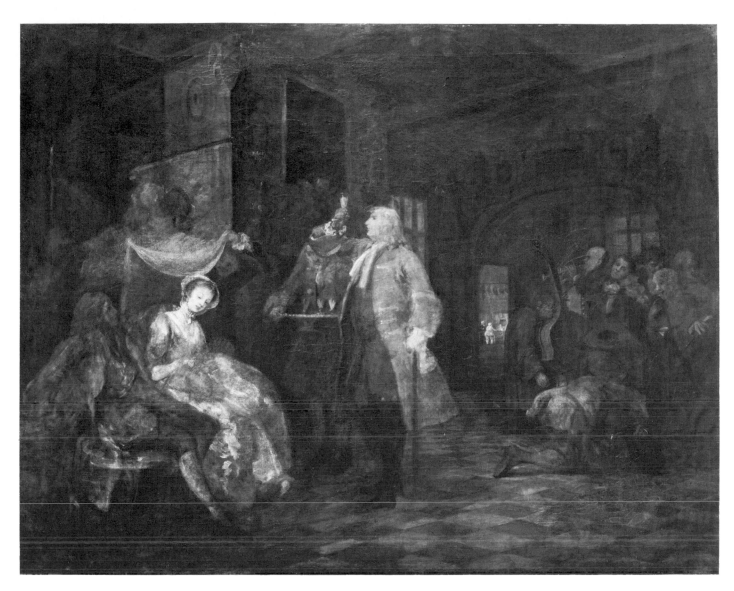

105. *The Wedding Banquet. c.*1745. Oil on canvas,
28 × 36 in. Truro, The County Museum (The
Royal Institution of Cornwall)

The Wedding Banquet and *The Wedding Dance*
(p.35), with also perhaps *The Staymaker* (Plate 123),
are approximately the same size, painted in the same
style, and seem to be concerned with the subject of a
marriage. It has been supposed that Hogarth may
have projected a series concerning a 'happy
marriage' following *Marriage à la Mode*.

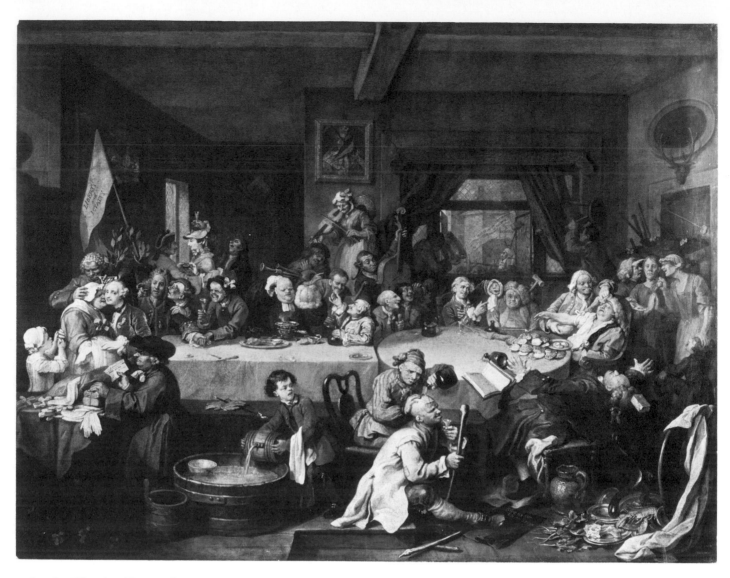

106. *An Election Entertainment*

An Election: Four Pictures. 1753–4. Oil on canvas,
40 × 50 in. each. London, Sir John Soane's Museum

The occasion for this series was the General
Election of April 1754, which, being a septennial
election, had been in the air for many months. In
Oxfordshire, where the Duke of Marlborough was
challenging one of the last 'Tory' strongholds, the
campaigning had been in progress for two years. For
the first time within memory the Whigs and Tories,
indistinguishable except as *ins* and *outs*, thought
they were polarized over some issues—primarily
the innocuous 'Jew Bill' of 1753 which had
naturalized Jews then resident in England. The
clamour of rival City merchants and old Tories, and
a campaign of wildly anti-Semitic propaganda, led
the Ministry to repeal the bill in the autumn of
1753. But the Tory attacks on 'The Act in favour of
the enemies of our Blessed Redeemer', the

'Crucifiers' who desired to circumcise English men
and boys, continued up to the election. Hogarth uses
Whig and Tory—or orange versus blue, New
Interest versus Old—as a final *reductio ad absurdum*
of the polarities he had been examining since *The
Four Times of Day* and *Industry and Idleness*: both,
he shows, amount to undifferentiated mobs.

The first scene is an 'Election Entertainment' in
both the sense of a political dinner—as ironic a title
as *Midnight Modern Conversation* applied to a
drunken revel (Plate 17)—and the sense of an
amusement for the civilized gentleman who looks on
such folly with detachment. The Whigs are inside,
the Tories parading outside with their outdated or
trivial issues of the Jew Bill, the Marriage Act, and
the Gregorian calendar; but the last of these ('Give
us our Eleven Days') has been brought inside the
dining-room by a Whig bruiser. And the Tories

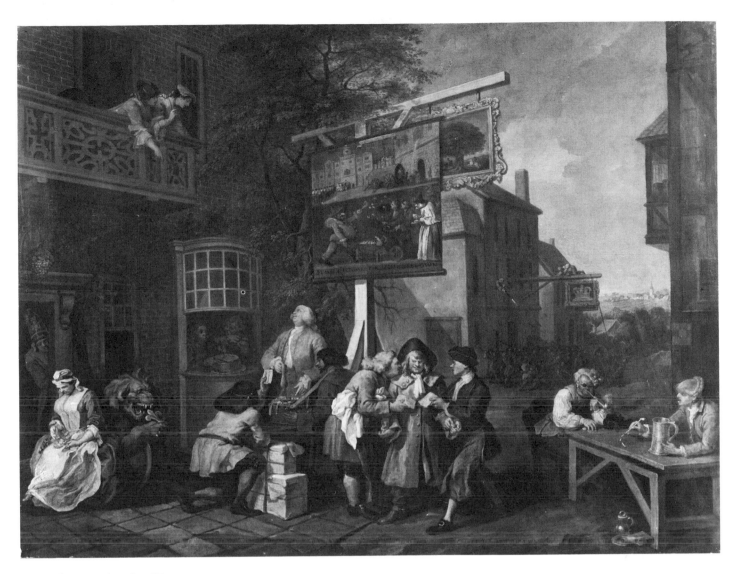

107. *Canvassing for Votes*

have used the dining-room the day before: the Whigs would never have slashed the portrait of William III. Both parties share the politician's coat of arms, three guineas, a bellowing mouth, and the motto 'Speak and Have'. Everything is interchangeable, including presumably the alcohol and the supporters. The mayor, at the right, has passed out from overeating and is being bled (Plate 109). The two Whig candidates, at the left, being harassed by their constituents, are nearly the least conspicuous figures at the dinner.

Canvassing for Votes shows three inns: one in the foreground is a Tory stronghold, the Royal Oak (its sign showing Charles II's escape after the Battle of Worcester), with a huge anti-ministerial poster labelled 'Punch Candidate for Guzzledown': Punch is bribing voters, and the stream of money from the Treasury is going into electioneering instead of the

armed forces. The local Tory candidate stands under the poster; despite the anti-Jew signs of the Tories in the first scene, he is buying trinkets from a Jewish pedlar to bribe the young ladies on the balcony. The inn in the background, with a crown and 'The Excise Office', is the Whig stronghold— being besieged by a Tory mob. The central group consists of representatives from each inn offering bribes to a voter: a Choice of Hercules composition in which both Virtue and Pleasure offer a bribe, again underlining the similarity in difference between rival parties.

The third inn, at the right, is the Portobello (we see on the tankard), named after the British naval victory over the French. Hogarth's message is that our sympathy should be with this pair reliving a naval victory; not with the politicians' nest across the way and its effigy of the British lion (without teeth in the engraved version) eating the fleur-de-lis.

108. Detail of *Canvassing for Votes* (Plate 107)

109. Detail of *An Election Entertainment* (Plate 106)

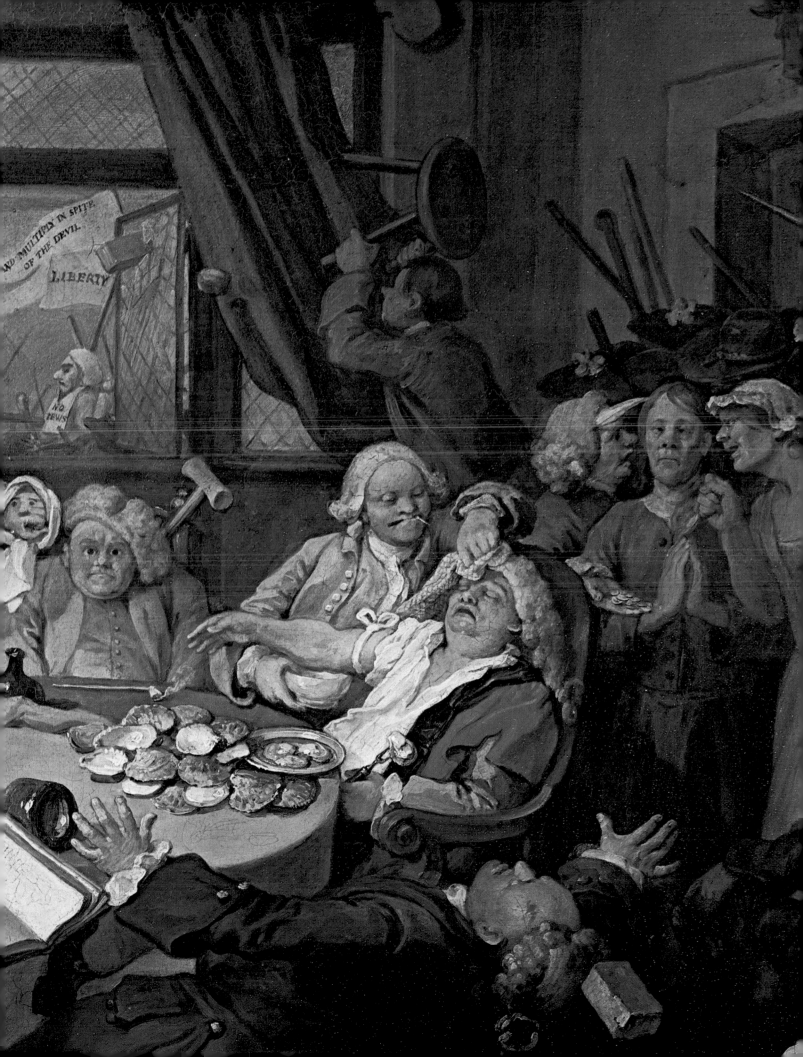

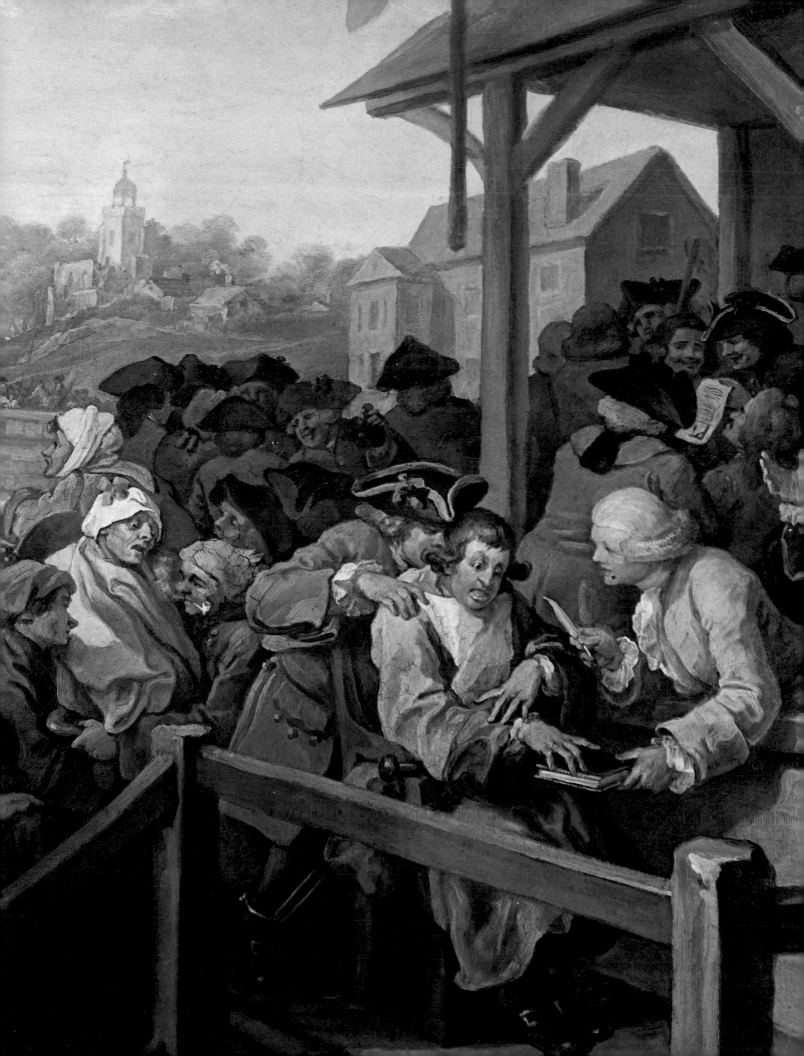

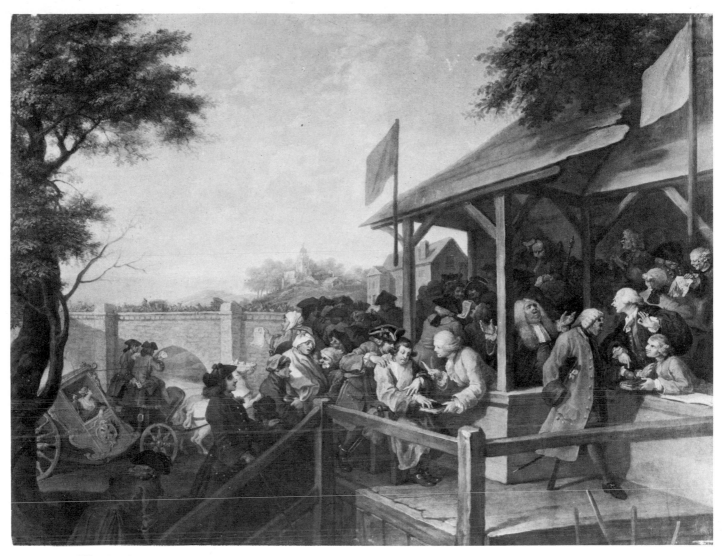

110, 111. *The Polling*

The halt, the lame, and the blind are dragged to the poll, some wearing blue, others orange, cockades. The Tory candidate appears to be more confident than the Whig, who is mopping his brow (Plate 113) All of this goes on while, ignored in the background, driven by cheating coachmen, poor Britannia sits in a collapsed coach which is England; and discernible in the gnarled trunk of the adjacent tree is a howling face, nature's response.

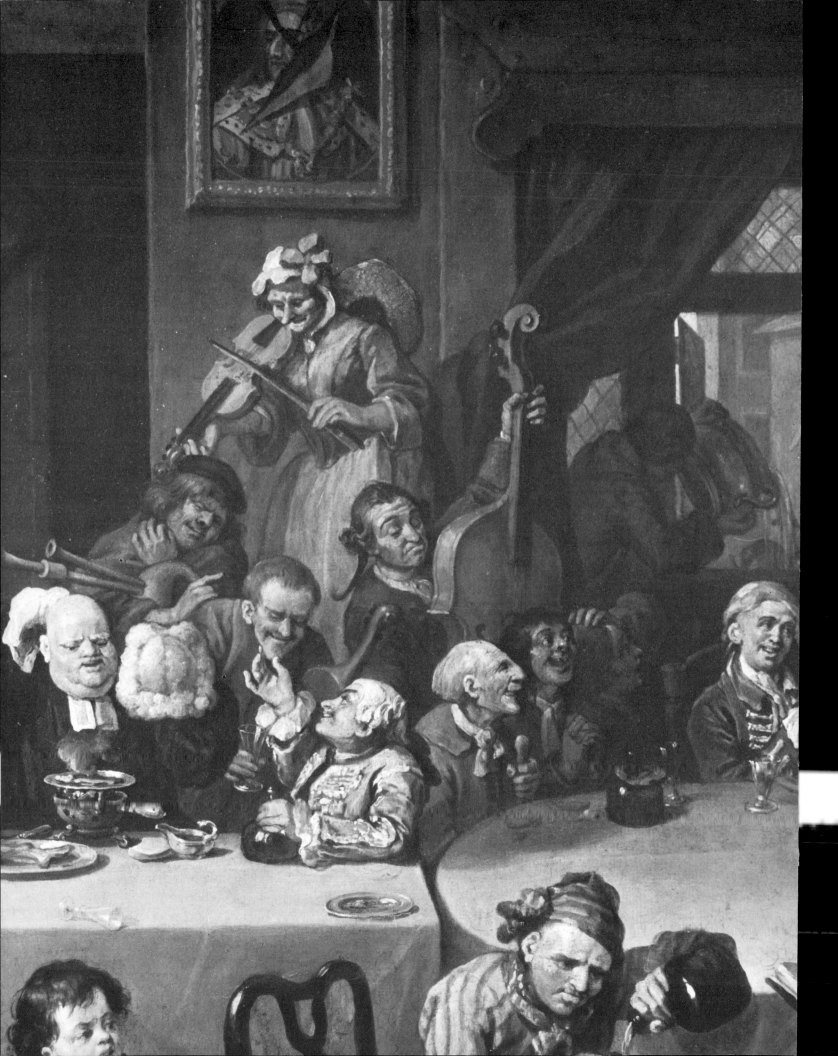

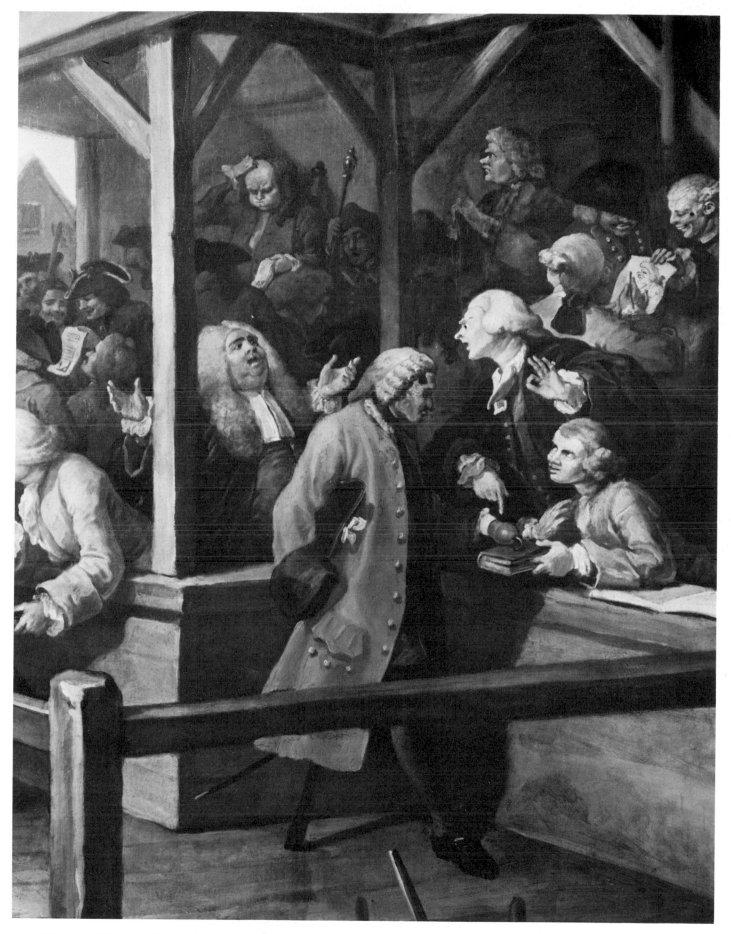

113. Detail of *The Polling* (Plate 111)

112. Detail of *An Election Entertainment* (Plate 106)

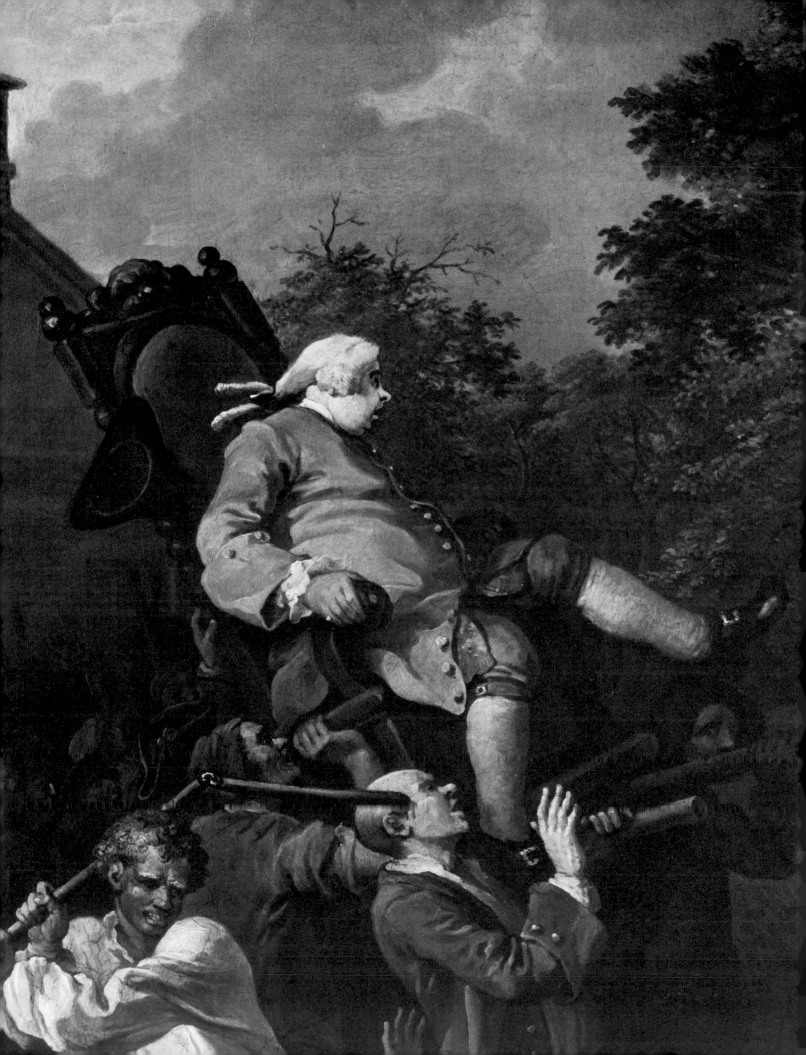

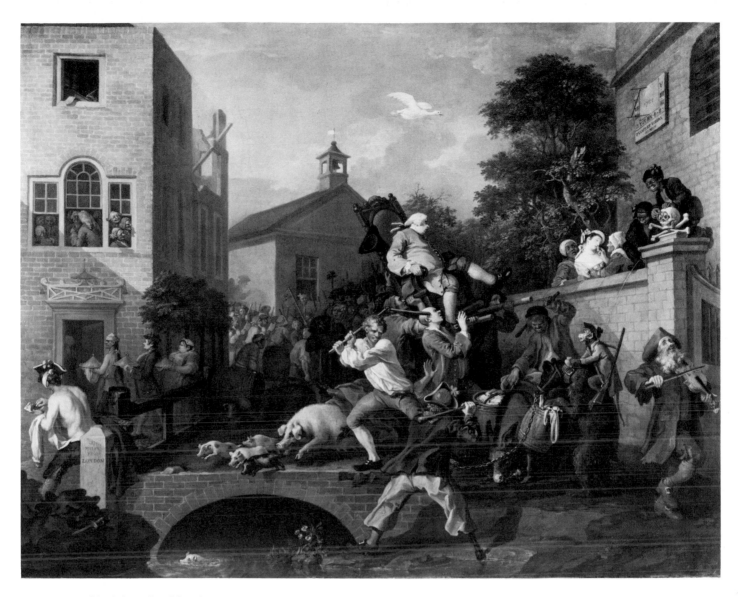

114, 115. *Chairing the Member*

The successful candidate is the Tory, being chaired by his mob of blues, while the orange counter-mob tries to unseat him. Ironically, his triumphal procession is led by a Jewish fiddler, paralleling the Tory procession in *An Election Entertainment* led by the Jew-in-effigy; and the swine (cf. Introduction, p. 64) reflect the election parodies of the 'Roast Beef of Old England' ('Sing oh! the Roast Pork of Old England, / Oh! the Old English Roast Pork') and the Tory dinners of pork and ham. If we may suppose the painting was not finished until after the election, the successful candidate is falling because in the Oxford election the Tory initially won but then lost when the issue was referred to the Whig-dominated House of Commons. And while his face was probably intended from the start to resemble the goose above him and the swine below (appearing the same in scenes 2 and 3), after the election returns he was given the specific likeness of George Bubb Dodington, one of the few Whig losers. The electioneer himself, the Duke of Newcastle, can be seen safe inside the building at the left while outside the crowd is loosed on the town and the successful candidate.

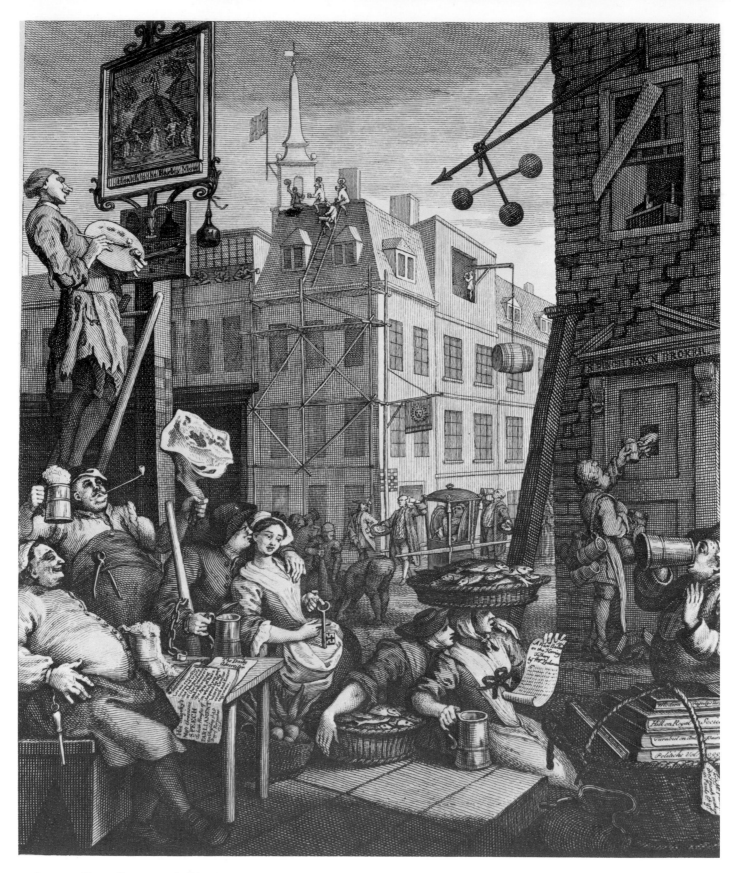

116, 117. *Beer Street* and *Gin Lane*. 1751.
Engravings, 14⅛ × 12 in. each. Captions
not reproduced. London, British Museum

After the failure of his picture auction in 1745
Hogarth momentarily gave up using paintings as
modelli for his engravings, turning instead to

drawings. In these drawings and prints he exploits
the simplicity and strength of the popular graphic
tradition. In *Gin Lane* (Plate 117) the least literate of
his audience would have sensed the horrifying
perversion of a Madonna and Child in the
gin-sodden mother dropping her baby; of a cross in
the pawnbroker's sign over the mother's head,

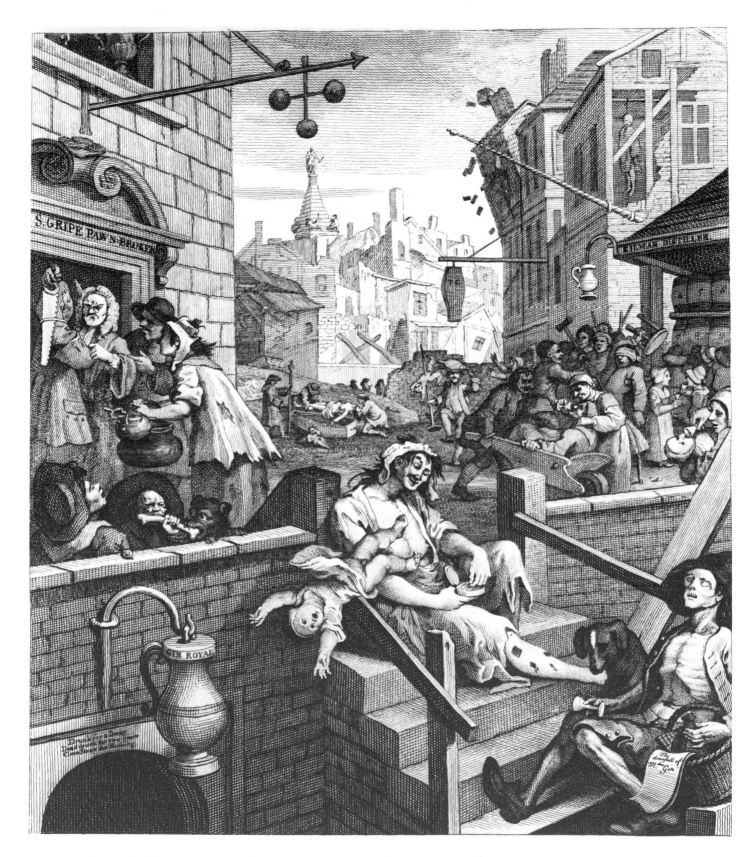

directly beneath which is the crossless steeple of a remote and inaccessible church (a statue of George I replaces the cross). But there is also a formal play at work that reminds us that Hogarth was beginning to write his *Analysis of Beauty* (1753; Plates 125, 126): we sense the relationship between the mother dropping her child and the man in *Beer Street* (Plate 116) with his arm around a young woman; and, for that matter, between the dying gin-seller

with his tiny gin glass and the beer-drinker whose mug resembles a trumpet pointing (as the gin-seller's glass does) into the inner scene. And between the dead woman being placed in a coffin and the fat live woman in her sedan chair, with the same number of attendants, each group under a pawnbroker's sign. And between the ovals that link the groups in *Beer Street*, from the artist's head and palette to the mutton, woman's face, and fish baskets.

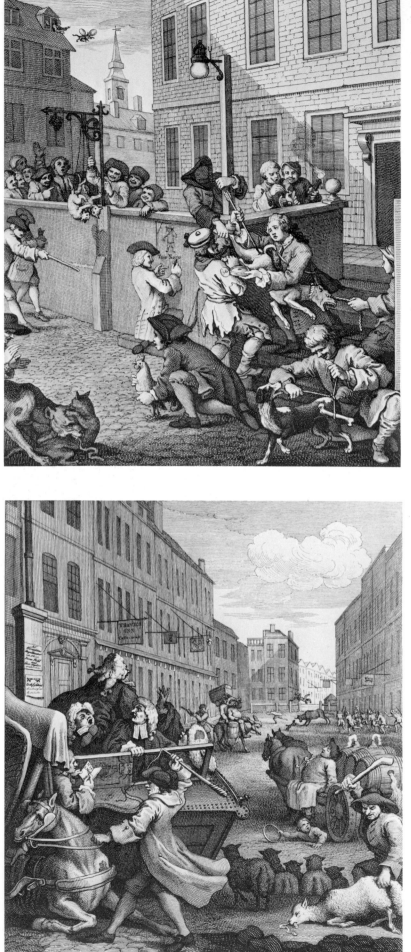

For commentary on *The Four Stages of Cruelty*, see the Introduction, pp. 61–2.

118. *The Four Stages of Cruelty: The First Stage of Cruelty*. 1751. Engraving, $14 \times 11\frac{1}{16}$ in. Caption not reproduced. London, British Museum

119. *The Second Stage of Cruelty*. Engraving, $13\frac{7}{8} \times 11\frac{15}{16}$ in. Caption not reproduced. London, British Museum

120. *Cruelty in Perfection.* Woodcut by John Bell,
$17\frac{5}{8} \times 14\frac{7}{8}$ in. London, British Museum

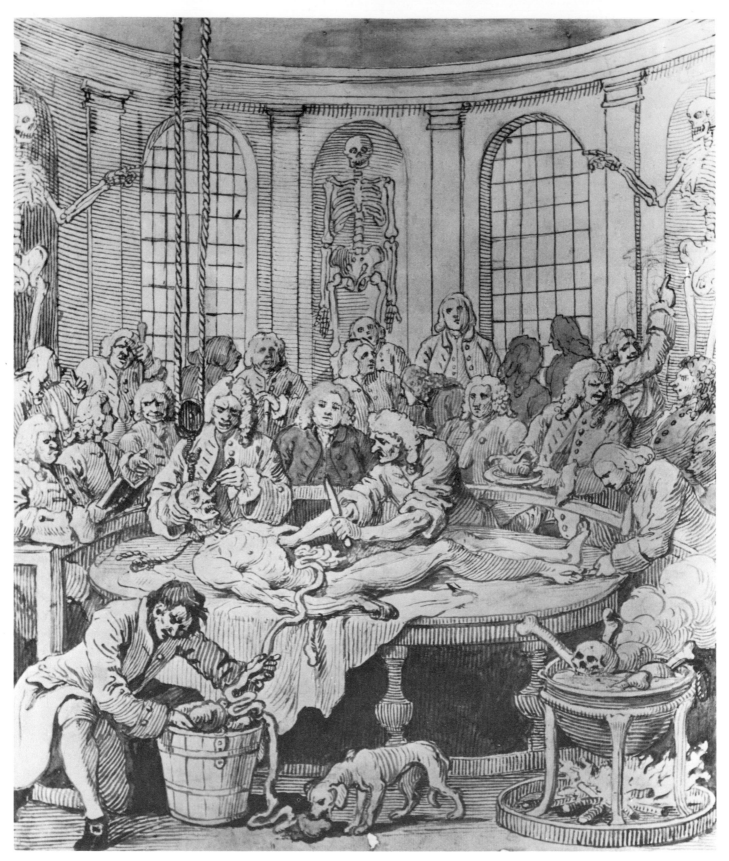

121. *The Reward of Cruelty*. Drawing (pen, brown ink, some grey wash), $18\frac{1}{8} \times 15\frac{1}{8}$ in. Windsor Castle, Royal Library

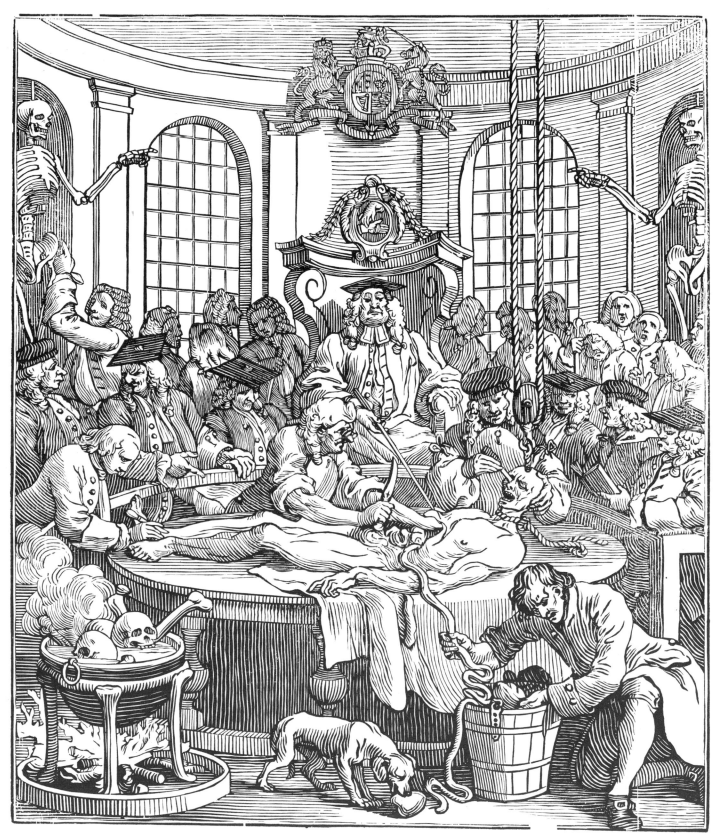

122. *The Reward of Cruelty*. Woodcut by John Bell,
17⅝ × 15 in. London, British Museum

123. *The Staymaker*. *c*.1745. Oil on canvas,
27½ × 35½ in. London, Tate Gallery

Besides its connections with the oil sketches of a
marriage (Plate 105, p.35), *The Staymaker* relates to
the other pictures of boys in uniform, especially *The
Enraged Musician* (Plate 65). In the background an
old crone is holding up a baby for an old person to
admire, and a somewhat more mature child is
pouring a glass of something into a hat.

For *The Shrimp Girl*, see Introduction, pp.67–9.

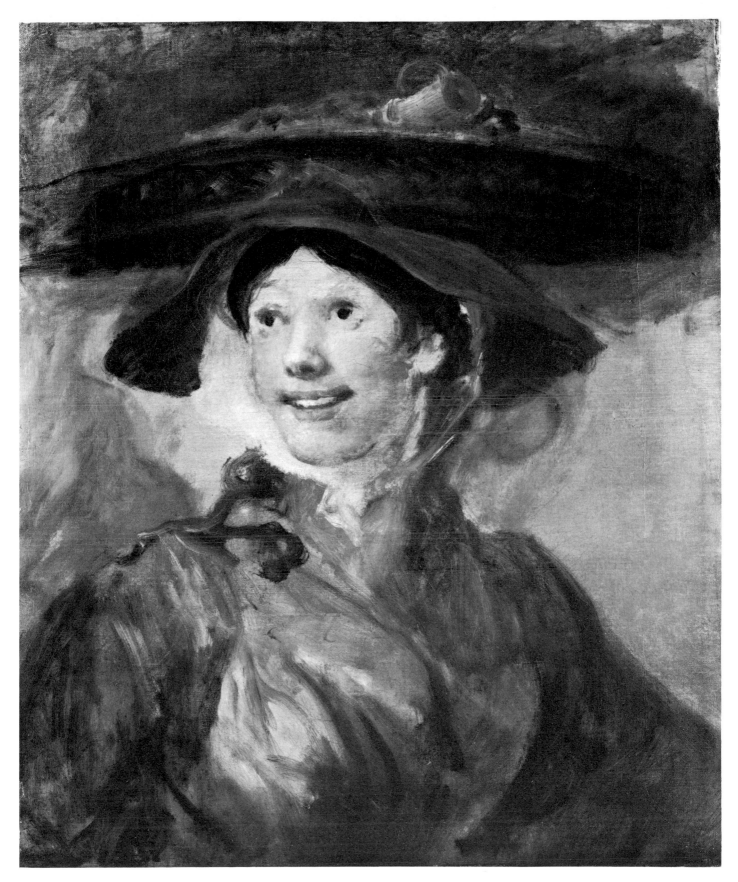

124. *The Shrimp Girl*. Mid-1750s? Oil on canvas,
25 × 20¾ in. London, National Gallery

125.
The Analysis of Beauty, Plate 1. 1753. Engraving, $14\frac{5}{8} \times 19\frac{5}{8}$ in. London, British Museum

126.
The Analysis of Beauty, Plate 2. 1753. Engraving $14\frac{5}{8} \times 19\frac{5}{8}$ in. London, British Museum

127. *The Cockpit*. 1759. Engraving, $11\frac{11}{16} \times 14\frac{11}{16}$ in.
London, British Museum

In 1753 Hogarth published his treatise on aesthetics, *The Analysis of Beauty*, accompanied by two elaborate engravings, of a statuary's yard and *The Wedding Dance* (p.35). The formal and iconographical play that relates the central scene and its parts to the diagrams along the borders is intricate and fascinating to unravel.

The Cockpit pretends to be an admission ticket to the Royal Cockpit in Birdcage Walk. The central figure, in the position of Christ in a Last Supper, is a blind peer, Lord Albemarle Bertie, isolated in his obsession, rank, and blindness from the others. The shadow over the arena is a man suspended from the ceiling in a basket—someone who has been unable to pay his debt, but is still trying to pledge his watch for further gambling.

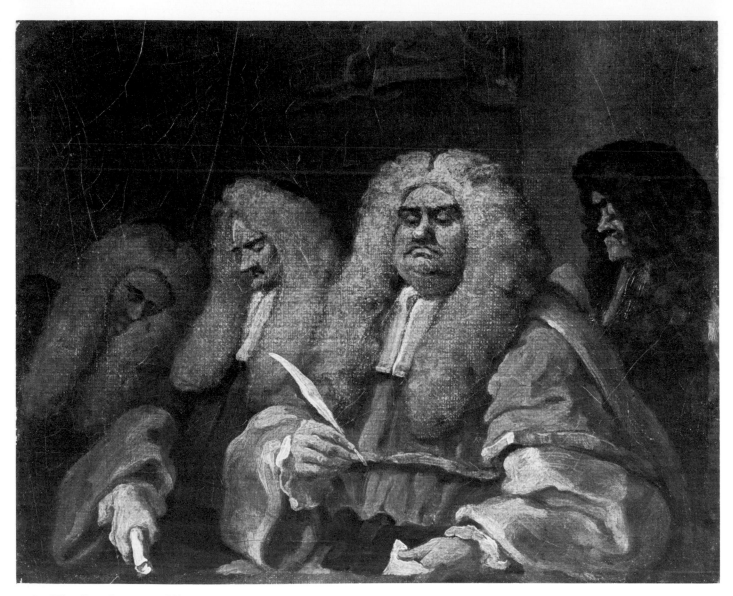

128. *The Bench*. 1758. Oil on canvas, $5\frac{3}{4} \times 7$ in.
Cambridge, Fitzwilliam Museum

The Bench is another case (like *The Wedding Dance*, p.35, and Plate 126) of an oil sketch painted *con amore*, which is engraved to illustrate a doctrine. The engraving, with its long explanatory caption, was one of Hogarth's attempts to prove that he was not, as some people claimed, a caricaturist. The design is closely linked to the *Analysis*, where Hogarth discusses the 'awful dignity' and 'sagacity' imparted by a judge's wig and robes (Chap. 6). The wig and robes are (in his terminology) 'outré', almost concealing the faces, which are themselves examples of 'character' and not 'caricature'. The long-nosed judge is taken from the funerary monument in *Analysis*, Plate 1 (Plate 125), where he was an example of false sagacity, of the bad judges of art, whose robes conceal stupidity or cruelty; and in *The Bench* the judges are themselves the caricaturers of judgement at whom the caption is aimed. (In the early states of the engraving, the inscription '*semper eadem*', *always the same*, was visible above their heads.) The engraving was first published in 1758, but Hogarth began a revision a day or so before he died, repeating the long-nosed judge and adding faces from Raphael's Cartoons. He shows how all of these can be exaggerated into caricature.

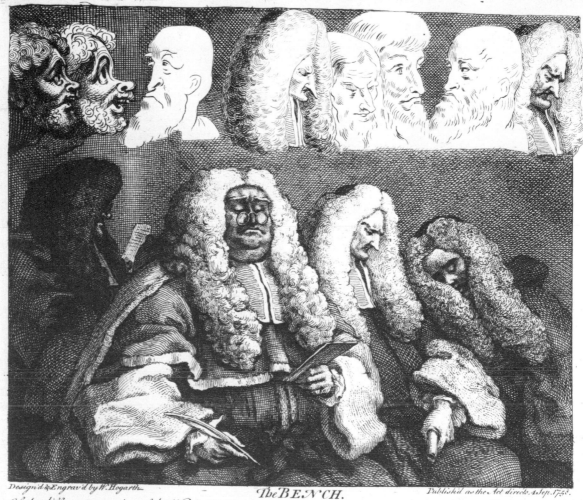

Design'd & Engrav'd by W. Hogarth. The BENCH. Publish'd as the Act directs 4 Sep.1758.

Of the different meaning of the Words Character, Caracatura and Outrè in Painting and Drawing.
This Plate would have been better explain'd had the Author lived a Week longer.

There are hardly any two things more essentially different than Character and Caracatura nevertheless
they are usually confounded and mistaken for each other: on which account this Explanation is attempted
It has ever been allow'd that, when a Character is strongly mark'd in the living Face, it may be consider'd as
an Index of the mind, to express which with any degree of justness in Painting, requires the utmost Efforts of a great
Master. Now that which has, of late Years, got the name of Caracatura, is, or ought to be totally divested of every
Stroke that hath a tendency to good Drawing: it may be said to be a Species of Lines that are produc'd rather by the
hand of chance than of Skill: for the early Scrawlings of a Child which do but barely hint an Idea of an Human
Face, will always be found to be like some Person or other, and will often form such a Comical Resemblance
as in all probability the most eminent Caracaturers of these times will not be able to equal with Design, be
cause their Ideas of Objects are so much more perfect than Childrens, that they will unavoidably introduce some
kind of Drawing: for all the humourous Effects of the fashionable manner of Caracaturing chiefly depend on
the surprize we are under at finding our selves caught with any sort of Similitude in objects absolutely re-
mote in their kind. Let it be observ'd the more remote in their Nature the greater is the Excellence of these
Pieces, as a proof of this, I remember a famous Caracatura of a certain Italian Singer, that Struck at
first sight, which consisted only of a Streight perpendicular Stroke with a Dot over it. As to the French
word Outrè it is different from the foregoing, and signifies nothing more than the exaggerated
outlines of a Figure, all the parts of which may be in other respects a perfect and true Picture of
Nature. A Giant may be call'd a common Man Outrè. So any part as a Nose, or a Leg, made
bigger than it ought to be, is that part Outrè. † which is all that is to be understood by this word, so
injudiciously us'd to the prejudice of Character. ——

† See Excess. Analysis of Beauty. Chap. 6.

129. *The Bench.* 1758. Engraving (final state, 1764),
$6\frac{1}{2} \times 7\frac{3}{4}$ in. (caption plate $4\frac{5}{8} \times 8\frac{3}{8}$ in.). London,
British Museum

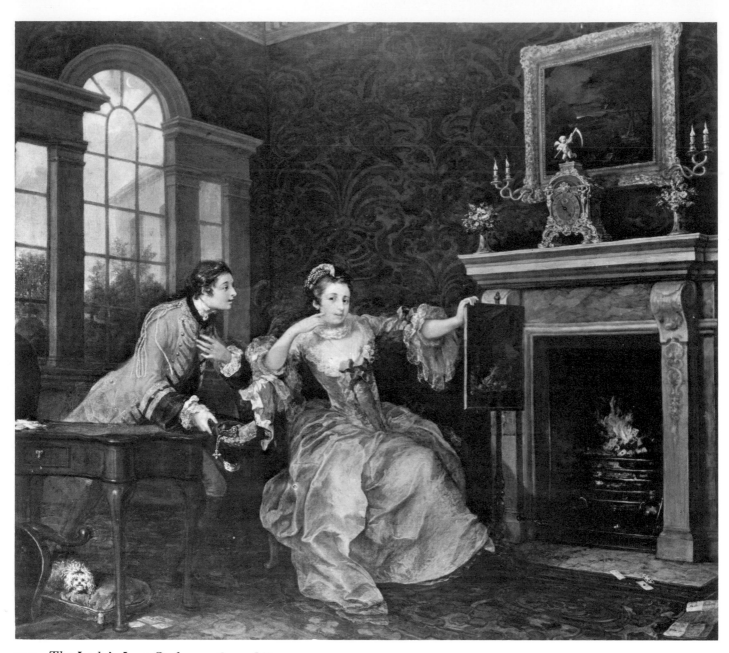

130. *The Lady's Last Stake.* 1758–9. Oil on canvas,
36 × 41½in. Buffalo, Albright-Knox Art
Gallery (gift of Seymour H. Knox)

Commissioned by James Caulfeild, Lord
Charlemont, as one last 'comic history-painting'
after Hogarth had announced his retirement, *The
Lady's Last Stake* shows an awareness of the
contemporary French genre-painting of de Troy and
Fragonard. The lady is choosing between husband
and honour on one side, and flying time, youth, and
chance on the other. A deck of cards has been cast
into the fire, and above the fireplace is a picture of a
penitent Magdalen in the desert and a clock on
which stands a cupid with scythe (cf. Plate 70). On
Cupid's pedestal is the inscription, 'Nunc Nunc',
below on the half-circle of sunrise and sunset. 'Set'
is replacing 'Rise', and the clock itself registers 4·55.
Through the window the moon is rising.

131. *Sigismunda*. 1759. Oil on canvas, 39 × 49½ in.
London, Tate Gallery

Encouraged by the success of Charlemont's
commission, another wealthy young man, Sir
Richard Grosvenor, commissioned a picture from
Hogarth on any subject he might choose. Instead of
a 'comic history', Hogarth set to work on a tragic
one, Sigismunda grieving over the heart (in the
goblet) of her lover Guiscardo, slain by her father.
The story was from Boccaccio's *Decameron*, but
Hogarth's source seems to have been Dryden's
Fables (1700). Grosvenor was unhappy with the
picture and Hogarth, after repeated attempts to
exhibit and engrave it for the public, and bitterly
disappointed by its reception, put it aside—but only
to attempt yet another engraved version just before
his death.

132. *The Five Orders of Periwigs.* 1761. Engraving,
$10\frac{1}{2} \times 8\frac{5}{16}$ in. London, British Museum

133. *George Taylor's Epitaph: Death giving Taylor a
Cross Buttock.* 1757. Pen over black chalk,
$9 \times 12\frac{3}{8}$ in. Collection of Mr and Mrs Paul Mellon

134. *George Taylor breaking the Ribs of Death.* Pen,
brown and black ink, $8\frac{7}{8} \times 12\frac{3}{8}$ in. Collection of
Mr and Mrs Paul Mellon

Published in November 1761, this engraving
satirizes the headdresses worn at the coronation, 22
September; it also refers, by its form and
inscriptions, to the archaeological diagrams of James
(Athenian) Stuart, whose measurements of the ruins
of Greek temples he feels to be equally appropriate
to wigs. The title alludes to the rigid rules of
architecture based on the orders.

George Taylor, the pugilist, had risen rapidly to
fame in the 1740s and died in 1757. Hogarth
made these drawings for his tombstone, now lost;
another version, in red chalk (D.L.T. Oppé
Collection) has a continuous decorative border along
the top (with a trumpet protruding from clouds in
the second) which shows that they were intended to
be seen side-by-side.

133

134

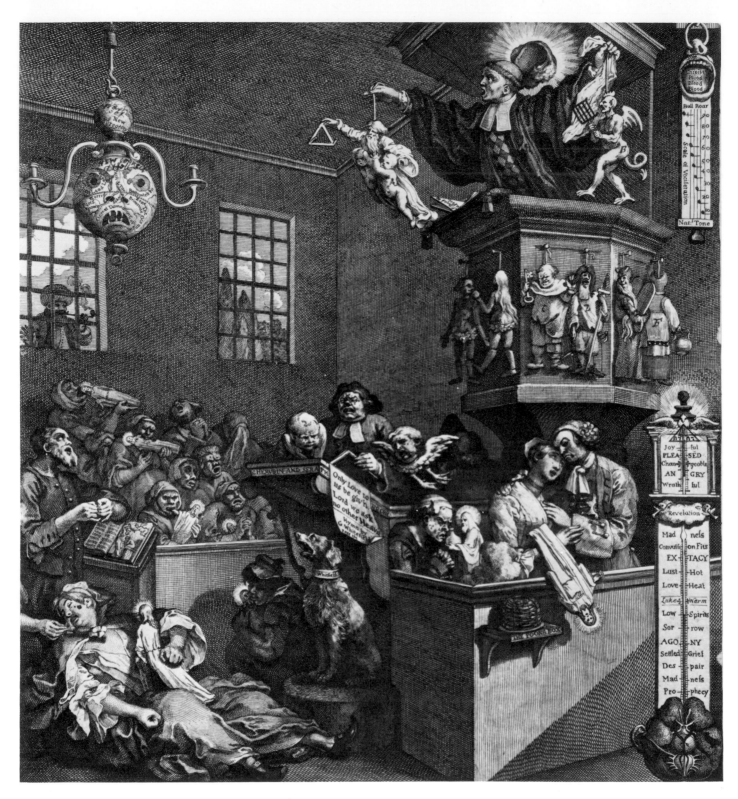

135. *Enthusiam Delineated. c.*1760. Engraved proof, marked in ink, 12⅝ × 14 in. San Francisco, California Palace of the Legion of Honor (Achenbach Foundation for Graphic Arts)

This satire, which should be compared with the interior of an orthodox Anglican church (Plate 59), depicts the effects of fanatical religions, ranging from Methodism to Roman Catholicism to Judaism, with a sober Mohammedan an amazed spectator outside a window. This outspoken plate was never published; thoroughly revised and toned down, it appeared in 1762 as *Superstition, Credulity and Fanaticism.*

John Wilkes Esq.

Drawn from the Life and Etch'd in Aquafortis by Will.^m Hogarth.

Price 1 Shilling.

Publish'd according to Act of Parliament May ye 16. 1763.

136. *John Wilkes, Esq.* 1763. Etching, $12\frac{1}{2} \times 8\frac{3}{4}$ in.
London, British Museum

John Wilkes had been a friend of Hogarth's, but they broke over a political disagreement in 1762; Wilkes attacked Hogarth in his *North Briton* (No. 17) and Hogarth retaliated, after Wilkes had been arrested for libel (for No. 45), by sketching him in court and publishing the print. He turns the demagogue Wilkes into a Satanic figure (his wig forms horn-like protuberances), who holds his symbolic cap of liberty in such a way as to make it a halo for himself.

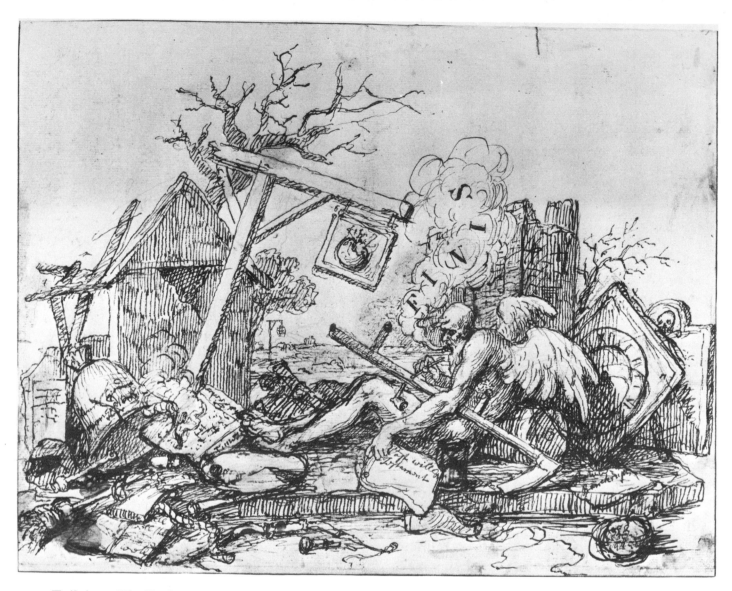

137. *Tailpiece : The Bathos*. 1764. Pen and brown
ink, 10⅛ × 18in. Windsor Castle, Royal Library

This drawing was engraved (in reverse) by Hogarth and published in April 1764 and was his last completed engraving. It was intended as tailpiece to the bound folios of his engraved works, but its puns on 'end' also refer to the state of politics and society, art and culture. Among other things, the *Tailpiece* shows the extent of Hogarth's knowledge of iconography, especially from Dutch still-life paintings. Take the pipe that has snapped: pipes had been used by the seventeenth-century Dutch artists as symbols equivalent to skulls in *Vanitas* still-lifes.

The reference was not only to the health-hazard but to Scripture: 'For my days are consumed like smoke' (Psalms 102:4). But Hogarth also inscribes, in Time's last breath of smoke, 'Finis', and as a part of his own meaning—the 'end' of things—breaks the pipe in two. In this final drawing he has spread out a large *Vanitas* still-life but informed it with topical analogies: his own anti-sublimity (an attack on Edmund Burke's 'sublime') and his own apocalyptic message about political and cultural life in England in 1764.

Bibliographical Note

Writings of William Hogarth

The Analysis of Beauty (1753), ed. Joseph Burke (Oxford, 1955). Burke also prints the surviving manuscripts of the *Analysis* and of the 'autobiographical notes' Hogarth wrote in the early 1760s (British Museum).

Hogarth's '*Apology for Painters*', ed. Michael Kitson, in *Walpole Society*, XLI (Oxford, 1968), 46–111, prints the remainder of the British Museum Hogarth manuscripts, which contain more 'autobiographical notes', a general work on the situation of the artist in England in the eighteenth century, and notes toward a continuation of Rouquet's commentary on the engravings.

Biographical Works

The main sources for Hogarth's biography are, besides the contemporary rate books, parish registers, newspapers, and the like, the *Notebooks* of George Vertue, published by the Walpole Society (Oxford, 1934, 1955), vols. XXII and XXX (Vertue, III and VI).

John Nichols, *Biographical Anecdotes of William Hogarth*, containing much contemporary material on Hogarth's life, was first published in 1781, and enlarged in editions of 1782 and 1785. Nichols was assisted by George Steevens, Isaac Reed, and others. All of this material was still further expanded and published in three volumes as *The Genuine Works of William Hogarth* in 1808, 1810, 1817.

A few extra biographical facts and anecdotes appear in Horace Walpole, *Anecdotes of Painting in England*, based on Vertue's *Notebooks*, vol. IV (1781); John Ireland, *Hogarth Illustrated*, 3 vols. (1791, 1798); and Samuel Ireland, *Graphic Illustrations of Hogarth*, 2 vols. (1794, 1799).

Austin Dobson, *Hogarth* (London, 1879), with expanded editions running up to 1907, gathered together much of the information from Hogarth's contemporaries and from articles published in the interim; included a valuable bibliography of studies up to 1907.

Ronald Paulson, *Hogarth : His Life, Art and Times*, 2 vols. (New Haven and London, 1971), is the standard life.

The Paintings, Engravings and Drawings

The tradition of commentary on the paintings/engravings begins with those sanctioned by Hogarth during his own lifetime, primarily Jean André Rouquet's *Lettres de. Monsieur ** à un de ses Amis à Paris, pour expliquer les Estampes de Monsieur Hogarth* (1746), to which was added a pamphlet on *The March to Finchley* in about 1750.

After his death the Revd John Trusler, in *Hogarth Moralised* (1768), and G. C. Lichtenberg, in *Ausfürliche Erklärung der Hogarthischen Kupferstiche* (5 vols., 1794–9), exercised their ingenuity and wit upon Hogarth's engravings. The latter has been translated uncritically by Innes and Gustav Herdan as *The World of Hogarth, Lichtenberg's Commentaries on Hogarth's Engravings* (Boston, 1966), and the analysis of *Marriage à la Mode* very carefully by A. S. Wensinger and W. B. Coley as *Hogarth on High Life* (Middletown, Conn., 1970).

The main tradition of Hogarthian commentary, however, runs from Nichols and Steevens (accompanying their biographies), ending in J. B. Nichols' *Anecdotes of William Hogarth* (1833); to John Ireland's *Graphic Illustrations*. This material is summed up, checked and corrected, and augmented in F. G. Stephens's excellent *Catalogue of Prints and Drawings in the British Museum*, II-IV (1873–83).

Ronald Paulson, *Hogarth's Graphic Works*, 2 vols. (New Haven and London, 1965; revised ed., 1970), is the modern *catalogue raisonné* and commentary; of which *Hogarth's Complete Engravings*, ed. Joseph Burke and Colin Caldwell (London, 1968), is a popularization.

R. B. Beckett, *Hogarth* (London, 1949), is a checklist of the paintings, no longer up to date.

A. P. Oppé, *Hogarth's Drawings* (London, 1948), is still an excellent catalogue with relatively few omissions.

Gabriele Baldini and Gabriele Mandel, *L'opera completa di Hogarth pittore* (Milan, 1967), is an accurate survey of all the secondary material on Hogarth to that date, with many serviceable reproductions.

Critical Studies

Besides much material in the books mentioned above, there is one major critical study of Hogarth: Frederick Antal's *Hogarth's Place in European Art* (London, 1962), which is particularly useful as a source study that shows Hogarth's connections to many artists before and after his time.

Finally, I should like to acknowledge my own debt to the magnificent exhibition of Hogarth's paintings held at the Tate Gallery, London, in 1971–2, organized by Lawrence Gowing, who wrote the catalogue. Most of the new thoughts on Hogarth that appear in the present monograph, especially those on colour, owe their conception to the weeks I spent wandering about the Tate among Hogarth's paintings.

List of Collections

Drawings

Prints

Index of Persons